Elements of Style
Phillip Bloch

Elements of Style

Phillip Bloch

From the portfolio of Hollywood's premiere stylist

Foreword by Martha Nelson of *InStyle*

with
British GQ contributing writer Kimberly Cihlar
Movieline columnist Diane Clehane
and
Elle and *Mirabella* contributing editor Ruth La Ferla

WARNER BOOKS

A Time Warner Company

Book design by Paul Roelofs

Photo editors: Laurie Kratochvil and Catherine Eng

Warner Books, Inc., 1271 Avenue of the
Americas, New York, NY 10020

Visit our Web site at http://warnerbooks.com

 A Time Warner Company

Manufactured in Canada by Transcontinental Printing, Inc.

First Printing: March 1998

10 9 8 7 6 5 4 3 2 1

**Library of Congress
Cataloging-in-Publication Data**
Bloch, Phillip.
 Elements of style / Phillip Bloch.
 p. cm.
 ISBN 0-446-67423-0
 1. Fashion. 2. Clothing and dress. 3. Beauty, Personal.
 4. Motion picture actors and actresses—Costume—United States.
 5. Fashion designers—United States—interviews. I. Title.
TT507.B575 1998
646'.3—dc21 97-41007
 CIP

ATTENTION: SCHOOLS AND CORPORATIONS
WARNER books are available at quantity
discounts with bulk purchase for educational,
business, or sales promotional use. For
information, please write to: SPECIAL SALES
DEPARTMENT, WARNER BOOKS, 1271 AVENUE OF THE
AMERICAS, NEW YORK, N.Y. 10020

I dedicate ELEMENTS OF STYLE
to God whose miracles and
creations guide and inspire me
to my destiny every day.

To Mommy—Monday nights
at Mays and the mall. Dressing
for nights out with Daddy
or just going to an affair. The
hours of time and affection
and being my friend—that is
where inspiration is born.
Your fatal attack by breast
cancer served as the catalyst
in creating this book. You are
always in my heart.

To Daddy—Your love, encourage-
ment, support, advice, trust,
respect, and money (well, 6 out
of 7 isn't bad) have made many
dreams come true. Thanks for
always being my biggest fan. You
know I am yours.

To Gianni Versace—Beauty is
where you find it. Your dreams
made all of our worlds a more
creative place.

CONTENTS

FOREWORD

FOREWOR

Say the word "stylist," and most people think you're talking about hair. But in the worlds of fashion, photography, and Hollywood, stylists are all about clothes. Variously described as image-makers, dressers, or shoppers, stylists are, in fact, a little bit of all three. Sometimes they are therapists, interpreting their clients' anxieties, demands, and fashion fantasies with an analyst's touch. The best are also sorcerers, able to make magic with a satin slip and a bit of boa. By any definition Phillip Bloch is one of the best.

Sometimes called the "Stylist to the Stars," Bloch laughs at the label, but he can't deny that he has come by it honestly. Living in Los Angeles since 1993, he has worked on literally hundreds of celebrity photo shoots, and dressed scores of actors for the Academy Awards, the Golden Globes, the Emmys, the Grammys, and a list of premieres as long as Cher's fingernails.

Still thrilled that he's found his way into the Wonderland

of fashion and celebrity, Phillip remains exuberant about his work and the people with whom he works. But when it comes to his clients, he is quick to point out, "I don't *give* them style; they've got tons of their own." His job is to help them create the look they have in their mind's eye. For a working actor, he explains, "Time is the biggest issue. Who can be on a set twelve hours a day and then come home and figure out what to wear to tomorrow night's premiere or a photo shoot next week?" That's where Phillip comes in.

Phillip will work the phones, the shops, and the designer showrooms from Milan to LA, searching for the right dress, the perfect shoe, the new accessory. And should you think this all sounds like jet-set glamour, take a look at his car—not some jazzy Jaguar convertible, but an anonymous black pickup with a custom-built box in back, capable of carrying two dozen designer gowns without a wrinkle or security risk.

He will work his tail off so when he hits the set, he can make it seem effortless.

But if it is his attitude that makes the work fun, it is his talent that makes his work good. There is a constant fast-cut fashion show going on in Phillip's mind, in which any image he's ever seen can be immediately accessed for reference. "Oh, very Cary Grant," he comments as a man walks into the room. A blouse is immediately ID'd as "vintage Pucci," a jacket is "So *Out of Africa*," a dress—"Prada two seasons ago," and a haircut—"completely Agent 99." It isn't just the knowledge of design and fashion history, but the freewheeling interior flip book of images from decades of film, television, music, and magazines that give him his freshness, his edge.

Phillip's list of clients could fill a book—and now, in fact, they have. Along with the celebrities he works with, he introduces us to the people

in his world—the designers, photographers, hair stylists, and makeup artists with whom he collaborates to create such memorable looks. "It isn't about me," he said frequently as he was working on the project. "It is about what we do together."

In writing this book, Phillip asked his colleagues, How do you think about style? What inspires you? How did you become what you are today? What matters to him more than the labels in your closet is personalizing your wardrobe, finding your own signature style, having a little fun with it all. Phillip does. He's never without his trademark Kangol hat, worn backwards above his probing green eyes and his electric smile. When he's interpreted just the right look for a client, his nonstop activity shuts down for a second, he cocks his head, laughs, and delivers his favorite compliment: "You look fabulous." So does he. So can you.

—Martha Nelson

INTRODUCTION

INTRO

"Inspiration may be a form of superconsciousness, or perhaps of subconsciousness—
I wouldn't know. But I am sure it is the antithesis of self-consciousness."

— AARON COPLAND

It's one thing to get dressed to go to a party with ten of your friends. It's another to get dressed for an event and have people talk about you for the next week, or to run pictures of you for the next year and discuss how you looked. But that's what people in the entertainment world face at every event, every time they walk down the red carpet in front of all the press. It can be stressful. We've all made bad fashion decisions at one time or another. In Hollywood, however, it's hard to say which is worse, being talked about or not being talked about? Can you even imagine going out and then having to read about how well or badly dressed you were?

My job is to help celebrities create the look they want. I love my work as a stylist. I like being a part of a creative and dramatic process, working with a team of experts—hair stylists, makeup artists, designers, photographers, and of course the stars themselves. Together we forge an image that expresses a particular person, mood, and occasion. Technically that image is just a moment, a single frame of film; but if you get it right, the moment can transcend that instant and last a long, long time—if not forever.

For me a fascination with moments—and in particular moments with some glamorous topspin—began early. Growing up in Seaford, Long Island, might not seem to be the most obvious training ground for someone in my line of work, but drama and excitement can make themselves felt in the most unexpected places. I remember, for instance, a day when my father insisted that I watch the U.S. astronauts land on the moon. It was the last thing I wanted to do, but he made me watch them. And you know what? I'll never forget that experience. Those images were my first encounter with the goose-bumping rush of a truly spectacular moment.

I have always been interested in fashion. I remember as a kid producing "fashion shows" with my dogs and stuffed animals wearing couture creations from my mom's favorite sheets. At about eight, I was reading *Seventeen*. By ten, it was *Mademoiselle*, and by twelve, I had graduated to *Vogue*. I always told the store clerk at the local 7-Eleven that the magazines were for my mother and hid them in brown paper bags. I longed for the bigger, more stylish life I sensed was waiting for me somewhere beyond Seaford. On weekends I would wander over to my school grounds and lie in the grass and watch the planes pass overhead. How different life must be in Paris, Madrid, Rome, I'd think.

I finally graduated from high school, even though I used to cut classes all the time. I was rebellious, right up to the last day of school. For graduation,

I got my father's old skinny plaid tie, his old vest, a big baggy cream-colored shirt of his, big, baggy pants, and suspenders. I went very Annie Hall—a hot look then—with the tie not tied right, and an old English cap. When I got up onstage I pulled off my mortarboard and put on the English cap. I thought it was so cool. My parents were so upset with me, asking me, "Why couldn't you behave just once?"

The movies, television, and music have been a constant source of inspiration. *Mahogany*, starring Diana Ross, had a big effect on me when I was sixteen. I walked out of the theater with my parents and announced: "I want to do that. I want to model. I want to design. I want to do it all." Fortunately for me, my parents, who were both amateur painters, always supported me in anything creative I wanted to do. They embraced my individuality. That unconditional acceptance is the greatest gift a parent can give a child,

and I'm sure that is why I'm here today.

Later, when I saw *Barry Lyndon*, I loved the plushness of the Renaissance costumes, the laciness and the empire waists. From then on, I began watching films for the costumes as much as for the stars. When I saw *Airport* in 1970, I thought Jacqueline Bisset was so chic, even in the midst of a raging Midwestern snowstorm. That was the first time I noticed how costumes can really enhance a character and create a mood. I learned that Edith Head was the costume designer, and it began to dawn on me that fashion could be a sophisticated form of character interpretation, as opposed to a merely visual display of beautiful clothing.

It was always the women in film that intrigued me. Those strong, tragic women. I love Sophia Loren in *all* the old movies. Grace Kelly in *To Catch a Thief*. Who can forget

Valley of the Dolls? Barbara Parkins, Patty Duke, and Sharon Tate. Linda Blair, with her innocent little waif thing in *Born Innocent* and *The Exorcist*, was doing Kate Moss before Kate Moss. And *The Poseidon Adventure* with Stella Stevens in that fabulous satin slip dress, and when the boat capsized, Pamela Sue Martin ripped off her skirt and had hot pants underneath . . . now that was something.

There was inspiration galore on the small screen too. My favorite television shows included *That Girl* with Marlo Thomas, *I Dream of Jeannie* (how I *loved* that luxurious bottle home with all the plush velvets and satins), and *Bewitched,* with Elizabeth Montgomery as Samantha in her simple shift dresses and Agnes Moorehead as Endora in her chiffon gowns. All of these women and the costumes they wore fed my fascination with clothing and style.

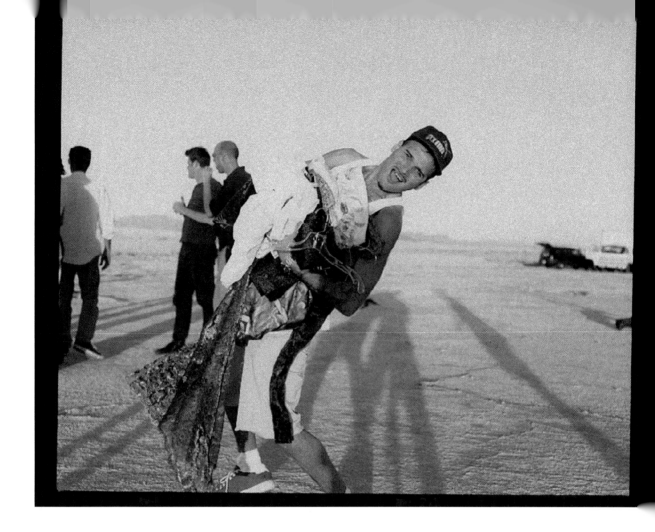

None of these celluloid women, however, had any greater influence on me than those I grew up with at home. My mother, Marlene Bloch, was a wildly energetic woman who pursued several different vocations—antique dealer, real estate agent, school bus driver. She died of breast cancer two years ago—a life-shattering event for me, which has also been one of my main motivations for putting this book together. My mother loved clothes and was fascinated by images of "the good life," and I always think of her when I get to do "glamorous" things. In my teens, she became a hair-dresser for the stars—but not exactly for them, she groomed their dogs' hair, in her pet shops on the Upper West Side of Manhattan, where she catered to a rather large celebrity clientele. I used to tease her that she was the Dog Groomer to the Stars and joke that show business must run in the family.

In truth, it was style that ran in my family—or at least in its female members. My Aunt Francis was very Angie Dickinson, and my Aunt Tibby loved her chiffon gowns and diamond earrings. My grandmother Cora Bloch was an avid shopper with a joie de vivre, who played the piano and sang. I'll never forget the Moroccan and Indian paintings she had on her walls and the exotically accessorized tables underneath them. Perhaps that is why I've always been so influenced, stylistically, by Moroccan and Indian culture. As a child I looked at those pictures on the wall, loving them and their exotic beauty. They became a part of me without me even realizing it.

Even after I moved to New York City and officially entered the world of fashion as a student at the Fashion Institute of Technology, it was my personal contacts that taught me the most and propelled me forward. At the age of seventeen, I was "majoring" in Studio 54, where I got to know many models of the time. I was enamored with Julie Foster, Patti Hanson, Janice Dickenson, Lauren Hutton—she had a space between her teeth and so did I—and especially Gia. We'd go to the East Village and hang out. Gia would be on the cover of *Vogue* and *Cosmo*, so beautiful—and yet she was really tough and rough around the edges. That was her sex appeal and her beauty. I was in awe.

Through a series of lucky breaks—and despite my height and weird looks by most fashion standards of the day—I was soon modeling my way through Europe and Japan. I worked some of the big shows— Gaultier, Versace, and even Galiano's first collection. I did shoots for *L'Uomo, Vogue, ID*, and *Max*, and there is no doubt that the connections I made doing this made a big difference for me later as a stylist. Two of my favorite magazine editors, Scia Scia Gambaccini and Monica Dolphini, who were the first to hire me for fashion shoots, later paved the way for my styling career. I needed a creative outlet beyond modeling, and after landing a job with Zama Sport for Romeo Gigli and then upcoming designer Ennio Cappasa (CostumeNational) I tried a little sales, a little publicity, even played photographer a few times. Eventually I went into business with my best friend in Italy, Stefano Disabatino, designing a line of clothing. We really did our best, but we had one very important business lesson to learn—financially we were out of our depth. It was a hard lesson to learn. It was at this time that Doris Day's "Que Sera Sera" became my mantra— whatever will be, will be. And things started to look up. When I finally returned to the United States, I was recruited by the Cloutier Agency and I went to

LA. I wasn't just watching my onscreen idols; I was working as a stylist for some of the most famous names in the world.

I do what I do because of the myth, the legend. The myth of Salma Hayek, the myth of Nicolas Cage or Will Smith. They're just people doing a job, but their myth, the image they project, brings so much joy and happiness to people. It's images we remember—Elizabeth Taylor lying on the bed in her slip in *Cat on a Hot Tin Roof*, Marilyn with the dress blowing up over the subway from *The Seven Year Itch*, Liza with the hat from *Cabaret*. During a shoot, one of my goals is to give back to the stars who give all of us our myths. Working with my friends and clients, I try to give them the kind of day they always dreamed of when they were just another little boy or girl, like you and I once were, sitting in some average house in some quiet town, dreaming of the day we would shine. I try to inter-

pret the dreams and make them come true.

It's hard work, though. I am on call any day, at any time. I put in a lot of late nights. Clothes don't just appear. There's a lot of thought, a lot of meetings and phone calls that go into it. So many phone calls, in fact, that on any given day my cordless phone can run out of batteries before 3 P.M. And no matter how much I like a gown, if my client doesn't, it's out.

People often ask me for advice about their own clothes. Do I like this shirt or that dress? I wish I could spend a day with them going through their closets, helping them determine their own personal style. That's one reason I created the book—to help readers find sources of inspiration, to discover the look that works best for them, to realize their dreams.

There is still another reason:

to give something back. It is all about making the most of life. After my mom died of cancer and several friends of mine died from AIDS, I knew I wanted to do more. I had to find a way to contribute something, because although I have really great experiences with this business, in many ways it's fleeting. I decided to do a book and donate the profits to several charities to help in working toward finding a cure for AIDS and breast cancer.

I have taken whatever talents God gave me and put them into play. Everything in life is about finding your place. I really believe that. I fell into a career in styling, but it really seems like the perfect match for me. I am working with the clothes I love, helping create the images that inspired me so much. It seems like destiny. It has been a circuitous route, but I feel like I am finally home.

A roundtable discussion featuring personalities from the popular media.

Phillip Bloch
STYLIST

Elycia Rubin
FASHION/TALENT EXECUTIVE AT E!

Rebecca Meiskin
FEATURE PRODUCER, ENTERTAINMENT TONIGHT

Jeanne Beker
HOST AND PRODUCER, FASHION TELEVISION

Brad Zamkoff
CHAIRMAN OF FIT FASHION DESIGN DEPARTMENT

Kimberly Cihlar
FREELANCE JOURNALIST

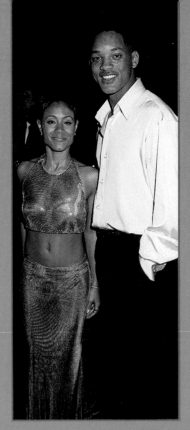

CAN WE TALK?

Kimberly: What is the fascination with shows such as E! and *Entertainment Tonight,* and magazines like *People* and *InStyle*?

Elycia: E's viewers look to celebrities for a glimpse of glamour.

Rebecca: Because of the accessibility to high fashion now, it has much more mass appeal. A lot more people have a heightened awareness of designers' names today than they did even ten years ago.

Kimberly: Top designers are almost as famous now as movie stars. Why is that?

Elycia: Armani is a celebrity now, like John Travolta.

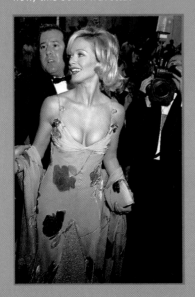

▲ Lauren Holly in Valentino.
Academy Awards, 1997.

Jeanne: Designers have become stars, they're on the same level as stars. You don't look to Hollywood, necessarily, for designers because you don't think of L.A. as a great "fashion city" like Paris or New York. Hollywood is laid back, but there are these fabulous parties where people dress up.

Phillip: Television coverage is often thought of as a million dollars' worth of free publicity. Is it bringing the designers the recognition that they thought?

Rebecca: After a fashion segment, we get all sorts of responses from viewers asking, "Where can I get that dress?" Or "I wore that exact same style in the sixties."

Phillip: Like Elizabeth Taylor, when she wore that slip in *Cat on a Hot Tin Roof,* and today that same look is seen everywhere. Certain styles come back around.

Elycia: Well, we've come out of a recession and now the economy is better and people are more into fashion. Designer logos are so popular, everything that wasn't chic is chic again.

Kimberly: Is Hollywood more influenced by fashion or vice versa?

Phillip: I think street style drives the runways, and Hollywood is in a class by itself. But . . .

Rebecca: I think Hollywood is influenced by runway fashion. Designers want celebrities to wear their clothes.

Elycia: What about people wearing vintage?

Phillip: That's saying, "I've got individual style."

Elycia: I think when somebody goes to Lily [the vintage store in L.A.] it sets them apart as being very chic and individual.

THE SYMPOSIUM

17

I think it's refreshing. It makes the celebrity stand out.

Phillip: I loved how Isabella [Rossellini] at the Golden Globes made the Dolce & Gabbana cherry coat different, by mixing it with other pieces of clothing for her own interpretation.

THE STYLIST THEORY

Kimberly: Why have stylists become so important today, especially in Hollywood?

Elycia: The stylist is very important. A celebrity can put a style together, but today, why not hire an expert to do it? If all eyes are on you, you just feel reassured if someone with a great sense of style and an eye are helping you. It gives a great sense of insurance. You'll feel confident and sexy and it will show from the red carpet or sitting in a chair for an interview.

Rebecca: In Hollywood, people can become famous so quickly that they don't have time to *cultivate* the image. They're in a different peer group now; they may have been waiters and now they're going to the

Academy Awards.

Phillip: That's why there are stylists. The stars are all so busy.

Elycia: They don't have the time. They might be on set 15 hours a day. Then they have a TV show or appearance, and have to get the dress, the jewelry, the shoes, the bag. Stars can be on auditions, too, or rehearsing all week, shooting all day.

Phillip: I want to remove that myth that people have about stars. They work long hours—up at 6 A.M. and working nights.

Rebecca: Sometimes they are on location in Utah, flying in for the premiere that day.

Elycia: And they know whatever Phillip brings them will look great.

Rebecca: Phillip is more an arbiter of style than a stylist. He's a real authority. He relates Hollywood fashion to the public.

Elycia: Fashion can be confusing. Phillip is there to make it understandable.

Jeanne: It's also the sensibility of how to put together options. Options are so intimidating.

Rebecca: I think he makes celebrities feel good about themselves. Phillip chooses feminine clothes in colors that work well with individuals.

Phillip: I feel so lucky because I really love what I do. In a sense, we're making history. People will remember Salma's tiara, Nicole's Chinoiserie. People live through these stars and their dresses vicariously.

Elycia: You can't remember who won Best Actor. But you can remember what Nicole Kidman wore to the Academy Awards.

FASHION ESCAPISM

Kimberly: Runway fashions can be so wild and out-there. What is the connection between runway and Hollywood?

Phillip: Fashion starts at couture, then moves to ready-to-wear. Then the editors and stylists interpret it. You narrow it down and disperse it into looks the public wants to see: glamorous, funky, sexy. But sexy, soft, and pretty is more my signature. We're reflecting society and what people want to see.

Elycia: It's escapism, it's fantasy. That's what fashion is. You look on the runways; it's art. The designers are geniuses. You might not wear it, but it's fun to see a gorgeous outfit modeled by a beautiful woman.

Jeanne: The last few years people have craved glamour. In the millennium, we'll probably see a backlash with stars not caring, and making anti-fashion statements.

Rebecca: Phillip, when you choose an outfit, do you keep in mind the paparazzi?

Phillip: That's a "press dress." You have to keep in mind who wants a press dress or who wants to just look beautiful.

Elycia: You always keep the media in mind for the big events.

Rebecca: What about movie premieres?

Phillip: It's about being less glamorous for a premiere.

Elycia: Yes, people are looking more fun and funky, more pared down at premieres today.

Phillip: Look at Will Smith and Jada Pinkett wearing camouflage at the premiere of *Independence Day*. That was cute and fun.

Kimberly: How do today's premieres compare to the movie premieres of the past?

Brad: The old premieres were a distinctive moment. There wasn't a particular gown or style that influenced fashion. It was glamour. The world would go mad for these people—Clark Gable, Vivien Leigh, Carol Lombard, Rita Hayworth, Lana Turner.

Kimberly: What is it about style that gets celebrities recognized today by the press?

Rebecca: Dozens of celebrities make it onto *Entertainment Tonight* because of what they were wearing.

Elycia: A lot of new actresses or those not so well known make it into *People* or onto E! that way. The right dress can catapult you.

▲ Angela Bassett in Nicole Miller. Courtney B. Vance in Armani. Cannes Film Festival, 1997.

Phillip: Remember Elizabeth Hurley, wearing the "safety pin" Versace dress. Now more than ever the relationship is working between the designers, the celebrities, Hollywood, and advertising. It becomes more about, "I have to have that dress because it's hot."

Kimberly: Why is image so all important?

Jeanne: It's all about image now. For better or worse. Image has never been so important.

Phillip: There are the celebrities who clearly want to change their image. For *Entertainment Weekly,* we're shooting Jenny McCarthy, who's all about the collegiate party girl, and they want her to be transformed into Grace Kelly. So even if only for a magazine shoot, we're creating an illusion.

Rebecca: Courtney Love did that—changed her image—and *ET* did a whole segment on it.

Kimberly: Tell us about designers and their muses?

Rebecca: Look at Brooke Shields and Calvin Klein . . .

Phillip: Elizabeth Hurley and Versace. Jamie Lee Curtis and Pamela Dennis.

Elycia: It's so true. That one celebrity can make them a recognized designer, or at least help them on their way.

Phillip: A recent biggie was Carolyn Bessett Kennedy with Narciso for Cerrutti and Nicole [Kidman] with Galliano for Dior.

Rebecca: Sharon Stone and Vera Wang . . .

Phillip: Madonna and Dolce & Gabbana

Kimberly: Are the Academy Awards one of the biggest nights in a designer's year?

Phillip: Well, you never know until the last minute what the celebrity will be wearing.

Elycia: All you need to have is one right person in your dress.

Rebecca: It's hard to do that.

Elycia: I thought Courtney Love and Jada Pinkett stood out that night at the Oscars in '97.

Phillip: At the end of the day, the designers don't do it for money. They just love seeing their creation on a beautiful person taking a life all its own.

THE MAIN EVENT

Kimberly: Looking at some of the celebrity pictures Phillip has styled, what are your thoughts?

Rebecca: This picture of Elizabeth Hurley wearing Heidi Weisel at the premiere of *Extreme Measures* goes against the whole school of thought

▲ Roma Downey in Rifat Ozbek. People's Choice Awards.

▲ Lea Thompson in Izaac Mizrahi, and husband, Howard Deutch, in Armani. Emmy Awards, 1996.

of the slip dress as being subtle.

Phillip: But it is just a simple slip dress—

Rebecca: But this is not subtle. She looks beautiful, confident, sexy, timeless.

Rebecca: I think she's someone who transports us back to old Hollywood—to the glamorous heydays of the forties.

Brad: There was this *magic* in the past. It made you want to go home and put on the platform shoes of Carmen Miranda.

Rebecca: The Emmys never used to be so big, the Golden Globes, the MTV Video Music Awards—it's all about the clothes now.

Phillip: The MTV awards appeal to a younger crowd, a trendy, personally styled crowd. The Cannes Film Festival has been such a big thing recently. Premieres now happen four to five times a week. People can relate to celebrities and not models.

Elycia: Look at Kyra Sedgwick in the new Ungaro ads. She is so amazing and so real.

Kimberly: How do today's stylists differ from the role the studios played in the past?

Brad: What we saw in the *PhotoPlay* magazines, the candids with the stars at home—the dates were set up, the clothes borrowed from the studio, as were the wigs. The stars were sewn into their dresses. Most of the time you saw cloaks or furs. It was the overall effect. And it was an illusion set up by the studios. Where did we see them in their lives: the premieres, the one window into their "real" life. But we believed it. We believed Joan Crawford woke up in her makeup. Who knew she was freckled? The reality of even their skin tone was hidden from us.

Phillip: Studios were the original stylists. Studios were the publicists of today. Now it's personal. Now celebrities have a lot more power. It's about personal style and freedom.

Elycia: The press wants to cover shows where the celebrities are. At E! we can do more fashion journalism, but designers know there's a celebrity angle. Look at the Versus show two seasons ago where every celebrity, practically, was in the front row.

Jeanne: It's a great symbiotic relationship. Both enhance each other's image and that's what Hollywood is all about.

GIORGIO ARMANI

It wasn't a question of some sudden, mystical revelation. My vocation for fashion was born in a rational way: I realized that I would like to design my own fashion when I saw for myself what the market had to offer— rigid and uncomfortable men's suits, without any research in the fabrics, full of conformism and lacking any personal style.

Even as a boy I had an interest in elegantly dressed people. I admired my mother, who although she was not rich, always dressed with a lot of charm and style—even in war-time. And if any image has influenced my style, it's that of the black-and-white American films of the '30s and '40s.

I'll never forget when I did my first fashion show, of my men's collection. There were only about forty people there, and I was terrified it was going to be a disaster. But at the last minute, I got the idea of pushing up the sleeves and turning up the collars of the jackets, and it worked: the audience got the idea that a jacket could be imagined and worn in a new way, mean something different in the modern wardrobe. The response was really enthusiastic, and it set the stage for everything that's come after.

Fashion is a hard, tough business that is often anything but glamorous. But it has its moments, and above all, for me the satisfaction is in imagin-ing things that will make other people's lives that much more secure, beautiful, and yes, glamorous.

BADGELY MISCHKA

Mark Badgely: One of my earliest memories was of a TV commercial for Chloe perfume. I was six or seven at the time. The image for the perfume was this amazingly glamorous woman wearing a gorgeous black cocktail dress with a fishtail hem, very tall shoulders, and a little carved silhouette. I would spend hours in front of the television set just trying to grab that silhouette, drawing it over and over. I was always drawing the women I would see on TV. Typically, it would be Lucille Ball, wearing an exaggerated, almost couture looking costume, even during the day.

James Mischka: She wore cigarette pants with a big overskirt. I was attracted to that. I had always loved glamour, and for me glamour started at home. We had this Danish Modern furniture and a French poodle that was more of an accessory than a dog. It was all very stylish. My mom would dress up fantastically to go out to cocktail parties. She had all these incredible falls and wigs. Everyone did in the sixties.

Mark: People certainly took more risks back then, even in Middle America. Clothes were a riot. Every woman wore big wigs and Courrèges-style cocktail dresses and crazy shoes that now don't seem to suit them.

James: My mother wore a metal mesh dress and ostrich feathers. And she had a diagonally striped dress that looked like an awning kind of thing. It was funny how outrageous people could be. They aren't outrageous very often now.

Mark: But certain women do go to extremes, in a different way. In the daytime they're practical; they dress like a man. But at night they're wildly sexy and feminine. We love women who are confident enough to really go for it: to go home after work, take a bath, sit down at their vanity, and afterwards put on something absolutely outlandish. Winona [Ryder] is like that. She's so modern. You see her looking grungy in jeans, but at night she can be so glamorous.

James: Our idea all along was to dress that kind of woman. We didn't go for grunge. We tried to stay with a certain sexy refinement. And all of a sudden, boom, Hollywood picked up on it.

Mark: That's only been in the last two or three years. Before that, we had six or seven years of backbreaking work.

James: Backbreaking. I think probably the most telling thing is that we would go to some fabulous fashion party and then we would have to leave early because we needed to run down to UPS. We were always leaving early. We had no staff, so we shipped the clothes ourselves. We did everything ourselves. Looking back, it was sheer torture.

I grew up in Cincinnati and went to a Catholic boys' school where we always wore a uniform. Every day I would do something to my uniform so it would look totally different. Having parameters around me as far as what I could wear made me really think about clothes as a way for people to express themselves.

I graduated from Harvard with a sociology degree. I knew I loved clothes, but coming from Ohio, I didn't really think fashion design was a career available to me, so I graduated from Harvard with a sociology degree. But two of my friends who had gone to Harvard both ended up going to fashion school. I knew that I had much more to talk to them about than I did to my sociology colleagues.

Still, what I learned in sociology totally applies. Fashion and clothing are very immediate forms of sociology. You learn so much about a society and culture by what people are wearing. I've noticed, for instance, that the boys and girls in New York high schools dress alike now. Everything is sort of asexual, oversized, genderless, which I think may be very much a post-AIDS reaction to dressing sexy. These kids became sexually mature when it was all about "safe sex." I'm sure that affected them on some level, and it affected their style.

For me style is so much about individuality. People who have style are dressing for themselves. I love Fran Drescher's style. She's so wacko. She's totally unafraid of color and pattern. She's not dressing to be chic or sophisticated. There's so much humor about her expression. The other person whose style I love is Jodie Foster. She's very discreet. A look is most successful when someone's personality comes through.

JOHN BARTLETT

I can't say I ever had an illumination like Saint Paul about becoming a designer, but there were quite a number of gentle whispers. One of those came from Emilio Pucci, who told me in 1951, "Why don't you create some men's fashions, instead of just working in fabric." Then, the launch of my special men's collection in Rome in 1958 or 1959, just after the release of *La Dolce Vita*, made a connection between fashion and movies.

In the mid-1960s, I went into business for myself with the Roman tailor Osvaldo Testa. We were determined to get out of Italy so that we could make an international name for ourselves. When you do these kinds of things, you start at the top, or you don't do them. And so with the courage born of ignorance, the kind you have when you are young, I jumped into the pool of Paris couture.

Fashion has changed a great deal since then. Today I think it is suffering dramatically from a case of bad manners; there is so much rudeness, aggressiveness, vulgarity, and narcissism in the business now. To combat these things, the best thing one can do is take it easy and develop a sense of humor.

When something has the mass appeal of fashion or music, it loses a touch of exclusivity. It is the same with movies. If you make three or four hundred films a year, you cannot observe the same standard as when that number is much smaller. I'm not saying this is bad for movies or fashion. There are jewels still being made. But you do have to become choosier.

The fact that so many Hollywood stars are aware of fashion and want to wear something that makes them look good and feel special is a very positive thing. Actors are the myths and heroes of our day and it is through them that fashion makes it onto the front page.

But no matter how wide its appeal, fashion is still a privileged profession, because it is a global profession, and because it is a business full of emotion, variety, and fantasy, in which everything you do is somehow related to your work. But like anything that's privileged, fashion should be approached with the greatest enthusiasm and in a spirit of sacrifice. The best advice I could give anyone about to go into this business: Don't fool around.

NINO CERRUTI

PATRICK COX

I never did anything remotely artistic as a child. I didn't even doodle when I was talking on the phone. I traced everything in art class just to get my credits so I could get out of junior high.

I was destined to be a doctor, but I was working so hard that by the time I finished school, I just didn't care anymore. That's when I came out. I became a host in a nightclub. I reveled in the power I had being involved with image, deciding on the basis of how people looked who would get in. I was amazed to discover that people would give validity to me or to anyone just because they looked good or had a certain style.

It was the time of the New Romantics, around 1981, the era of Culture Club Boy George, *Face* and *ID* magazines and Spandau Ballet, when Vivienne Westwood was doing her private collection. I was living in Toronto, which had always considered itself a suburb of Los Angeles and London. I was slightly Adam Ant–ish, with braids in my hair and pirate clothes.

To me, dance music and fashion are always, always linked. I think the most creative forces now are white English teenagers and black American teenagers. I live in London, but I think New York is very modern. Everything is constantly moving and evolving, and that suits me. I want to be a part of the place where something starts, or where it ends up. One of those heartbeats-of-the world kinds of places.

But I didn't set out to be a fashion designer. Fashion is about art. I picked shoes because shoes are about craft. A shoe is like a piece of architecture. There's an inside and an outside and a structure that supports it. That's concrete; it appeals to my precise way of thinking.

Shoes require a sense of shape, form, and proportion, but I go about designing them in a whole different way: I don't do the drawing first. I go to the last maker. First you get the last right, then the heel, and then you draw. It's very real.

I chose my heel maker because he does the work in front of me.

I like to be part of the process. I never became a designer because I wanted to be famous. When I'm asked what it is that I do, I always say I'm a cobbler. I don't put "designer" on my passport. I put "entrepreneur."

But there was a moment when I was working on my first ad campaign about three years ago: I was just sitting on the floor watching Helena Christensen wear my shoes, and I got goose bumps. I thought: Oh, this is why people get excited by fashion: It's the sensation of seeing the most beautiful product, the most beautiful woman, and the most perfect location all come together on a single day.

PAMELA DENNIS

I was eleven or twelve when I noticed at school that all the girls had blond hair and blue eyes, but there I was with my dark curly hair. One night I went home and just cried. I thought nobody looks like me, something's wrong. So I went back to school with my blow-dryer, and I worked on my look. It wasn't that I wanted to be a designer when I grew up. What I wanted was to be accepted but stand out at the same time. I guess that's why my approach to fashion is kind of contradictory.

I've always had a taste for mixing the simple and the extravagant. When I started in the business I was working on Fortieth Street in New York City, and Mel Cohen at B. & J. Fabrics helped me pick out my first fabric; he told me when I could get it made, and introduced me to some people who could do the sewing at home. At night I would work with them; I would lie on the floor, and they would cut a pattern around me, and that's how I made my first dress. It was long and black with a low back, and, believe it or not, feathers.

For me, designing usually starts with a void. I found that designers were making dresses that would walk into a room before you did. I didn't understand that. I remember wanting something to wear to my best friend's wedding in Great Neck, something that was young, something that didn't wear me, and I couldn't find it, so I had to make it. When I did buy a dress in those days, I would always change it. I guess I've always had a different vision, a fashion edge.

I think of my style as Hollywood glamour with a modern approach. I know when to stop on the beading. I think beading should just be an added zest. Maybe the photographer isn't great tonight, maybe he's not getting you in the best light, but a certain beaded something is going to hit your face, light it up.

When I started dressing Jamie Lee Curtis, I used a stretch fabric studded with Austrian crystals. It was so soft that basically she could roll around in the sand in it, scrunch it up into a ball, and nothing would happen to it. She brought it over to alter one day stuffed inside a little Ziploc bag that she carried in her backpack, and when we took it out, there was not a wrinkle on it. That kind of comfort and informality is what attracted Jamie and customers like Cindy Crawford and Bette Middler. Who wants to be in a costume? These women just want to have fun.

In Santo Domingo, where I was born, there is no tradition of fashion design. I went to the university to study architecture and later I went to art school in Spain. At that time in my life I wanted to be an architect or a painter. I think if I ever told my father I was going to be a fashion designer, he would have had a heart attack and died.

But while I was in Spain I did fashion illustration to make extra money, and that led me to the fashion houses. I entered Balenciaga as a sketcher. Balenciaga was the best school that anyone could go to. You could visit the sample room and see the clothes being cut and fitted. That was when I fell in love with fashion.

In a certain way fashion is close to architecture. Design has to do with construction. It gives you a feeling for balance and an understanding of form. Balenciaga always used to say, "You don't have to have a body. I'll make you one."

I think fashion today has pulled so much away from what Balenciaga was all about. Dressing now deals more with comfort, ease, practicality, and individuality. As clothes get more uniform, we tend to put pieces together in our own way. It comes down to dressing with a strong sense of self.

Women today possess that. You are dealing with the most self-assured, intellectually superior women the world has seen. At no time in history have women been as emancipated or as much in control. And never have they known more about fashion. They approach fashion to seduce, yes. But at the same time they are practical and not afraid to please themselves. Thirty years ago, when I started in this business, a woman might go to the store and see the same dress in pink and in red. She might love the red but she would remember that her husband likes her in pink. Thirty years ago, she would have bought the pink dress. Today she buys the red. It's not that she loves her husband less. It's that she's found a greater balance in the relationship and in her life.

OSCAR DE LA RENTA

Inspiration . . . where does it come from? Stefano and I believe that one's inner beauty can best be expressed when you really identify with your self and your heritage. We find inspiration from our Mediterranean culture. From Sicily. From Italian Neo-realistic films. And from our families.

While following these inspirations, we have had many amazing experiences throughout our career. But nothing ever tops the excitement of seeing someone, famous or not, who looks wonderful in our clothes.

As for style, that is a little more difficult to define, but we can say this. Style definitely is enhanced by inner beauty and by someone's passion, love for life, and sense of humor. And though we continue to refine what is the essence of Dolce & Gabbana, we have always believed that this is the basis for style.

DOLCE & GABBANA

RANDOLPH DUKE, HALSTON

When my mother was at work I used to take to the sewing machine. I was always making things; once I was into this whole Egyptian trip; I used to bleach out my jeans, then paint them with embroidery paint. I had Cleopatra and Nefertiti all over my bellbottoms. When the other kids saw me at school, there was quite a lot of envy for my hieroglyphic bell-bottom jeans and flower power shirts. In the early seventies I was Mr. Arts and Crafts.

But it wasn't until I was in the theater department at college that my future really crystallized for me: I had set out to be a costume designer but I suddenly realized I was more interested in clothing than in costume. It was a feeling I had that what you see in fashion is vitally new. Fashion, like costume, may have a historical element, but it also has originality and the excitement of mixing things up. And so, on a dime, I decided to go to fashion school in Los Angeles.

What inspired me most in those days—and there's strange, sweet irony to this—was Halston. I can still see his image, larger than life behind those shades, always dressed in a cashmere turtleneck. He painted a picture of such elusive glamour; it colored the whole era for me. I can still see the visuals in my head: The photos of [his friend, the designer] Elsa Peretti in a bunny costume, of all his models dressed in red or in head-to-toe cashmere; of his trip to the great Wall of China with his whole entourage—can you imagine the cost of that! Halston was the first American designer to have a *cabine*, the Halstonettes, models who were almost exclusively his.

There was tremendous impact in the imagery of all that. And fashion for me ever since has existed somewhere in the coupling of those Halstonesque theatrical elements with his kind of luxurious simplicity. Fashion has to have an element of drama, a feeling of decadence, of luxury, and, always, change.

Change is essential to me. I realized at some point that I have a fickle personality. But if you're going to be in fashion, that helps. You've got to get bored to go forward.

ALBERTA FERRETTI

Becoming a designer, a stylemaker, working around an idea of harmony and grace, was an instinct more than an ambition. That ambition wasn't perfectly clear to me at the start, when I began displaying the clothes that I liked in my boutique in Italy. But the day came when someone suggested, "Why don't you try to design your own collection?"

Was that the decisive moment? Or was it when I saw my first outfits being made, or when I realized that certain fragmentary images, dreams, and impressions could be transformed through a process of elaboration and interpretation, into something one could wear.

Of course, I grew up in my mother's dressmaker's shop, a good, solid laboratory with seventeen seamstresses—larger than one would expect in a small Italian town. I grew up touching the fabrics, breathing in their scent, and noticing how carefully they were measured and cut. I've always thought that clothing would become my world.

I don't believe that any career could be more fascinating than this one. To work in fashion means to be constantly in search of an aesthetic concept, a type of elegance that goes beyond any particular outfit to become a mode of communication, a way of presenting ourselves. I think the most vivacious intellects, the most inquiring personalities, and the most extravagant talents sooner or later cross our paths and leave traces on our work. And glamour, that very particular glitter accompanying certain kinds of behavior, people, and encounters, is fashion's very own characteristic, its defining quality.

I had to be on my own. It wasn't until I had control as creative director of Gucci in 1994 that l could really ask myself, What do I think Gucci should be? It took me a season to figure it out. That first collection was very nice, very pretty, but it didn't have the real point of view I wanted. Gucci's history is flashy film stars, jet-setters. I wanted to take that image and make a 1990s version, and I did.

Three years ago I was worried. I thought, What if I couldn't do this again? What if I couldn't think of anything else? But the more you move along, the more you grow up and mature, the more you feel comfortable about what you are doing. I may be wrong, but it doesn't upset me as much to think about that now.

Of course every collection can't be a blockbuster. I think about that. It's scary. Our business is so difficult and I've known so many people who aren't even around anymore. You know, someone says a name, and you say, "Oh, God, I remember that; I loved that!" And they're just gone. I don't think you can ever become complacent and think, okay, now I discovered it and I don't have to push any further. But you have to trust yourself; the clues are always there, you just have to open your eyes and try to see them. But you can get lazy and stop looking.

There comes a time when you don't know where to look. To be a part of your time is what is important for fashion designers today—to capture the mood or the moment and to turn it into clothes or accessories that people want to buy. At some point for everybody, you're on the fringe of your time. You're at a certain age, and the mass population of the world is twenty years younger than you are. They grew up watching different things on television or seeing different films with different reference points, and so what they want and what they need—unless you're very, very lucky—is something that, hard as you try, you just can't relate to.

That's sobering. On the other hand, there are a lot of other things I'd like to do besides being a fashion designer. And if the day comes when I don't feel I have anything to contribute to fashion, to be completely in creative control of a film would be the ultimate design project. In film, you're designing an entire world: the look of it, what the characters say, what they do, what happens to them. Do they live? Do they die? It's fascinating. And it lasts.

TOM FORD, GUCCI

I never went through the requisite phase of wanting to be a vet, a nurse, an actress. Those things never crossed my mind. I always, from the get-go, wanted to be a designer. I would sketch clothes for my Barbie dolls, and my mother had a seamstress who would fit them. Consequently, I never learned to sew, and I still don't sew.

But I designed my grammar school graduation dress. It was white piqué, slightly A-line, with cap sleeves, a little mandarin collar, and a heavy sort of zip-front. It was short and sort of mod, and very cool. It was a lot like some of the things I do now. Funny how you don't really go that far astray from wherever it was that you started.

When I was in sixth grade my father had a show on Broadway and Donald Brooks was the costume designer. I loved Donald Brooks; he was the be-all and end-all for me. So my father arranged for me to have this meeting with him in his townhouse on the East Side. I was all of twelve and I wore my best Marimekko dress to go across town by myself. I met Mr. Brooks, and he tried to explain to me what my path was going to be. He said, "When you grow up, you're going to go to Parsons School of Design. After that we can talk." I think he was sort of getting himself off the hook for twenty years.

I did go to Parsons, and before that, Sarah Lawrence. I had been backpacking through Europe the summer between my junior and senior years, and in Greece, on Mykonos, I sketched some sweaters and took the drawings to the local knitters to have them made up. When they were finished, they would leave their work tied up in little bundles on my doorstep. I thought at the time that I was just making some nice sweaters for myself. But really, I was starting to be a designer.

It's just as exciting now as it was then to watch a sketch come to life. There's something about seeing your designs on the stage or in print that can bring you into other worlds. That's how I felt doing Bonnie Raitt's last tour. And I have to say it was a great thing to do Tipper Gore's dress for the second-term inaugural. She wore a gold lace dress with garnet beads, and, over that, a garnet-colored velvet opera coat; the lining was in black, with all the states embroidered on it and outlined in gold stars.

It was thrilling to be in Washington that day, in close proximity to the fire of it all. There was a moment when I was in a room alone with the President and his wife, and Tipper, and maybe four other people. It was electric. There I was, and the whole city was about to explode with the events of the night. Literally, my hair was standing on end. I can't say you don't work in fashion to have moments like this. You do.

JENNIFER GEORGE

NORMA KAMALI

I never had an idea of myself as some kind of grand designer. I saw myself as more of a background person, working in a solitude situation. I had always wanted to be a painter, alone in a room with my work, interacting with the paints and with the canvas. But, with my mother's prodding, I began to wonder: How was I going to earn a living as a painter?

So I turned to illustration. I studied anatomy and old issues of *Vogue* and *Bazaar*, thinking that if I did those things, I would get to know every silhouette and every accessory, so that I would be able to draw fashion from every period. Kenneth Paul Bloch, Antonio, and all of those other incredible fashion illustrators, they were my idols.

But after graduation, I couldn't get a job in illustration. So I went to work in the office of an airline, which meant free travel. From 1964 to 1969, I sold tours to the Orient for Northwest Airlines and I traveled to London every weekend. In London I danced through the night, listened to music, met music people and other people who were really entrenched in the sixties London fashion world.

In the sixties, fashion was it and everything in fashion was really new. It was a time of great invention and creativity. I brought clothes back from London to New York and I opened a basement shop. But eventually, once I'd stopped seeing things I really loved or found inspiring or wanted to buy, I started *making* clothes. The first time I sold something

was the moment I realized that fashion was going to be my career. That was such a high. I thought, wow, I can't sell a painting, but I can do this. That first dress was all hand-whip stitched, and made of a very thin, very drapey suede. I was also working with patchwork snake skin patterns. Clothes then were like works of art, and those clothes were my first real experiments; I was doing whatever I wanted to do with clothing.

I still identify more with the behind-the-scenes creative process of fashion than with the idea some people have of fashion as a glamorous career. I'm the type of person that if you have to have your picture taken, I want to do the other thing: I want to take your picture.

Becoming a designer wasn't a decision, it was something that was meant to be. My choice of career could have been influenced by the fact that my family works in the fashion world—my father was a tailor—and I guess you could say it was born from within. Even so, when I started out as a designer for Anne Klein, I was petrified, although to tell you the truth I was working so hard I didn't have time to worry. At the same time, I was experiencing one of the most important events in my life: the birth of my daughter Gabby. It was a very difficult period, and I paid a high price in order to be able to continue advancing in my profession, because I wasn't able to enjoy my daughter as much as I would have liked.

The high point in my career came in the late 1970s when I designed my first collection for Anne Klein after Anne Klein died. It was the most emotional experience of my professional life.

In the 1980s I started my own business in my living room with a team of three: my husband, Stephen Weiss; one of my best friends, Patti Cohen; and me. When I was first on my own, women were going through a very competitive period, fighting for their place in the working world. They had no time for themselves. I went through that, too—I put all my efforts into my company. But in 1993 I decided to call a halt. That summer I spent a lot of time thinking and clarifying my ideas. The result was a change in the way I do things. I learned to delegate so I could devote more time to creating. But my decision was not unique. It's something everyone learns sooner or later. Today I'd tell anyone starting out in fashion two things: work in a clothing store to learn what customers need. And learn to draw so you can express your ideas.

DONNA KARAN

CALVIN KLEIN

I've been designing and sketching ever since I can remember—when I was a child of five or six. I have a natural curiosity about all things visual: shape, form, and texture. There's magic when you look beneath the surface.

I think that my curiosity has been rewarded with a career that is reaching its high point right now. An important part of the reason is that fashion today has a truly world view; it also seems to me that our modern, American point of view is interesting to people everywhere. As a result we're expanding our business internationally, opening stores, and designing for contemporary women and men around the world.

Over the years, the fashion business has changed and grown, but my philosophy of design and style has remained consistent. For me the key words are and have always been: *relaxed, modern, elegant, sexy.*

I never had any idea of being the grand couturier. I wanted to be an actor. When I was about thirteen we lived on Long Island and I used to come into New York to take acting classes. And as soon as class was over, the first thing I wanted to do was shop. Every week I would run to Bendel's, Bonwit's, Bergdorf's, whatever *the* store was at the time.

Then, at fourteen, all of a sudden I got a little pragmatic. I thought: There are so many people who want to be in show business, and the competition is incredibly fierce. In dance class I had two left feet, so I said to myself: You know, you are never going to be a fabulous dancer. You love clothes, you love stores, and you love looking at people and solving problems. Those things were concrete and logical, so I thought: Let's get on with that.

As it turns out, fashion is show business, or at any rate, the two are incredibly linked. They're both public-eye professions. And they're both about illusion, and about changing people's perception of themselves. The right film, the right music, the right clothes can do that.

For about seven minutes a year I think this is a truly glamorous business. And for me the most glamorous moment is always just as my show is about to start. There I am backstage, looking at twenty remarkably beautiful women, all perfectly groomed, perfectly coiffed, perfectly dressed. But the instant the show starts, that moment disappears. I always say, a fashion show is like having a wedding two times a year. There's that fabulous walk down the aisle, and the rest after that is saying hello to a lot of relatives you don't know.

Yet the minute you put the clothes on someone in real life, everything makes sense again. So many times when I'm at a trunk show, I'll see a woman I thought was a Plain Jane put on a dress, and all of a sudden she's a little more gorgeous. Or, on the other hand, she might look a little over the top, and the right something gives her a certain refinement. When I see that kind of transformation, I always say: Thank God! And I do see it, all the time. If I didn't, I couldn't keep doing this.

MICHAEL KORS

NICOLE MILLER

I was a fashion junkie. I grew up in Lennox, Massachusetts, a very insulated small town, but I felt surrounded by fashion. I had a French mother. She was Miss Fashion Plate in Paris in 1943. How did she stay so well dressed during the war? She would smuggle food through the German lines—they used to kill people for that. The local tradespeople were grateful, and to reward her the shoemaker would cobble her shoes, the seamstress would run up a dress.

At home in Lennox, my mother looked like a regular fifties person, but she made sure that in our house we always had a subscription to French *Marie Claire*. We would go to New York once a year. My mother had to shop every store there was top to bottom, and we always went to French restaurants—the Les Pyrenees of their day. I lived for those trips, for everything about New York: the shopping, the department stores, the food, the street sounds.

But by high school, London had become my inspiration— Mary Quant and the whole sixties thing. God, I was totally copying all those looks. I would go to New York and get myself a Sassoon haircut. I had short boots and a million little striped dresses. I think that time period was a tremendous influence. I didn't see college as that exciting, so in my sophomore year I went to Paris.

France was sort of stuffy then. Kenzo was just coming on the scene, but between Kenzo and high fashion there was no middle ground. There weren't any hip designers. And my friends at the couture houses were making forty to sixty dollars a week. I thought I could do better. I thought that if I went to New York I could make at least two hundred dollars. I used to tell myself I was going to open up my own couture house in New York, because even in the States haute couture was all there was.

Have you ever tried on a couture dress? You need somebody else to help you get into it. There are hooks and eyes all up the back, and loops and buttons on top of the hooks and eyes. I never understood the couture mentality. It was so complicated, and most of the stuff was so matronly that I felt at the time there was really a void in the market.

So I became a designer, though I didn't have the easiest time learning how to draw. To this day I don't trust designers who can draw really well. I always put in the hip bone, so the clothes will hang well, but still, I'm glad I don't have to put faces and feet on my sketches anymore.

ISAAC MIZRAHI

I remember the exact moment when I knew what I was going to do with my life. It was 1976. I was fourteen and using the basement of my parents' house as my atelier—sketching, making puppets, cutting patterns, making clothes, and all that. One night in August I was looking at *Vogue*, leafing through the New York collections. It was a fantastically inspiring issue. I also had on the TV and was watching *Back Street*. So there I was, at four in the morning, reading this fashion magazine, feeling so incredibly inspired, and watching Susan Hayward play a fashion designer, and I said to myself: Look no further. This is it. This is what you are.

I am a fashion designer now, but I'm not the type to sit in judgment of someone else's style. Style is when a person does what he pleases—that's all it is. And if he looks bizarre? Well, who's to say what bizarre is? I was having dinner with a friend of mine at the Restaurant Daniel and a woman came in with the scariest hair and a terrible gold lace dress. My friend said, "Ew, look at her, isn't she awful?" And I said, "What's awful? She's just wearing what she likes." And he said, "But it's in terrible taste, and we are men of taste." But taste is not about knowing what's wrong. It's about knowing what you like and surrounding yourself with that. The pleasure of style is doing what you really love.

M y mother was my teacher and my muse. It was from her that I learned technique and inherited my extreme enthusiasm for fashion. Part of that excitement has always stemmed from my fascination with glamour.

Glamour is an important word: It means elegance, personality, and individuality. To be glamorous is to express yourself in the most passionate way. If you simply fall back on trends or rely on mere clothes as the tools of self-expression, you are nothing but a mannequin with no real roots or substance. It is through passion that you develop style.

Style, I believe, is the image of ourselves that each of us creates—an image of strength, elegance, and freedom. One's style can be extreme, even kitschy sometimes, but never boring or superficial. Style is evident in the unexpected way one mixes things: the simplest diamond necklace, for instance, with a white cotton T-shirt.

A person with style has not deleted his true nature or censored his experiences, his roots, and the tensions that coexist inside him. You can't buy style; it's a gift. I would say that my daughter Rossella, who oversees the Anna Molinari collection, has a lot of style,

something she's possessed since the age of four, just as my mother possessed it.

Just as my love for my family fills my life, fashion fills my life. Certain clothes fascinate me to the point that I am breathless, as if I were admiring a painting or some other work of art. I have a real collector's passion for these pieces and for the environment in which they are born. I find the world of fashion uniquely stimulating, creative, and exciting. But for me the fashion shows, especially, are moments of such high emotional intensity that I feel intoxicated, mind and soul.

ANNA MOLINARI

I always knew I wanted to be a graphic designer, and today, in reality, that's what I am. If you think about it, designing clothing is all about placing icons, emblems, and motifs on the human form in an attractive manner that is practical, accessible, and also, you hope, lovely. I'll bet if you asked any graphic designer, he'd say that he does the same thing, except that he'd substitute the words "on paper" for "on the human form."

I have no idea why I wanted to be a graphic designer. I probably first heard about graphic design on TV—I had always loved to suck in TV. But if I'm watching television, I immediately snap into the technical part—pulling out the information about how a thing is done. When I look at an ad, or even a movie, I'm likely to relate first to things like printing and technique. The imagery is secondary.

In fashion it's enormously helpful, but not essential, to master technique. For the first three years I was in business, I made all of my patterns myself and still make patterns all the time. But you can get mired in technique. All my ideas are based on technical knowledge, and sometimes that stops me from trying to execute each and every flight of fancy.

I'm still driven by fantasy and always affected by people with great personal style. My grandmother has been a tremendous influence: Her spirit—and her sparkly cocktail earrings—are a hundred percent my inspiration. She wears sweatshirts with cocktail earrings, housedresses with cocktail earrings, and evening dresses with cocktail earrings. I can picture her now, wearing a big smile and two shiny punctuation points under her ears.

TODD OLDHAM

MIUCCIA PRADA

I've never had an ambition to become a designer—I never thought that I would like this kind of work. But I did have an impulse, a feeling for visual elements, and an aesthetic that I directed toward particular objects, in this case fashion. I think of fashion as a glamorous business, but I have a contra-dictory relationship with this glamorous business.

Being fashionable is far too easy; it is much better to care about a woman's true nature—who she is as a person.

I believe you are part of your past, your memories, but you have to live what you want to be now. To me this is harmony.

When I was about three years old I wore an old, giant, white lacy crinoline, a little pink cardigan, black patent leather Mary Janes, and white tights every day for about a year, because I thought I looked so princess-y and pretty. That was my idea of glamour at the time. But I definitely got that fairy princess out of my system early, and I guess it's a good thing. I'm a bit cleaner now, not all lace and frills—though I wouldn't mind owning some black patent Mary Jane stilettos.

My involvement with fashion, even if it wasn't really conscious, probably started with that first crinoline. By the age of seven I had started making clothes and wearing my creations. I remember in particular making a dress with a clothesline tied around the waist as a belt. I definitely had my own ideas about the way I should dress. *The Brady Bunch* influenced me, though I've gotten that out of my system, too. So did *I Dream of Jeannie*.

Jeannie I thought was really cool and so sexy—based, of course, on whatever I may have known about sexiness at age twelve or fifteen. I loved all that midriff-baring stuff she wore, the bellybutton and the beads, and I loved the bottle she lived in. But my true ideal was Cher. In Cher I saw a great mix of raw hippie cool and TV glamour. At the time, there weren't a lot of glamour figures on television, though I have heard that Loretta Young looked pretty stylish. Somebody told me she bought one of my dresses recently, a linen-y, swishy kind of thing. I like knowing that she owns something of mine.

It's great to see people admiring or wearing something you designed. It makes you grateful to be in this industry. When I started my business I used to laugh, then cry, it seemed like all the time; it was a Liza Minnelli concert. Now things are calmer and quite a bit smoother.

And there is the glamour—intermittently. I'm not the type who goes running around with a lot of super models, wearing dark glasses and riding in a limo. But you do get a moment or two. Being on the *David Letterman* show was one of those times. Letterman is one of my idols. I remember he was nervous about having a designer on his show. I think he was afraid I was going to be all "fabulous" and "darling"— you know, someone kind of from the next town over. But we had a great time. And being recognized on a different level, in a world apart from fashion, was, I thought, pretty cool.

When it's one in the morning and you're cutting up little swatches of fabric, and you're tearing your hair out because you can't figure out what goes with what, those are the moments you remember and hold on to. And then you go on.

CYNTHIA ROWLEY

JILL STUART

I was born into fashion, I guess you could say. My mother was a famous designer, Lynn Stuart—her company was Mr. Pants—so fashion was the topic of conversation every night at the dinner table. I was always around fashion, visiting my mother's office, very curious about how everything was made. And I've always loved clothes. I loved playing dress-up with my sister. We used to put on my mother's high-heeled stilettos from I. Miller in every color, and I guess we dressed in grown-up Mr. Pants.

But because my mother was a fashion designer, I wanted to do my own thing, and my own thing was accessories. A dia-mond stickpin was the first piece of jewelry I made. I can still remember it in Blooming-dale's and Bergdorf Goodman's windows. And after that fashion came as a natural progression. I still think of it as a little like playing dress-up, only now I'm dressing my two sisters and my three little daughters. They inspire me. I make pretty-girl clothes, but I don't think of them as costumes. I like them to be clean and sexy and modern at the same time.

I was thrilled when Courtney Love, who likes very feminine, pretty clothes, came up to my studio one day and stayed for hours. She told me that my tulle dresses with the full short skirts from my last show re-minded her of a Degas sculpture she had. She's daring, and I think she has great style, which for me means that a woman wears what looks good on her and doesn't buy it because it's the trend. I think Nicole Kidman always looks good, and Uma Thurman. She's subtle and very chic, in good taste but not too serious.

But people in the street inspire me too. Other people are what make this business glam-orous. Otherwise it's tough, and you have to devote your life to it. I think the most glamorous and luxurious thing that could happen to me would be to have a free weekend.

ANNA SUI

When I was little, growing up in the suburbs of Detroit, I'd get together with the boys in our neighborhood, and we used to play with little army men. Pretty soon I started dressing those toy soldiers in gowns made out of tissue. I discovered that toilet paper and Kleenex worked quite well for the puffy look of that time and I guess I was treating the stuff like chiffon. I finished the dresses and we staged a whole Academy Awards ceremony. At that moment—I was in first or second grade—I thought: This is what I want to do. I want to design clothes for movie stars.

I started my business in 1981. Before that I had worked for a few sportswear manufacturers. I was at Glenora at the time, but I was also moonlighting a collection of my own. My boss found out and asked me to stop, but I didn't—I thought that would have been going backwards—so I got fired.

So, there I was doing this underground business, selling to all the rock-and-roll stores. My goal at the time was to sell to all the Trash and Vaudevilles of this country, and I did.

After I'd had my business for about ten years, my friends started telling me I ought to have a fashion show, but I was nervous. I thought, How am I going to compete on the same stage as Karl Lagerfeld? But all of my friends pulled together and helped me get there: hiring the models, staging the show, getting the editors to turn up. Yeah, that was definitely a high point. And do you know what? I still have the same friends, and they're still helping me.

I feel that I was born to do what I'm doing now. I was always a designer. When we were young, I didn't have much money to buy clothing, so I was always designing my own clothes to have something special to wear. I crocheted headbands and bags and made all my own accessories. Every day I would go to school with my hair braided in different ribbons. In school we wore a uniform, but for parties when I really wanted to be different, I would make something new. I had just seen *Romeo and Juliet*, so I wanted something very romantic. I remember making a dress with drop shoulders and an elastic waist in a kind of cheesecloth fabric, and a long skirt with gathers on the bottom. I was always sewing; sometimes, before a party, I spent so much time at the machine that I would end up being late.

I was trying to create my own style. Style, I believe, comes from inside. It is a part of character. Clothing should enhance that character, never overwhelm it. I think everybody can be stylish.

When I went to Beijing a few years ago, I was so impressed by the way the girls dressed. They wore short skirts in a sheer fabric, and no matter what color the fabric was, the lining was always white and shorter than the skirt. These girls looked so sexy, but that's not why they wore their skirts that way. Fabrics were expensive, so they were just trying to save.

In China the girls don't have a lot of money and there are certain things they can't wear. But working through these limitations brings out a certain quality—call it individuality. To me that's the basis of style.

VIVIENNE TAM

My life in fashion wasn't really planned. I was sixteen or seventeen and I was wagging classes every day—that's Australian for cutting. Finally one day the priest came to my mother's house and said, "Ma'am, your son has not been to school for six months."

Afterward my parents sat me down and said, "Okay, we know, and what are you going to do about it?" I told them, "I want to be a designer." I don't know why I said that. I could have told them anything: hairdresser, architect, doctor, and they would have supported it. But "designer" was the first thing that came to my mind.

The very next morning my mother, who was a designer herself and had taught me about the construction of clothing, took me by the hand and got me a job. I started laying fabrics in a bra factory. Later, I became a cutter, and worked my way up from four-pounds-fifty a week to seven pounds a week.

At eighteen I opened a store with my mother. I did the sewing. Two years later, I thought I knew everything so I opened up my own store. In the eighties, after my mom and dad had passed away, I came to the States. I had some really rough times, holes-in-your-shoes kinds of times.

Just the same—and this may sound soapy—I feel I've been quite blessed. So many people more talented than I am never really got a break. But I've felt all along there's been someone looking after me. I think fate has played a part in everything I've done, from having the most incredible parents to meeting my wife, Lisa.

We met at a club called Helen's in Los Angeles. She was an actress and she'd just come back from the Edinburgh Film Festival. This was a Monday and I was supposed to be leaving for home, but I had cashed in my plane ticket and spent my last hundred dollars. I had a line of

men's clothing—I had made all the samples myself in my hotel room on this little portable sewing machine. Lisa saw them and just sat me down and said, "What you're doing is magic. What do you want to do with your life?"

No one had really said that to me before. "I think if we went to New York," I told her, "we could sell these clothes, find a miracle backer, and make lots of money." She said okay, and a week later there we were in Soho with our samples. Boutique bought them and we had our start.

We were in love. We didn't really set out thinking what we could do for one another. It all evolved that way and just flowed. But if we had to start over, we could. We like to joke that we would have a caravan. Lisa would do the wash and I would do the alterations. To this day, we tell each other that if things don't work out, that's what we'll do.

RICHARD TYLER

VALENTINO

From an early age I enjoyed designing shoes during my classes at school. But it was later, while designing my sister's wardrobe for her important debut in society, that I decided I belonged to the world of fashion.

I consider the presentation of my couture Spring/Summer 1968 collection in Florence a very important point in my career. It was my very first season showing couture. The organizing committee had notified me at the very last moment that I would be included on the schedule, and this caused all the international buyers to delay their departure from Florence so that they could check out the new young designer. The next day—total success!

I think the world of fashion today is as glittering as it was then. Certainly the magic of the movie screen and Hollywood are a continuous inspiration. I have noticed while watching or attending the Academy Awards, movie premieres, and other similar events that that silent goddess, the Movie Screen, has returned in a massive way and is now the main theme in this field. Fashion is once again riding high on glamour.

VERA WANG

My mother was a clotheshorse. She didn't work. Women in those days didn't usually have careers, so she expressed herself through clothes. Dressing was like a profession for her. She was one of the early advocates of Saint Laurent, and she wore the best of American fashion—Mort Zuckerman, Norman Norell—she had that kind of eye. And she taught me to appreciate clothing from a very young age. I knew about Hermès crocodile bags when I was eight, and I owned a little Courrèges dress that had an illusion bodysuit underneath, and a knitted collar and cuffs. We kept an apartment in Paris. In terms of fashion, there was nothing that I didn't see.

It also helped tremendously that I had been a career figure skater and that I danced. Dancing makes you very conscious of your body, how it moves. It takes vanity to a whole other level. If you stare at yourself in the mirror all the time, aware of every muscle and curve, that's bound to have an effect. And a natural product of that kind of intense self-scrutiny is a heightened interest in what you wear.

I'm always trying to do plastic surgery with clothes. I jump into my own designs to see how they feel. That's the advantage of being a woman designer. When men design it's visual. But women feel the clothes. It's not just about the way they look, it's: How do the clothes make *me* look?

When I work with stars, I think about what they want to enhance and what they might want to diminish. My aim is always to make their legs look longer, their shoulders wider, their waistline narrower, and their back more seductive.

Audrey Hepburn understood that. Working with Givenchy—because that was a great collaboration—she made things that weren't necessarily beautiful symbols of high elegance. And of course, she made being flat-chested chic. Hepburn's style, like all great style, was based on a contradiction: in her case, on a childishness that was brought out by clothes that were very sophisticated.

When you talk about style, the same women's names always come up, and there's a reason. They are always women who had a real understanding of mixing things. Jackie O. mixed a masculine quality with a very deep-rooted femininity. She could wear a ball gown, or she could wear pants, and sometimes she combined the two attitudes. So did Slim Keith. For me style might consist in combining a pair of twenty-five-dollar Gap leggings, a black silk-and-cashmere turtleneck, and if you want to be extravagant, a Fendi fur. That's clever. Style is not necessarily about how much money you spend. It's about freedom, modernity, and living in your times.

I always made my own clothes, fabulous things that I wore to school. I remember in particular a little tight dress, an A-line with a great bell sleeve, in a steel-blue kind of stretch fabric. And I had this incredible mohair lavender-periwinkle two-piece outfit with a small jacket and a dirndl skirt. What was so special was that it had a very narrow velvet trim. I must have been sixteen when I designed it, but I would wear it today, it was that beautiful.

Some things stay in your memory. I'm thinking about that ombréd chiffon in different gradations of blue that Grace Kelly wore when she first met Cary Grant in *To Catch a Thief*. Whenever I look at it, it takes my breath away. I did a similar gown in an icy blue in one of my last collections. It just floats when you walk, like a vision of the sea. I did it with a cashmere top. That was *my* interpretation.

Grace Kelly was so natural, so effortless, clean, classic, regal. She was sexy in an obscure way, and so dreamy. But other images stayed with me, too: Eva Marie Saint in *North by Northwest*, in that beautiful red taffeta boat-neck dress with a very tight bodice and a full, full skirt; or Marilyn Monroe in *How to Marry a Millionaire*, and Rita Hayworth in *Gilda*. I've seen each of these movies ten or twenty times. Women looked so beautiful then, so simply pulled together and terrific. And they had such incredible fabrics.

Some of the best moments start with a fabric. When I launched my business, I knew a man who represented the best mills in the world and he had a Bianchini chiffon that I just fell in love with, and I had to have some urgently. I told him I needed ten yards and he just looked at me and laughed: "Nobody is going to cut just ten yards!"

But he knew me and liked me, so he told me to wait. Later he came back and said, "You know what: Geoffrey Beene has the exact same fabric you want. I'm going to get some from him," and he did. That was so exciting, and I always felt it was a good omen that this fabric literally came from Geoffrey Beene. It was a great way to start my first season.

HEIDI WEISEL

FINTECH

THE ELEMENTS OF STYLE

Some would consider God our first fashion designer, the Garden of Eden his first show-room, and Eve the first celebrity. Now, Eve knew a thing or two about collaborating with nature's ultimate accessory—the flower—and you could say the rest is history. • Flowers are special—just look how luminous both the daisy and Salma Hayek are in the Davis Factor photograph—each beauty shines in the company of the other. Flowers are exotic. I loved when Sandra Bullock wore budding roses in her hair to the 1997 Oscars—she was the unrivaled romantic hippie princess. Flowers are seductive. You might even tuck a large fiery hibiscus into the waistband of your jeans or the top of a sarong skirt for a night of salsa dancing. Or if floral dresses are your preference, pin multicolored flowers into your ponytail for a little "sumthin sumthin." And flowers are fun. Think of the tow-ering flower headdress Enzo Angileri created for one of Fran Drescher's trips to the Golden Globes—you can bet they were both praying for no wind that day (and a little rain to keep the flowers fresh). • Today flowers can be the perfect finishing touch. A simple flower worn in the lapel is elegant for a man and feminine for a woman. Try a freesia or gardenia—they'll be therapeutic for your senses. If all suits wore flowers in their lapels, just think how much more beauty we would see every day. Pick one perfect bloom from your garden and tuck it behind your ear; take time to smell the flowers.

Gloria Swanson favored tucking pink silk roses in the neckline of her favorite gown to blend with the pink satin trim, drawing attention to the face.

Flowers

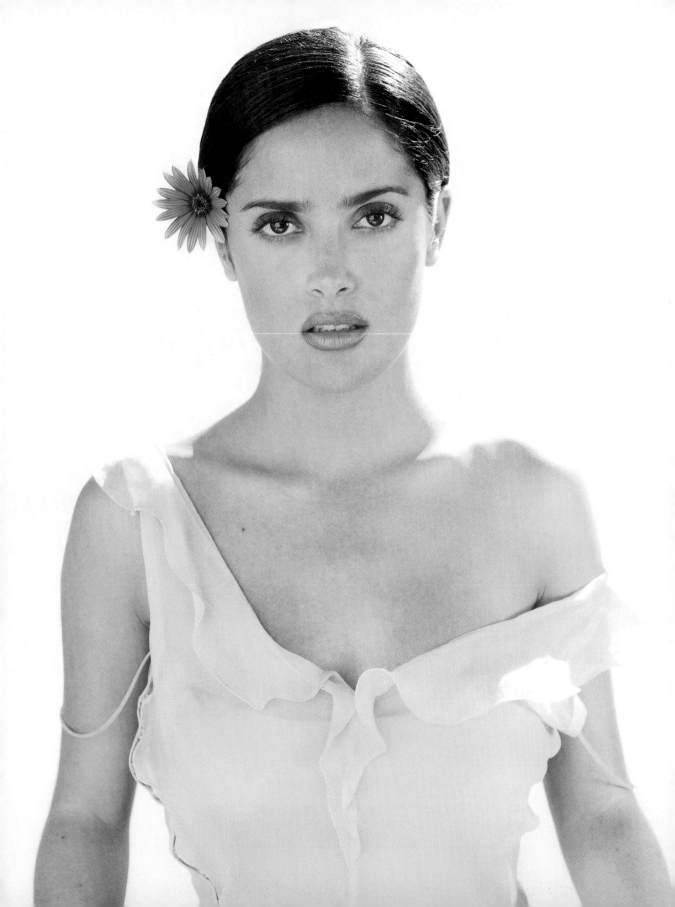

Marilyn Monroe said it best: Diamonds *are* a girl's best friend. They certainly are in Hollywood. Every actress I know owns a pair of diamond studs that look as good with jeans as they do with a couture gown. Gwyneth Paltrow, Cindy Crawford, and Halle Berry live in theirs. When I go to pick out diamonds for *the* fashion event of the year (you know, the Oscars, Emmys, Golden Globes) I usually head for Rodeo Drive, home to Harry Winston, Van Cleef & Arpels, Tiffany, Cartier, and Fred. A favorite secret of Hollywood's hottest is Martin Katz. Although not on Rodeo Drive, he has exquisite one-of-a-kind estate pieces at his show-room. The diamond of choice for the young ingenue on the go is the four-carat stud—they look tasteful, yet are substantial enough to act as flashbulbs in the paparazzi's photographs. Other diamond styles that dazzle are the tennis bracelet and the anniversary band; both are great for stacking (the more the merrier!). • In recent years, with many women opting for more understated diamond styles, the diamond solitaire necklace has become hugely popular. It is a favorite of Ellen DeGeneres, Vanessa Williams, and Jodie Foster—all ladies who don't need any help sparkling on their own. • Whether it is an antique ring or an Elsa Peretti signature necklace, diamonds are truly the ultimate luxury gift. The good news is that there are diamonds for every budget—not everyone has Rodeo Drive or Fifth Avenue nearby. There are many quality stores across the country, such as H Stern, Zales, and Freedman's that have fabulous selections, and don't forget to check out the fine jewelry counter at J.C. Penney. • The most important rule of diamonds was best stated by Marvin Gaye and Tammy Tyrrell: "Ain't nothing like the real thing, baby! Ain't nothing like the real thing."

"I never hated a man enough to give him diamonds back." —Zsa Zsa Gabor

Diamonds

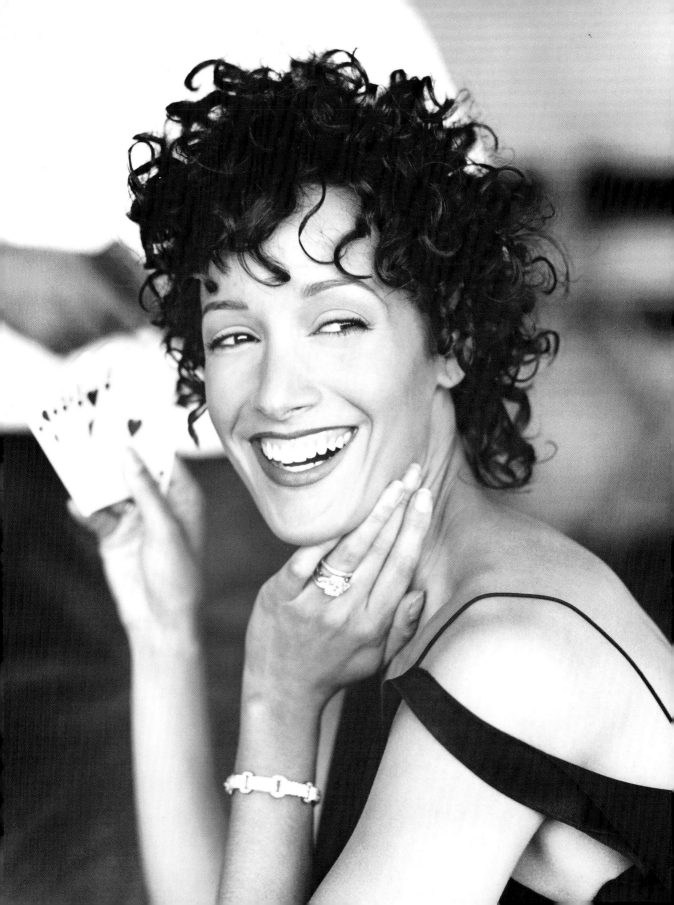

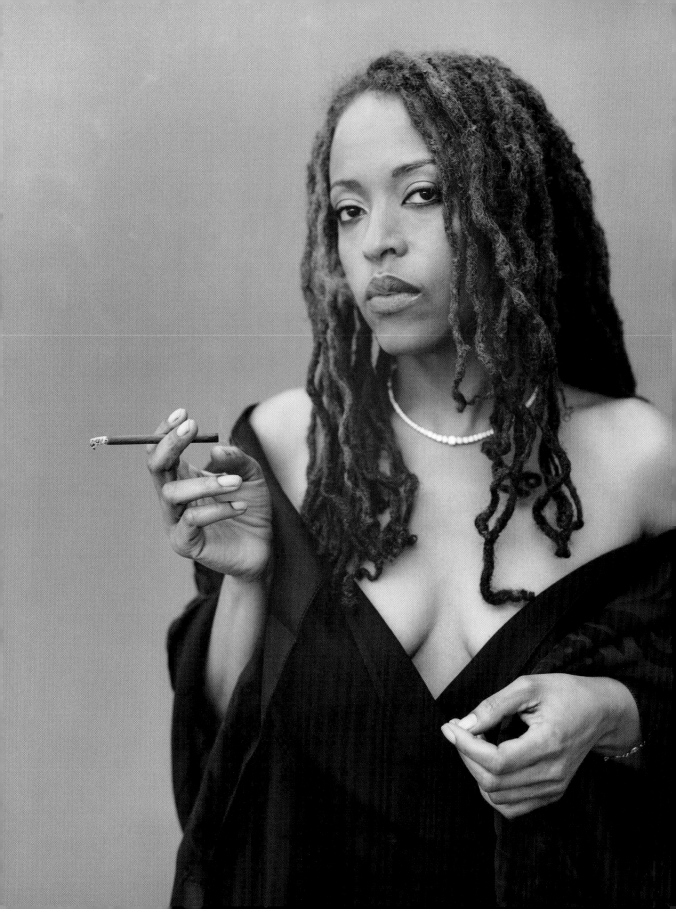

Designers used to go to great lengths to decide what the hemline of the moment should be. Thank goodness, those days are over; these days, you can wear long styles, short styles—and anything in between. So don't hem and haw over one length—the skirt is one element of style that offers you more options than ever before. • I think every woman needs a variety of skirts in her wardrobe. My advice is: When shopping for skirts, buy the best classics you can afford —and you'll wear them again and again. A short, slim skirt (or a knee-length style if you want to camouflage heavy thighs) in a versatile color and fabric is something that can take you straight through the workweek. If you buy a classically cut suit, you can wear the skirt with a sweater twinset for a softer yet equally polished look. I also recommend having a sexy black leather mini to maximize your wardrobe for those times when you really want to dress to thrill. A long full skirt billowing to the ground can look very pretty and feminine. A fitted jacket worn with a long slim skirt—especially one with a slit up the back—can be worn for day or evening depending on how you accessorize. For a carefree weekend wrap up a sarong and get away—it will add just the kick you need to jump start any party. • Just keep in mind it's all a matter of proportion. Here are a few hints on how to find a skirt that will fit and flatter: Make sure the skirt's fabric is substantial enough to stand up to multiple cleanings—too-flimsy styles look shoddy after one wearing. Check the waistband, zippers, and pockets. If they don't lie flat, don't buy the skirt. • So if you've got great gams, go to any length to strut your stuff. And if you don't—well, you can always skirt the issue.

Skirt

In 1964, with his four-inches-above-the-knee skirts (the shortest in all of Paris), André Courrèges started the biggest fashion trend of the decade—the miniskirt. He showed his shocking designs with white calf-high boots and snub-toed Mary Janes.

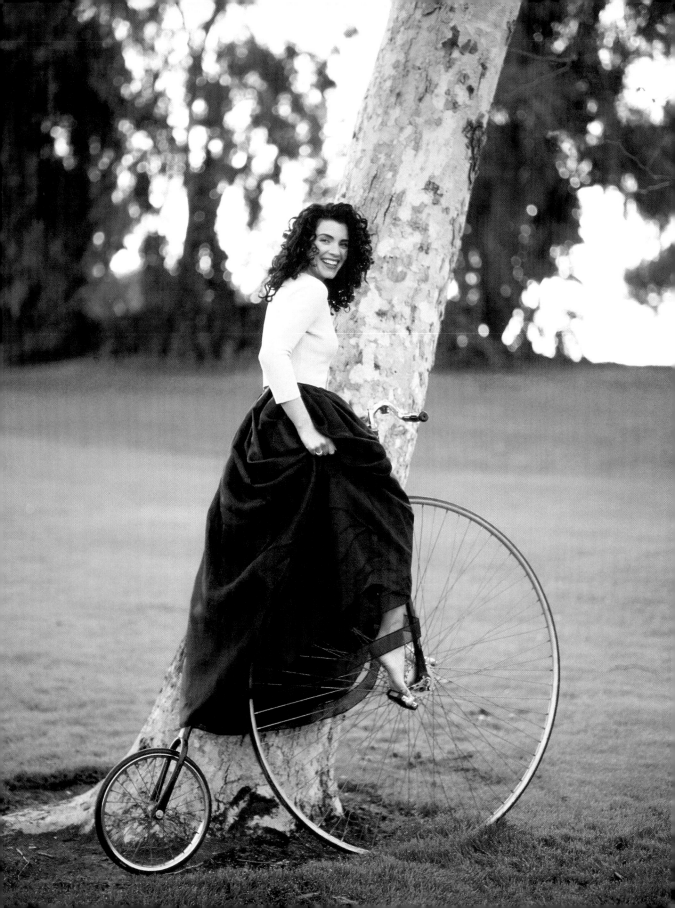

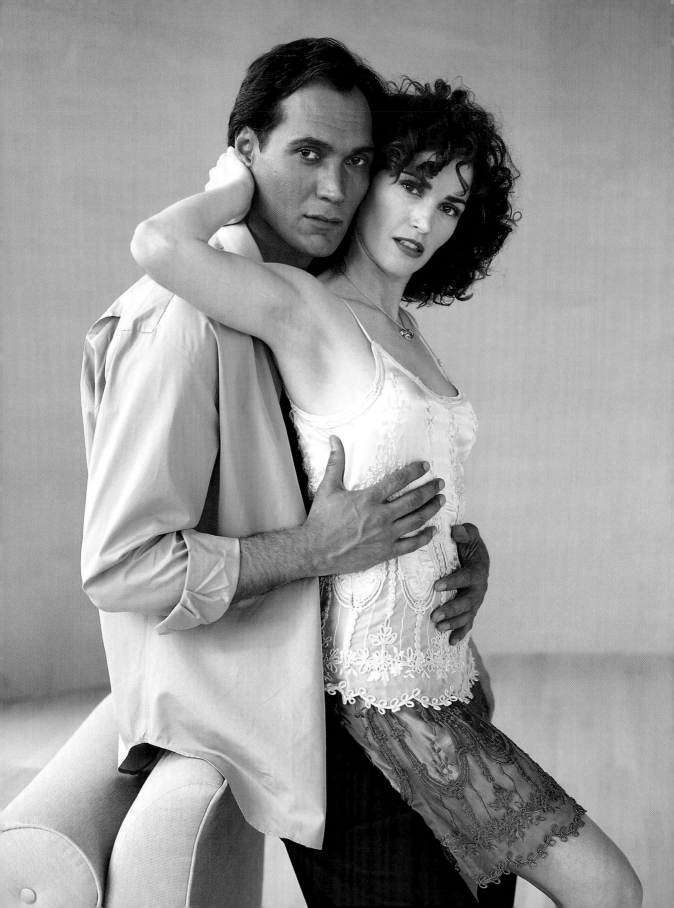

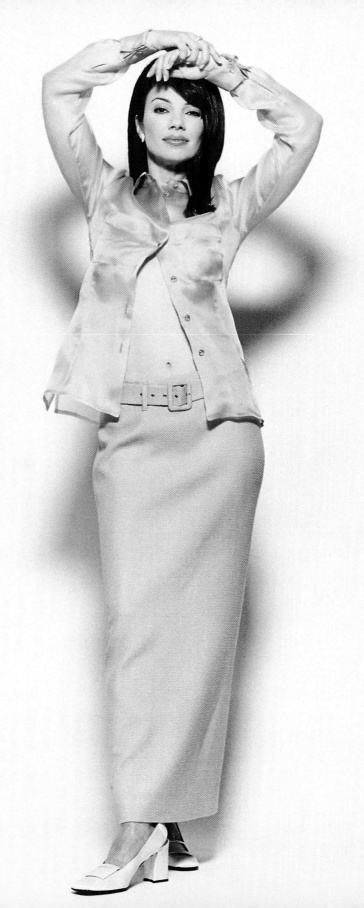

Pants: You'll get arrested if you're not wearing them, unless you're wearing a skirt. Everyone in Hollywood puts them on just like you do—one leg at a time. Whether they're cropped and slim or long and baggy, the most important thing about finding the right pants for you is the fit. In the past few seasons, designers have been offering a wide variety of styles: the bootleg pant (now a classic), hip huggers (if the StairMaster is your friend), the wide-cuffed trouser (that looks sexy again when worn with heels), the skinny pant (an option for slim-legged bodies only), pajama pants (an elegant way to camouflage a few extra pounds), and of course, khakis. • Choose your pants carefully (check out the view in a three-way mirror before buying) to find the styles that flatter your figure. Here's some guidelines: If you have heavy thighs, avoid anything with pockets and pleats. Flat-front side-zip styles will work best. Cuffed pants overwhelm petite women; try a classic trouser instead. Capri pants look elegant on lean, long-legged bodies with either ballet flats (à la Laura Petrie) or mules. Palazzo pants worn with heels are great for just about everyone. • Sometimes it's the no-fail classics that offer the most up-to-date look. I love Dickeys (sold at Kmart, Sears, and lots of other stores that specialize in inexpensive fashion). They also make great cut-off shorts. And a word on shorts: unless you're built like Elizabeth Berkley, just say no to short shorts.

Named after the Italian island, Capri pants became popular in the fifties after many women began wearing the style while vacationing at the hot spot.

Pants

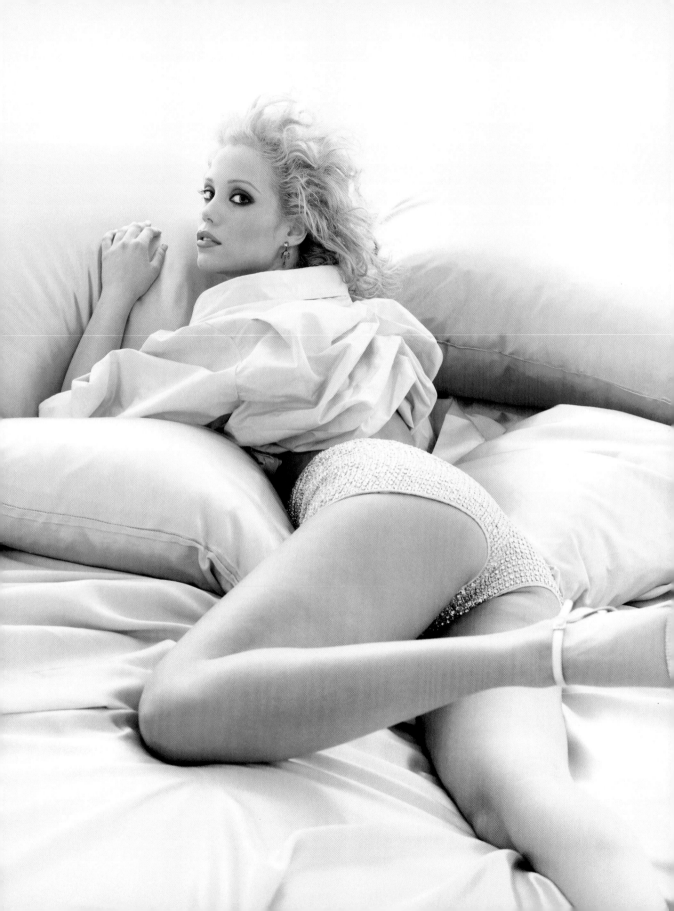

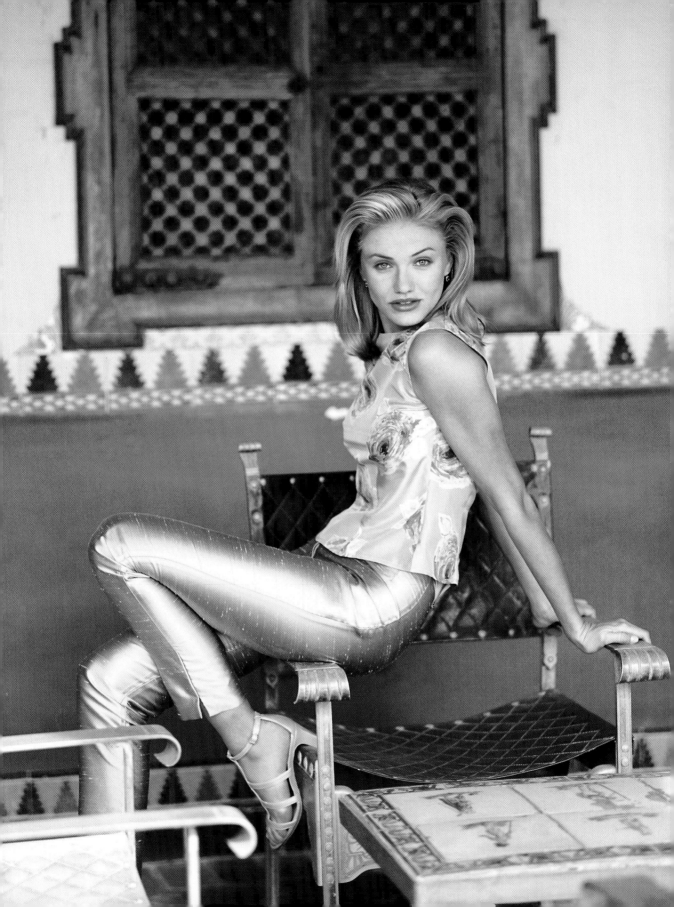

Shirt

Apparel historians say that when men began wearing suits in the nineteenth century, they never took the jackets off in public. Shirts were considered underwear, to be washed every day; white cuffs showed that the shirts were clean.

I can say with all honesty that I've given at least a few stars the shirt off my back. My silk/velvet shirt by Equipment has been brought to at least one hundred shoots. A classic white cotton shirt gives anything it's worn with a crisp, tailored feel; the same style in silk organza is transformed into elegant evening-wear or a barely there coverup for the pool. If your summer suit is stifling try a sleeveless shirt like Julianna Margulies is wearing—a look that is classically cool. • Suede, leather, and wool shirts can double as jackets, they're great for layering to keep the chill out and for chilling out. You can wear them neatly tucked in or hanging out. (Just don't tie them à la Daisy Duke unless you're walking along the beach in Bali.) Shirts are sexy when they're open (even sexier when they're off), revealing a hint of skin or some beautiful lingerie. Richard Tyler's satin shirts are among my favorites—especially with the cuffs a little long and unbuttoned. And speaking of cuffs, French cuffs look very refined when they're worn with vintage cufflinks. My best advice: When the heat is on, keep your shirt on—and just open up a button or two to stay cool.

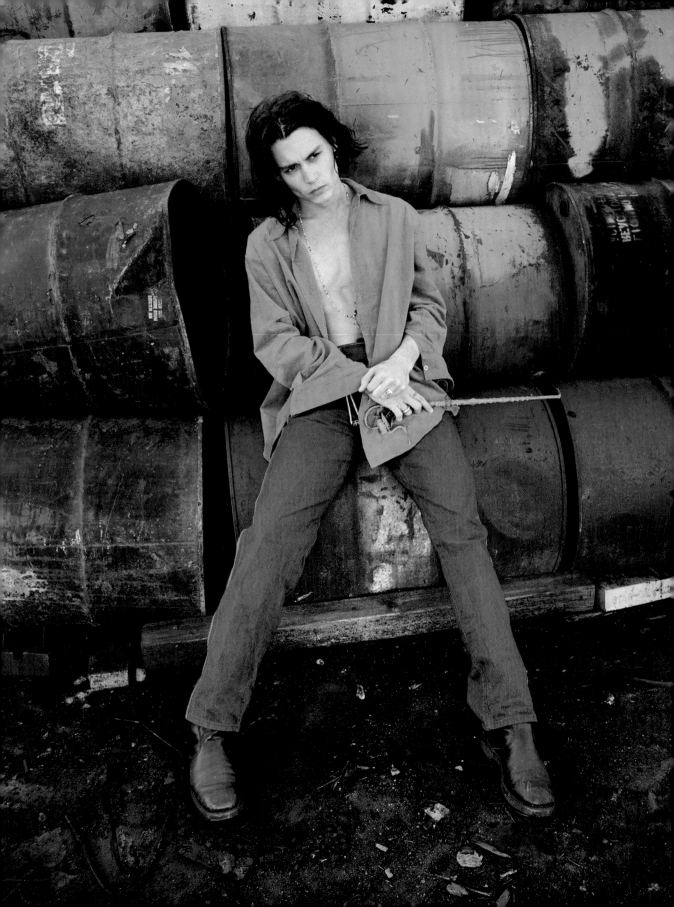

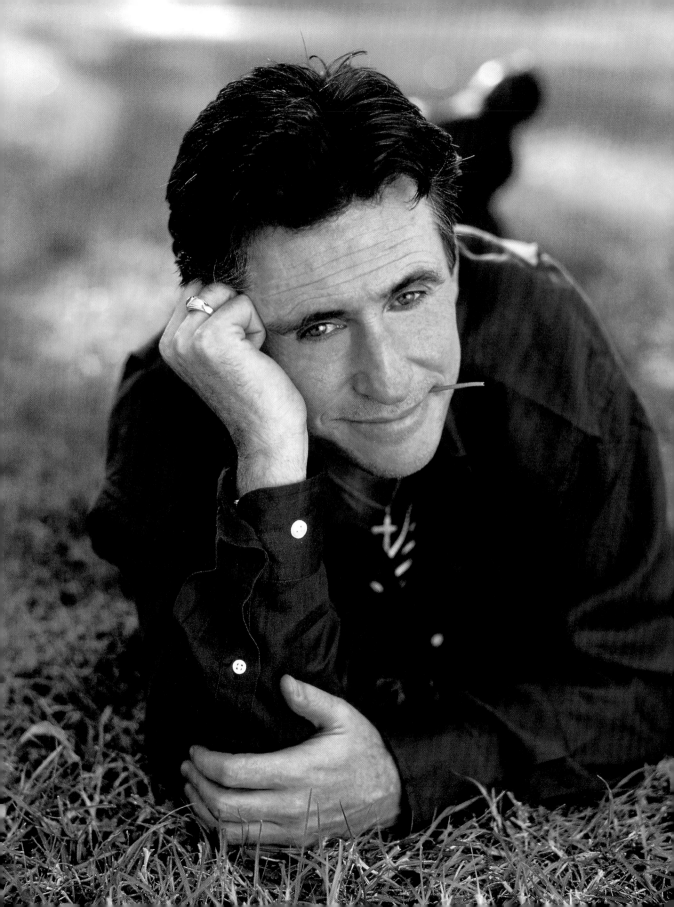

Jeans are the ultimate icon of American style. Originally worn by cowboys, the uniform of a T-shirt and jeans has been a wardrobe staple of both sexes since the late fifties. Ever since the seventies when nothing came between Brooke and her Calvins, designers including Donna Karan, Versace, and Dolce & Gabbana have made a fortune putting their names on jeans. They can make you look like the girl next door or a motorcycle mama. Jeans look best broken in—they definitely improve with age. In Hollywood, overalls are the biggest thing (along with jean jackets and vests) in denim these days. (Remember Demi Moore's overall-clad spin at the potter's wheel in *Ghost?*) These days, jeans have gone beyond their true-blue roots (although thanks to Helmut Lang, stiff indigo denim is making a comeback), and are available in a rainbow of colors and a variety of weights and finishes. • If you've never been able to find jeans that fit perfectly, I have good news: The search is over. Levi's now makes red-tag custom-fit jeans, called Personal Pair, that are available at Original Levi's stores for $65—a small price to pay for perfection.

One pair of Levi's flagship 501 blue jeans consists of 1¾ yards of denim, 213 yards of thread, 5 buttons, and 5 rivets.

Jeans

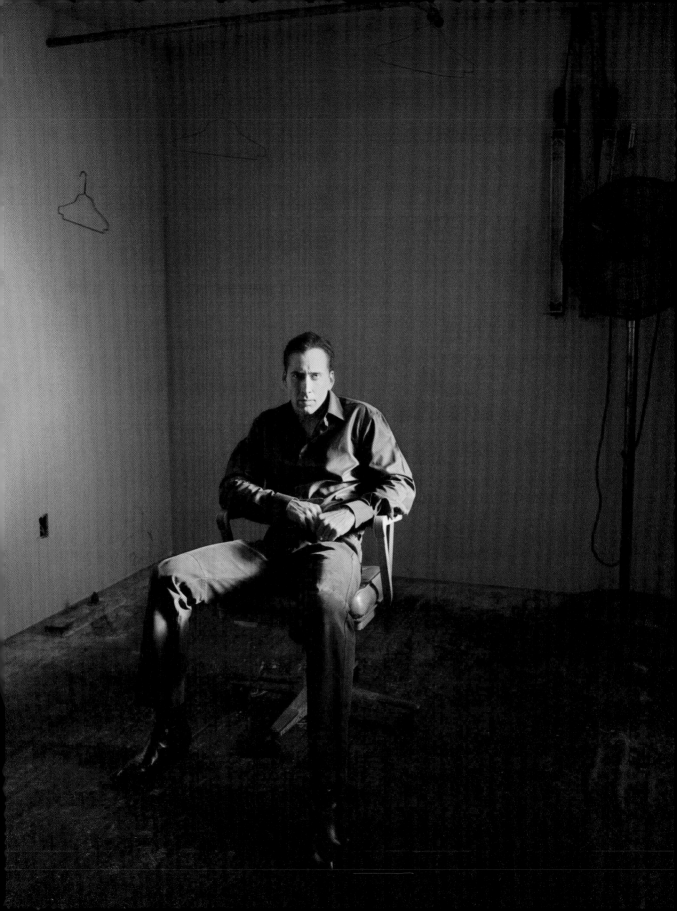

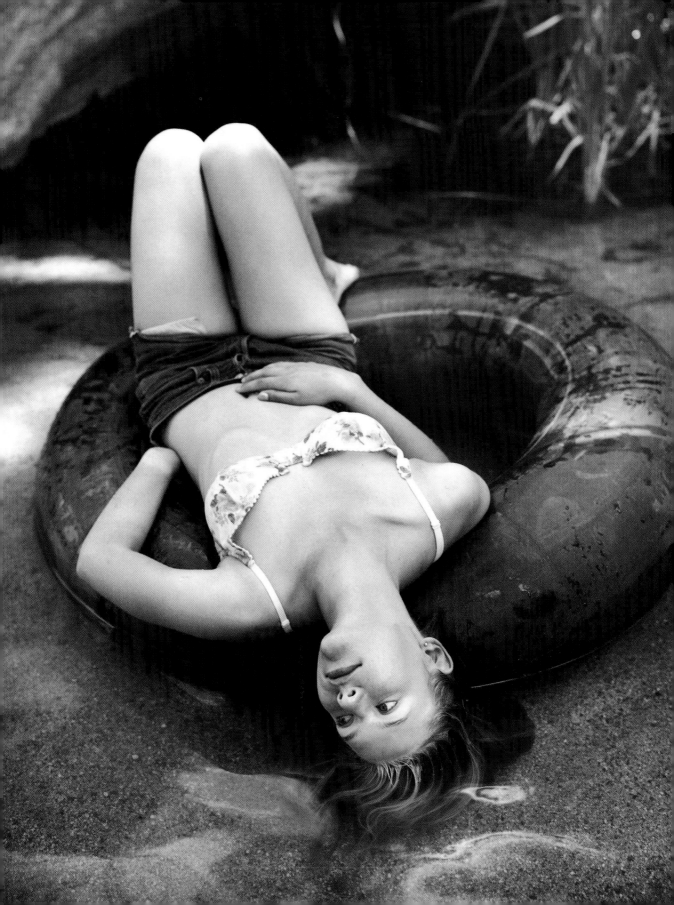

Four years before James Dean made the T-shirt fashionable in *Rebel Without a Cause* in 1955, the T-shirt became the ultimate symbol of masculinity, thanks to Marlon Brando in *A Streetcar Named Desire*.

T-shirt

T-shirts are a great fashion basic (and an essential element of style) that you can wear anywhere with anything. Crew neck or V neck, cotton or cashmere, fitted or oversized, long or short sleeve—even sleeveless—the options are endless. T-shirts look great striped or solid—the white T is undoubtedly an American classic. They can be worn to the office under a suit (a look popularized by directors power lunching in LA) or with shorts at the beach. There's no single item of clothing you'll ever own that's more versatile. Finding the right T-shirt for you is all a matter of choice. The simplest (and least expensive) option: Hanes ($8 for two). Brooks Brothers, Gap, Banana Republic, and Agnès B. All make T-shirts that differ in fit and feel. A great place for women looking for tiny Ts is boys' departments in stores. These days you'll find a T-shirt for every cause like Tim Roth's Che Guevara, and now that designer logos are chic again, Calvin, Ralph, and Donna are on everybody's back (and front). • Another great thing about T-shirts is that you can layer them. Colored T-shirts can give you the *je ne sais quoi* you've been looking for, and don't underestimate the simple yet striking sweater-girl look à la Debi Mazar (T's when made of angora, cashmere, or even wool, like this Emporio Armani, become instant scene stealers). The T-shirt dress is a terrific packable piece (perfect for those 90-degree summer days when you want a wilt-proof look) that you can just throw on and go. You can't go wrong in a T-shirt—it's the timeless must-have for everyone's closet.

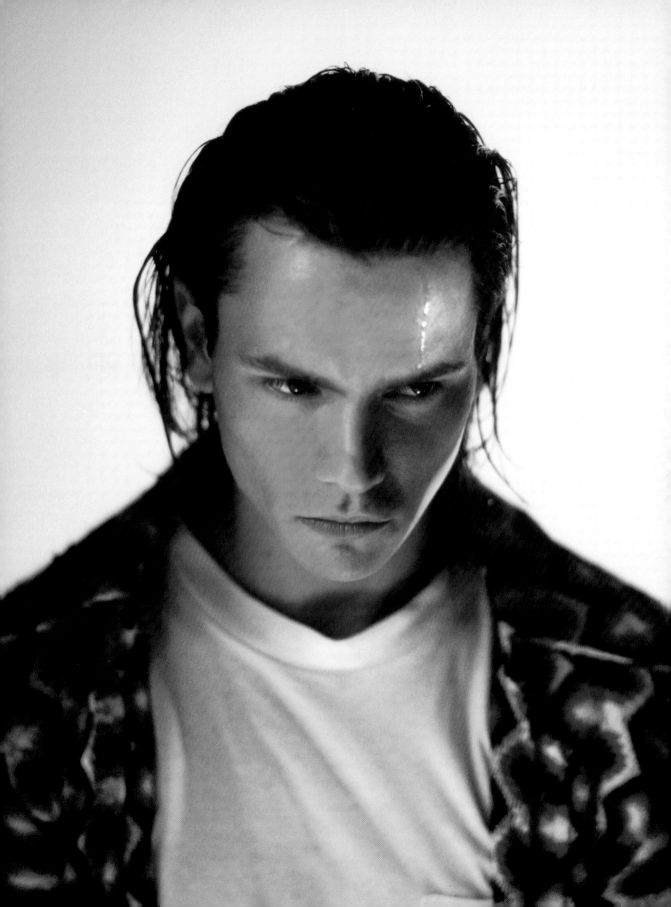

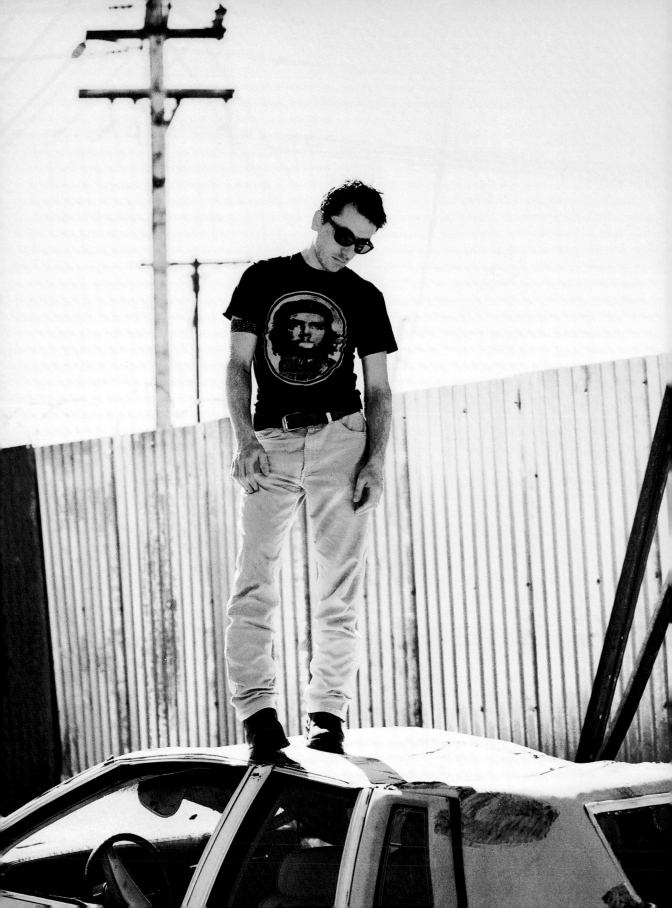

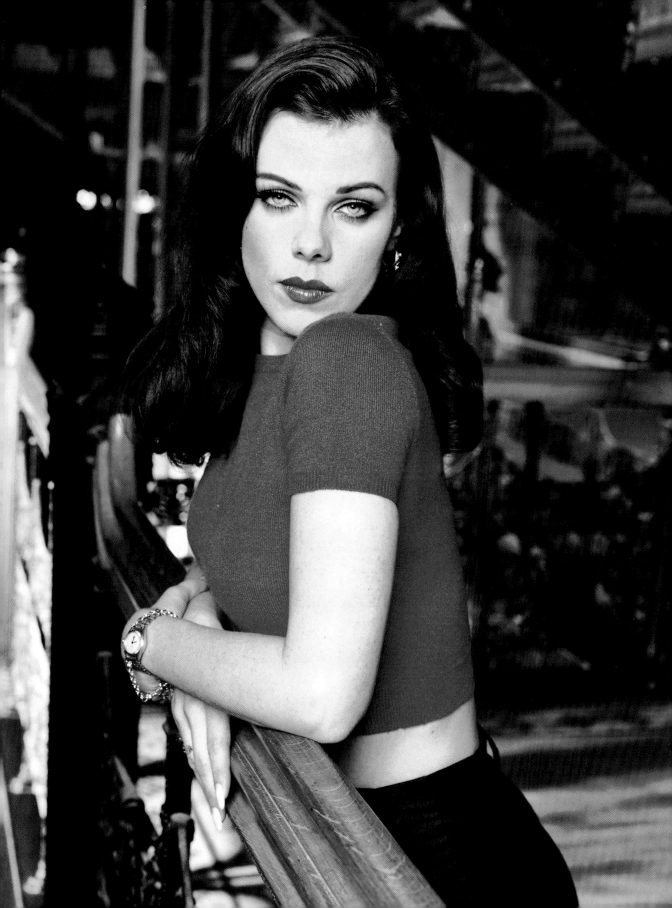

In the Victorian era, when somber-colored fabrics dominated, vests and ties provided creativity in men's clothing.

In *Saturday Night Fever*, John Travolta wore a vest as part of a three-piece white polyester ensemble. Sales of these types of disco-era suits skyrocketed.

Vest

Here's a bit of sound fashion advice: Invest in vests. You can dress them up or dress them down. They can be functional (like the essential down vest that Toby Bailey is wearing) or fashionable in silk, velvet, or brocade. Ever since Diane Keaton suited up in *Annie Hall*, vests have been a popular way to express a personal style. • I love vests layered over a T-shirt on both men and women. They look incredibly sexy against bare skin. Vests can be serious when they're buttoned up under a suit (but please make sure the patterns don't clash) or slimming (try an elongated vest over a long skirt or pants). Steal one from your brother, boyfriend, or husband, and wear it with your favorite jeans for a casual, relaxed look. Vests can also add a touch of whimsy to a wardrobe, but please don't overdo it—the only people who should be wearing cartoon characters on their bodies are those too young to know better.

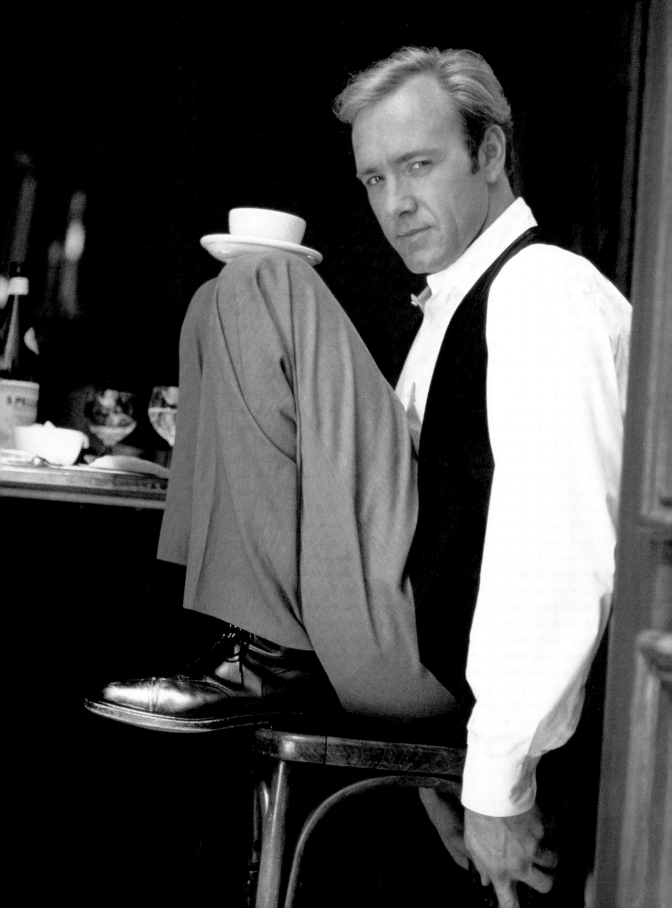

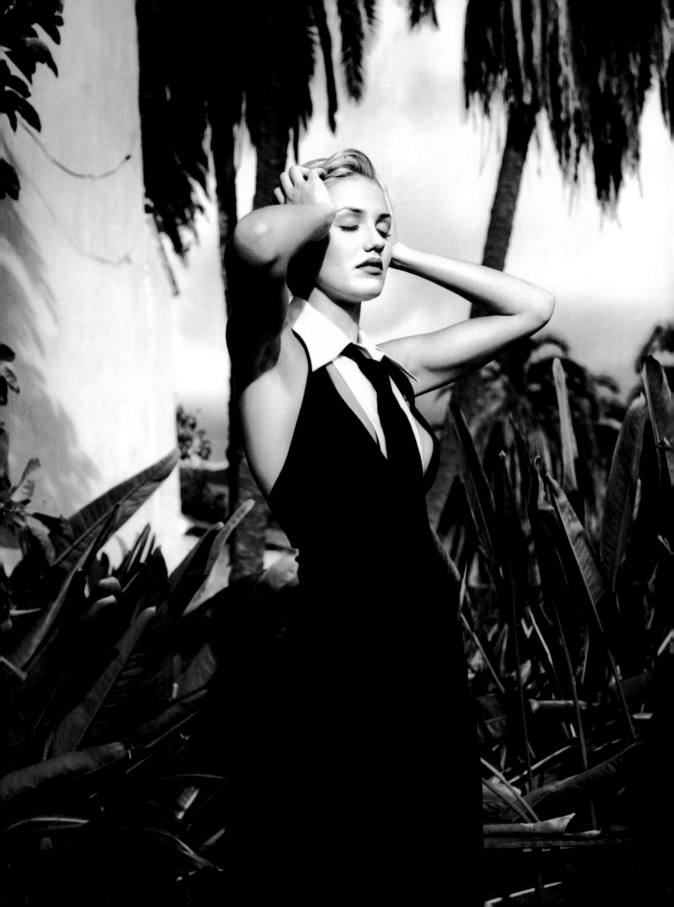

If you want to have a ball, wear a gown. They can be sexy and sophisticated or sweet and princesslike. In the nineties, they have become more fun, a bit more casual, and a lot more comfortable. They are also the benchmarks of a woman's life; you'll never forget the gown you wore to your first high-school prom, the one worn to your first black-tie party and, of course, the ultimate gown—the wedding dress. • With today's everything goes fashion you can spend a fortune on a gown or not. For proms, think vintage for the dress and the jewels (real or fake but never gaudy). Slip dresses also make great prom dresses, but when the prom is over and the limo has turned into a pumpkin, put on some platforms with the dress and head out for your next shopping spree. For Gianni Versace gowns were art, a canvas. Add a woman and you have something to rival any museum piece. • There are ways to reincarnate your favorite gown into many different forms. Here's how you can extend the life of a classic white (or light-colored) gown: Gala Number One: Wear your gown in all its glory. • Gala Number Two: Have the gown dyed a medium shade, and change your accessories. • Gala Number Three: Dye the gown navy, black, or brown and add a sweeping shawl. • Gala Number Four: By now, you and your gown are best friends and you can't get rid of her, let the designer in you loose—cut it short and make it a dress. • If it's versatility you want, try separates. Who said a gown has to be one piece? Be the bell of the ball—try a shantung silk or organza full skirt with a bustier or fitted camisole, or try sheer illusion bodysuits (Giorgio Armani and Vera Wang often top their ball gown skirts this way). • Wearing a gown is like waving a magic wand over yourself—pick the right one, and something great is bound to happen.

Mae West had two versions of several evening dresses by designer Travis Banton—one to walk and stand in, and one in which she could sit down (without bursting out of it).

Gown

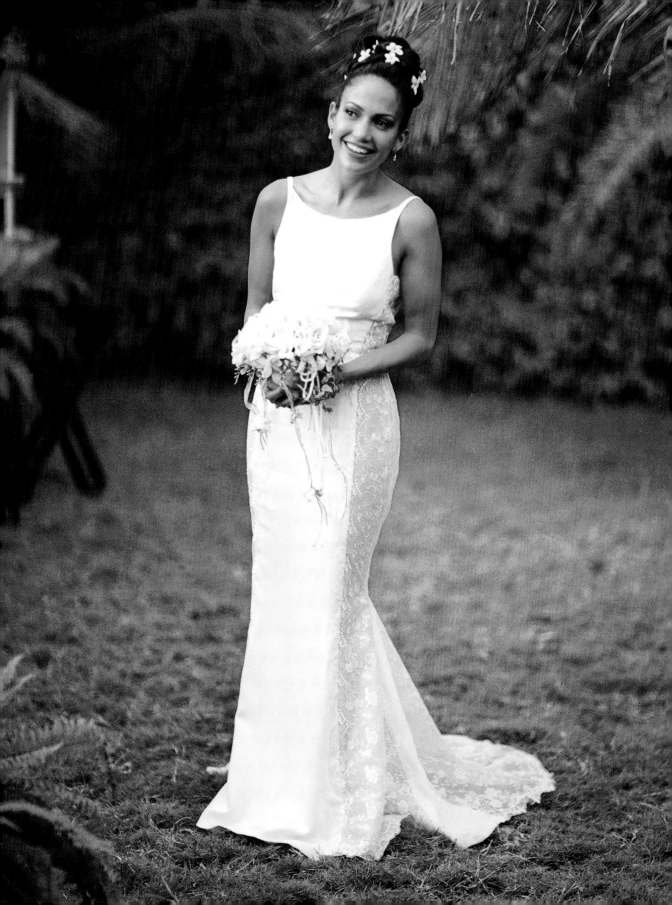

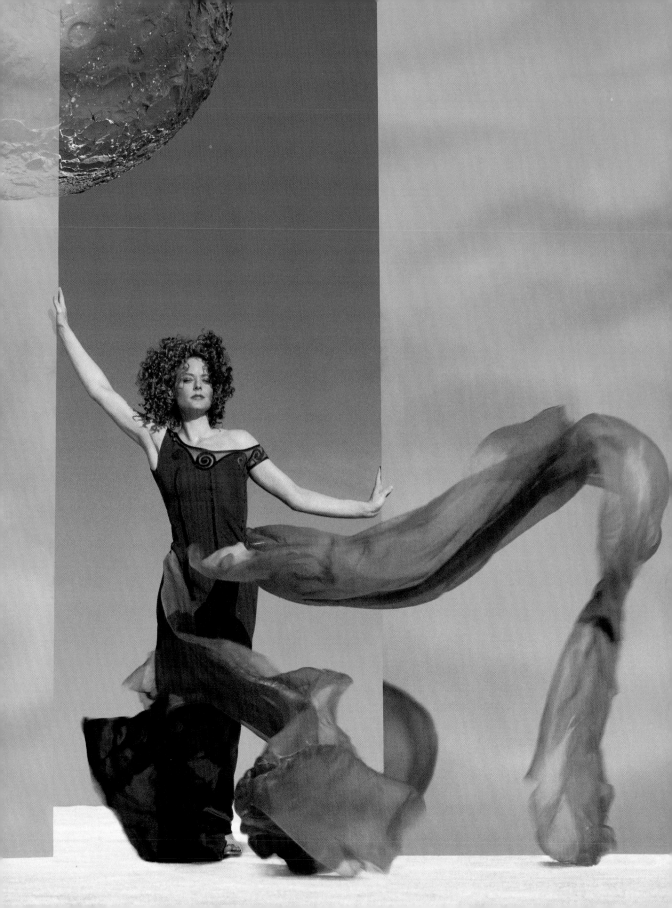

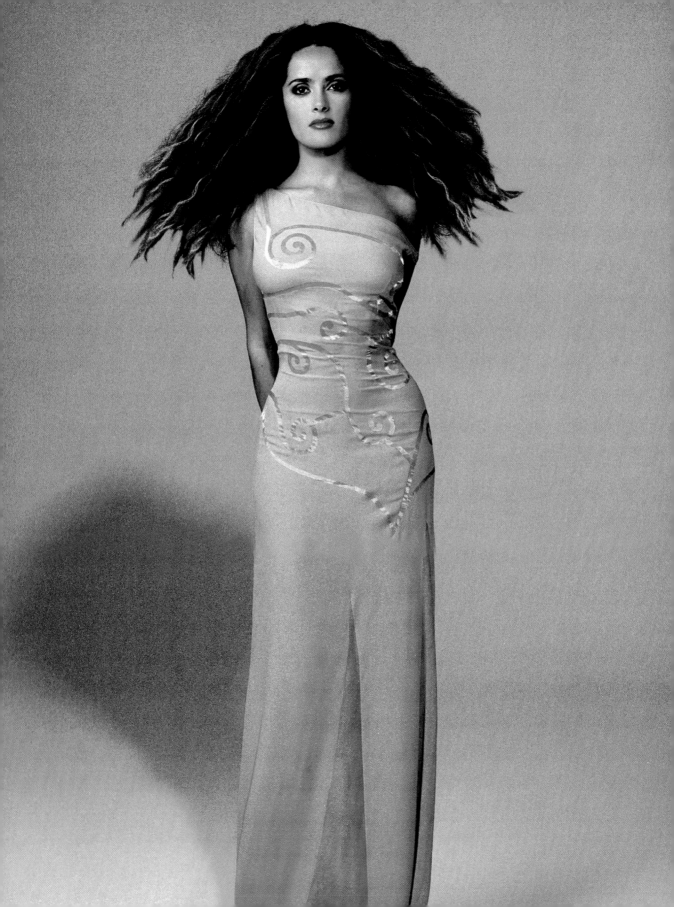

In 1930, Greta Garbo wore a ruffled blouse in *Anna Christie*, setting off
a fashion trend. Ruffles began appearing on Vionnet's bias-cut dresses
and became popular along with draping, shirring, scrunching, and ruching.

Ruffles

Just for the frill of it, wear something with a ruffle. It's a completely romantic look
that's been worn by pirates and royalty alike. Ruffles have been used on everything from
men's collars to women's dressing tables, and they are enjoying a well-deserved renais-
sance. I love them on the hem of a full skirt (it reminds me of flamenco dancers and
Toulouse-Lautrec's can-can girls) or on a blouse (Faye Dunaway is picture perfect in her
face-framing ruffles). A ruffle on a shawl can add just the right amount of drama when
worn over a simple evening dress. When it comes to men wearing ruffles, unless you're a
lounge singer (and even then I'd think twice), it's best to wear ruffles only with a tuxe-
do. • Ruffles should look rich. When you're buying something with a ruffle, pass up
anything that looks skimpy. My rule of thumb for picking out the best ruffled styles: if
the fabric is soft (like silk chiffon), the ruffle can be small; if the fabric is stiff (like
taffeta) you can wear a more sweeping, voluminous ruffle. To avoid looking like a walk-
ing doily, try on as many different styles as you need for just the right look. • Some
of my favorite ruffled styles come from the collections of John Galliano and Gianni
Versace. Galliano's stunning flamenco dresses have been worn by Melanie Griffith and
Elizabeth Hurley. At the 1997 Academy Awards, Courtney Love chose an elegant Versace
slip dress that got its flair from a featherweight ruffle that fell from one shoulder. So
when you feel a tango coming on, go for something with a ruffle. *Olé!*

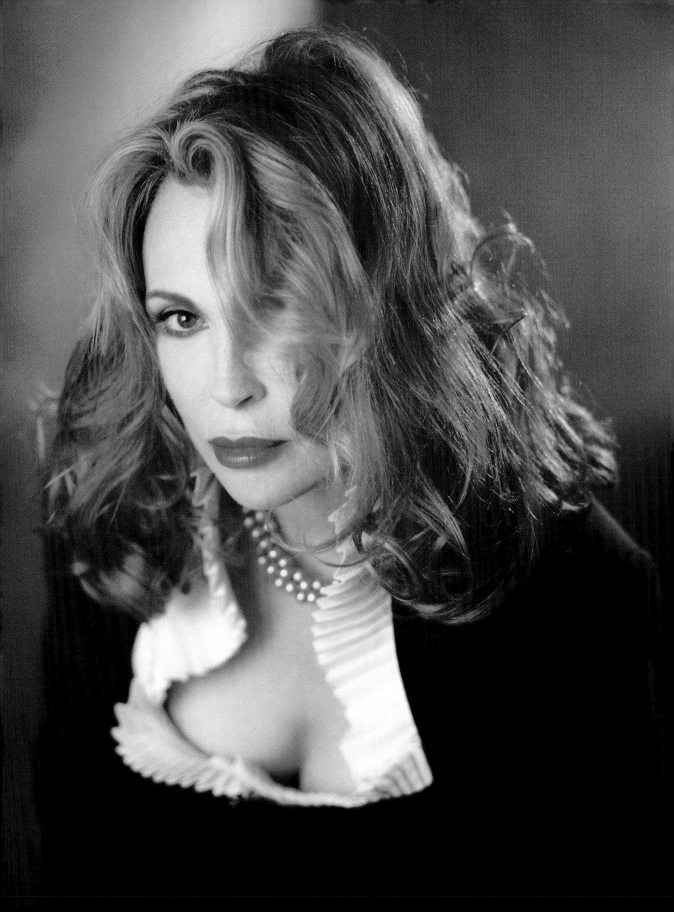

When it comes to looking fashionable in feathers, there's a fine line between costume and couture. A longtime staple of starlets and lounge singers, feathers can be a fun way to go glam for special occasions. There's something very Hollywoodesque about tossing a trail of feathers over your shoulders and making a grand entrance. • You don't have to spend a lot of money to achieve an Oscar-worthy, fine-feathered look. Feathers look particularly alluring when they frame the face. You can buy a strip of fine feathers—like marabou—at a good fabric store. (Avoid the wider, coarser type that tend to look cheap.) The more exotic the feather, the more exotic you look. Another option: Scour the best vintage stores near you for a fabulous feather stole. Like on Georgina Cates or Carol Channing, you can wear it as a wrap or sew narrow strips onto the collar of a sweater or the cuffs of a jacket. Never wear feathers on the hem of a skirt unless your name is Barbie. For a rich, sophisticated look, surround yourself in black feathers; for something more fun, try them in bold, bright colors. • Of course you wouldn't wear feathers to the supermarket (please!), but spread your wings for a night on the town. Just pluck something feathered from your closet, and watch your fashion spirit soar!

Ginger Rogers's famous ostrich-trimmed dancing dresses, like the ones she wore in *Top Hat* in 1935, were designed by Bernard Newman (who came to Hollywood from Bergdorf Goodman in New York).

Feathers

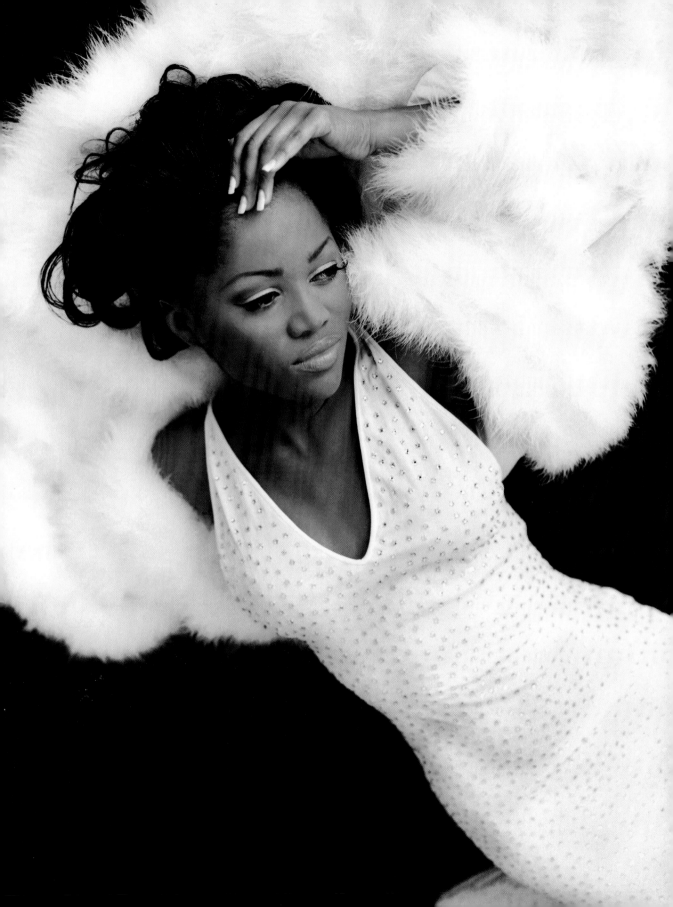

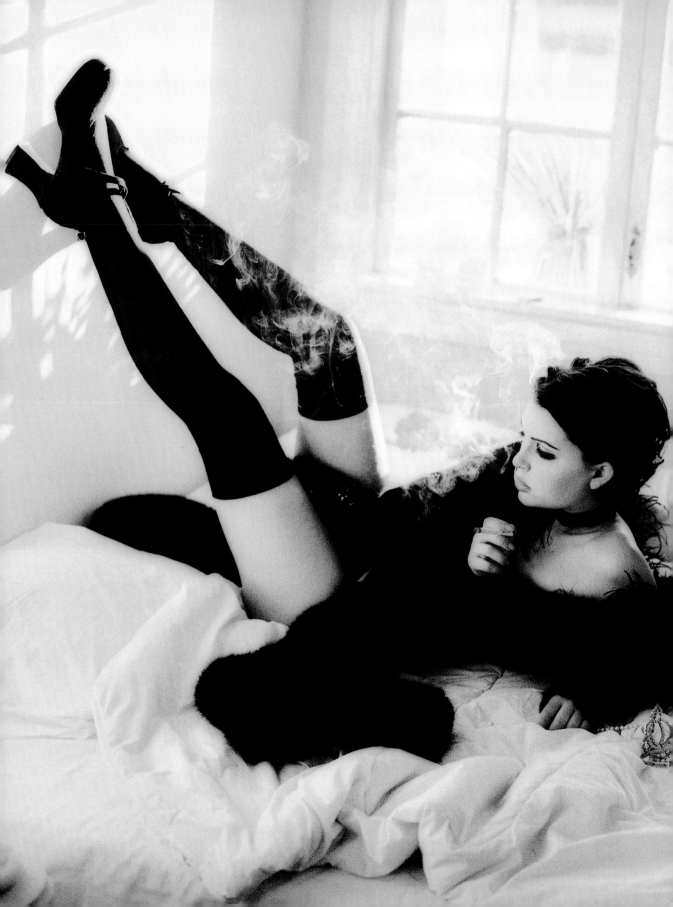

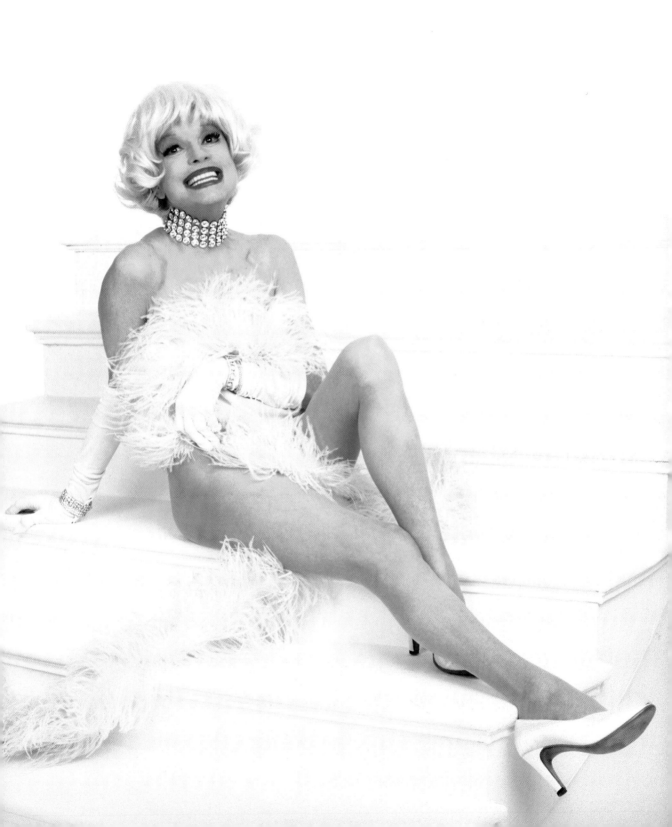

If you've got it, flaunt it, so why not take the plunge and wear a revealing neckline? The right neckline for you should frame your face beautifully and bare as much (or as little) as you're comfortable showing. Necklines, along with hemlines, are the designer's playground. • A draped neckline is an elegant way to show deep cleavage without somehow feeling overexposed. Draping around the shoulder gives a very fluid effect that "swallows" you into the neckline. The collections of Galliano and Donna Karan frequently feature draped necklines. Strapless dresses look best on women with toned arms and upper body. When bustiers from Gaultier and Vivienne Westwood busted onto the scene it gave the neckline a new boost, and they are a great way to enhance most figures. Another eye-catching option: one intricately beaded or jeweled strap on a simple neckline that goes straight across the bustline and draws attention to the collarbone—a very sensual area on women. One of the best examples of this look is the Versace dress adorned with a vine of diamonds, worn by Salma Hayek. One-shoulder dresses have been very popular for Hollywood award shows and work best on a dress in solid colors. For an all-out glamorous look, try adding elbow-length gloves. • The classic V neckline looks good on everyone (I love Malo's luxurious cashmere V-neck sweaters). A simple diamond or pearl necklace is perfect with V necks. Wide open V necks or even boatnecks that slide off the shoulder are very sexy on all women. This neckline is all about the shoulders, neck, and collarbone and draws a lot of attention to the face.

Neckline

The plunging necklines worn by Jane Russell (with the uplift bra that was designed by Howard Hughes) in the publicity stills for *The Outlaw* made her a world-famous pinup girl before the film was released three years later.

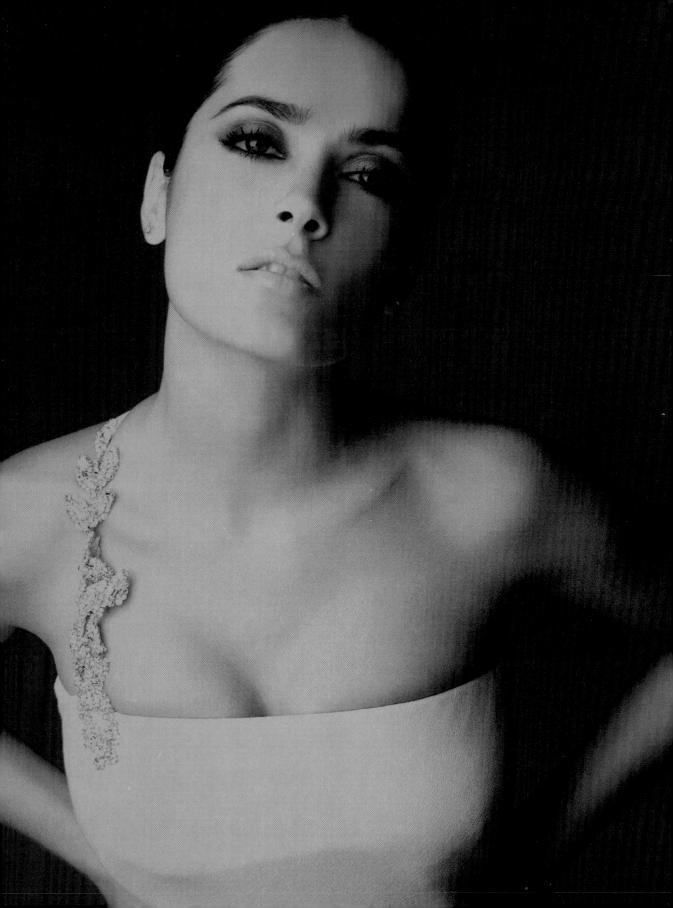

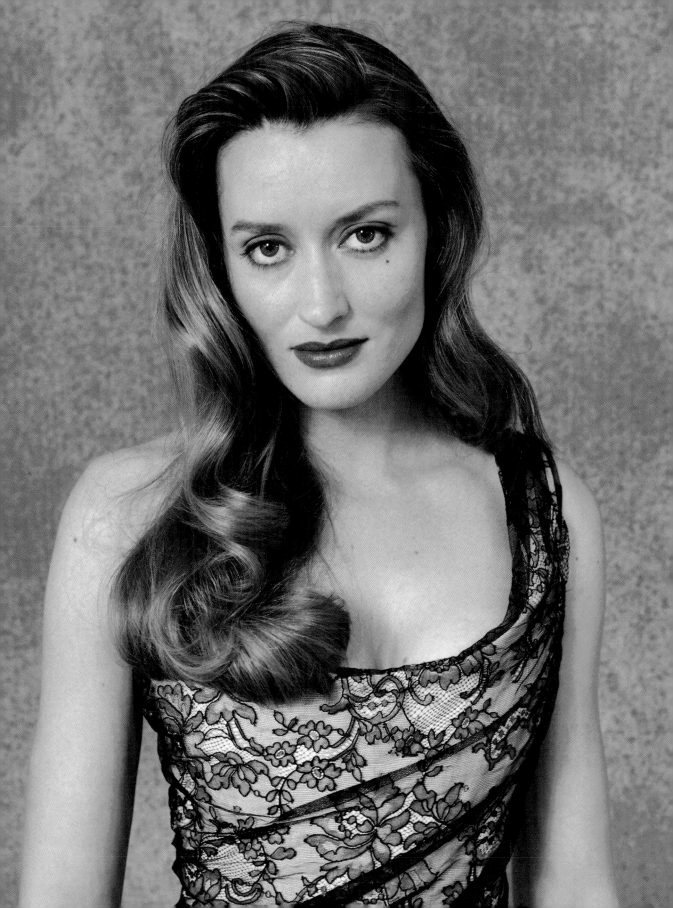

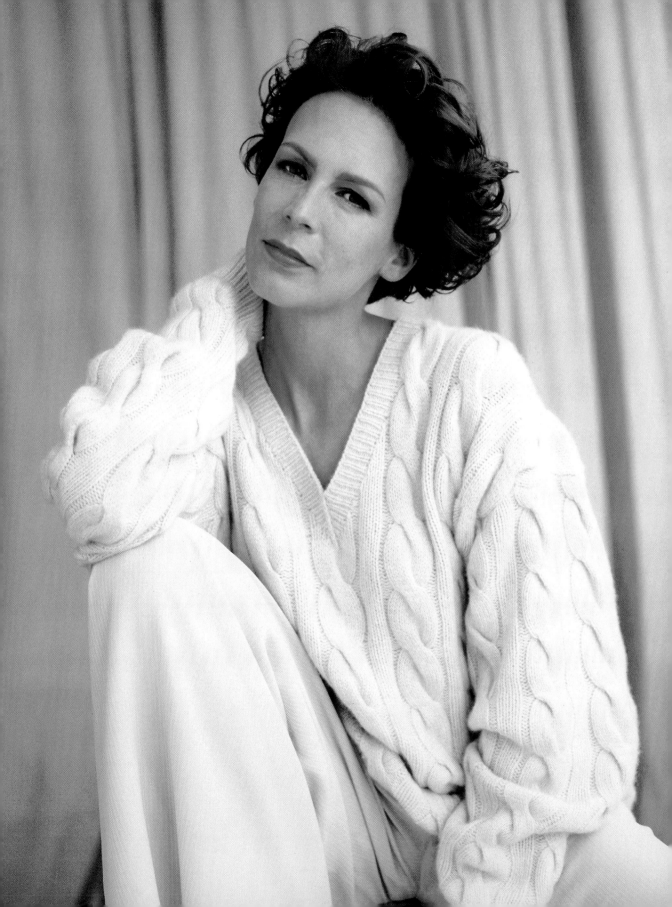

Layers

As I always say, it's not what you wear, it's how you wear it. Layering is a great way to make a look your own. What you wear under your favorite slip dress (try your prettiest camisole) or over it (slip into your grandmother's beaded cardigan) speaks volumes about your personal style. • Layering works best when you infuse unexpected combinations of color and textures. Don't be afraid to mix moods. Kate Garner's photograph of Cameron Diaz is a terrific example of how I think layering can really look great. Her look is equal parts Mary Tyler Moore, Katharine Hepburn, and Cyndi Lauper. The effect: purely original and ultrahip. One of my all-time favorite looks is a V-neck sweater layered over a T-shirt—it's a simple, classic style that looks great on everyone. • Layering sheer fabrics is a very modern way to dress right now. Try layering two chiffon slip dresses for one really romantic look. A sheer shirt over a bra that's meant to be seen is layering at its sexy best. At other times, you might want to keep your layers under wraps (and only reveal to that special someone that you're wearing silk underwear underneath it all). When you layer, remember fabrics are key; each piece you wear should feel comfortable—not constricting. • Layering can be a weighty issue. Layers can definitely add bulk, so if you're not as thin as you'd like to be, lighten up on layering. Remember: Sometimes a little layering can go a long way as camouflage. Why do you think the big thing in layering has been to tie a shirt or sweater at the waist for so many seasons? When it comes to layering, take your cue from Matt LeBlanc, who looks *Great Gatsby*-ish in a linen jacket over a traditional button-down and striped T-shirt—casually confident.

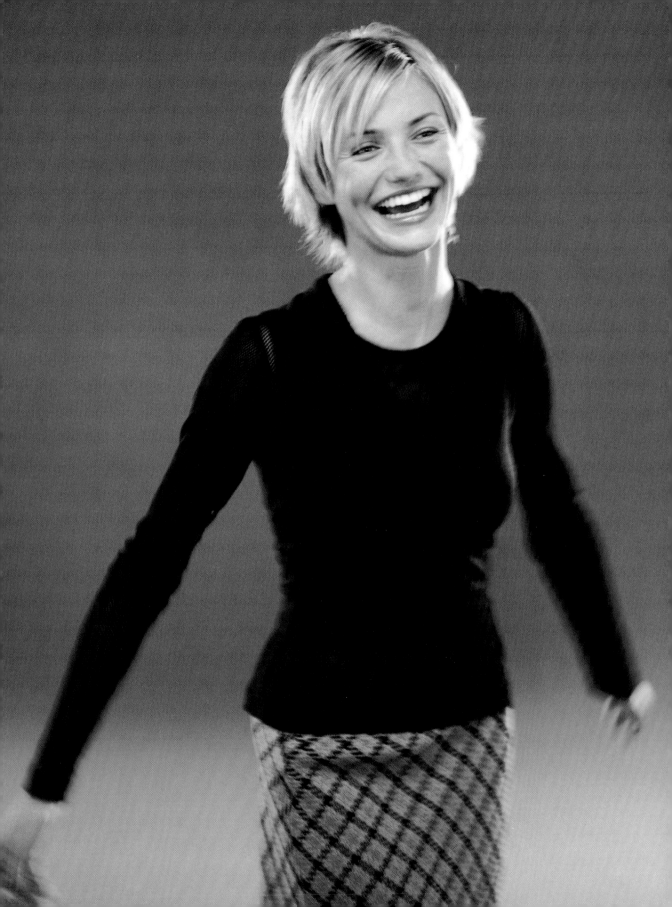

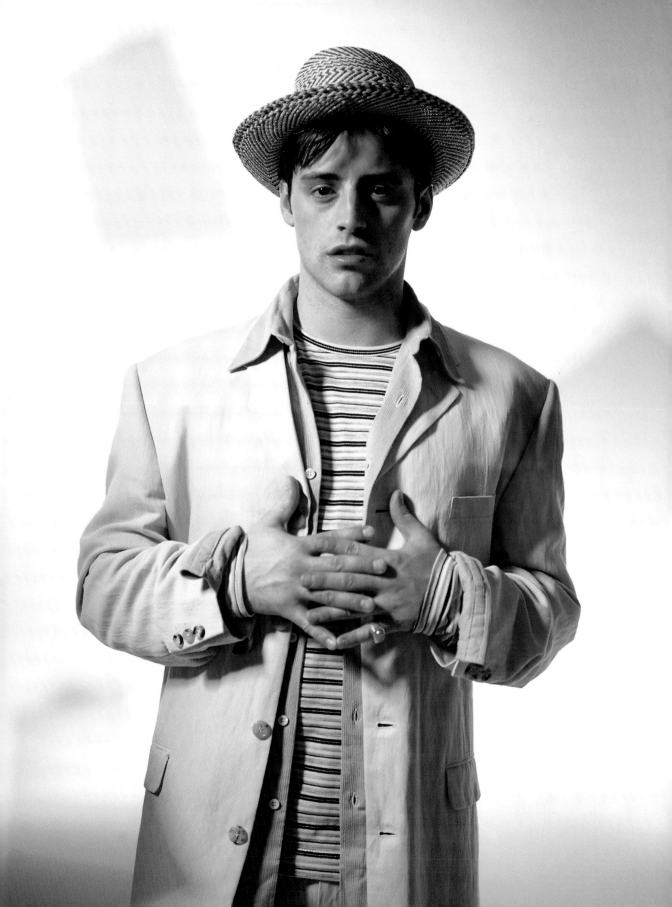

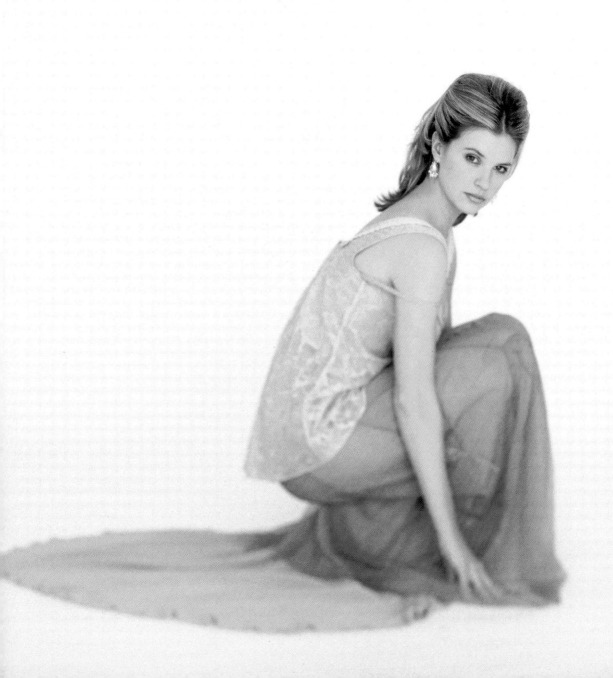

Funky Patterns

Extremely popular with many Hollywood stars today, funky patterns were worn as early as 1927 when such stars as Gloria Swanson and Theda Bara wore the modish designs to enhance their shingled hair and exaggerated makeup.

If there's one thing I'm sure about in fashion, it's that history definitely repeats itself. One of the biggest trends to be resurrected recently is funky patterns. Old classic geometric prints, formerly preppie plaids, foulards, and paisleys have all made a comeback. I think they look better than ever now that they're being reinvented and reworked in a fresh way. • I like mixing them. But there's a trick to it: Do it right and you'll have earned admiring glances for your stand-out personal sense of style, do it wrong and you'll send people running for cover (at least their eyes). Here are some hints on how to pull it off: Try small patterns, mix textures as well as patterns, and limit the mix to two elements of style. Some of the best funky patterns around can be found at vintage shops. Look for those great polyester shirts from the sixties, plaid jackets, and madras golf pants to wear with T-shirts for that cool, surfer dude kind of look. Funky patterns (like Pucci) can also be very chic. Keep looking until just the right one grabs your eye. • These days, a funky pattern can be the ultimate status symbol. As we will see in "Floral," eye-catching patterns can leave a lasting impression. You might want to think about how much you want to invest in a funky printed dress, because it will quickly date. Here's my advice: If you want to buy a funky pattern from your favorite designer, take the plunge, wear it a few times and then put it away for five years. When you take it out, it will look chic all over again. If you want to go for a less expensive clone (otherwise known as a knock-off), be careful to buy something that's good quality (nothing looks cheesier than a really bad imitation of *anything*). If you find a good look-alike, snap it up, enjoy it—but don't try passing it off as an original.

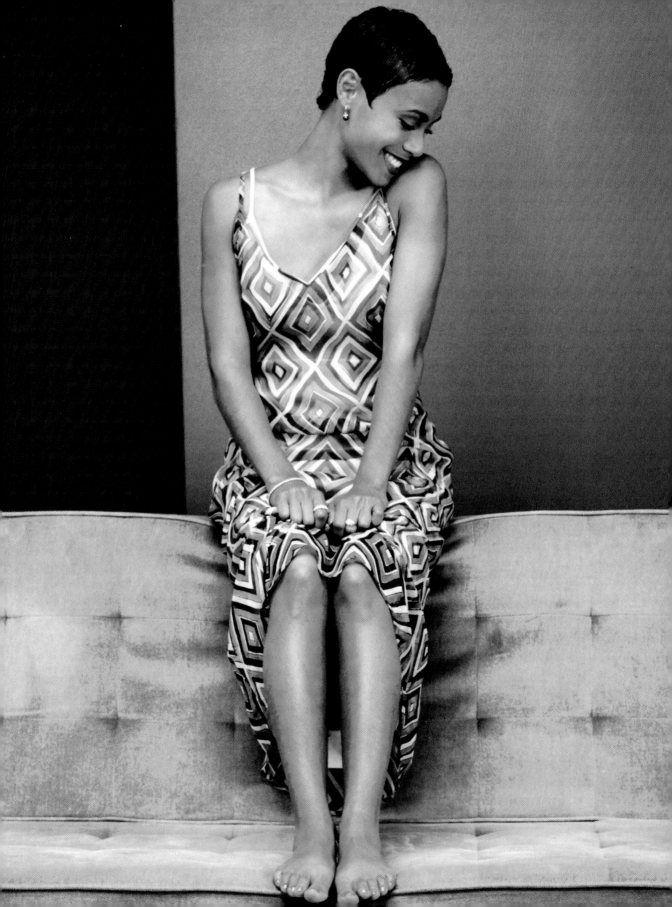

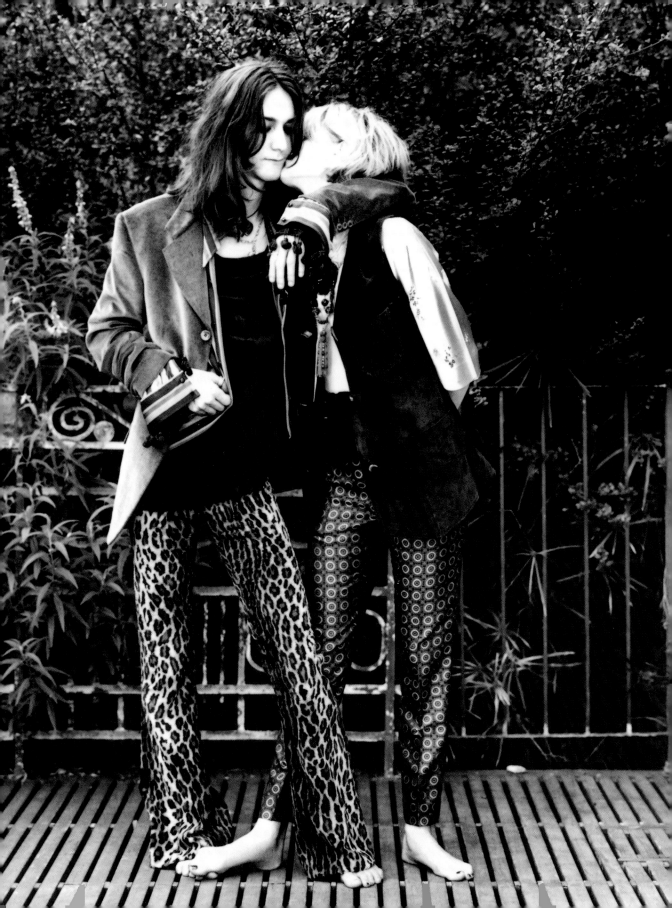

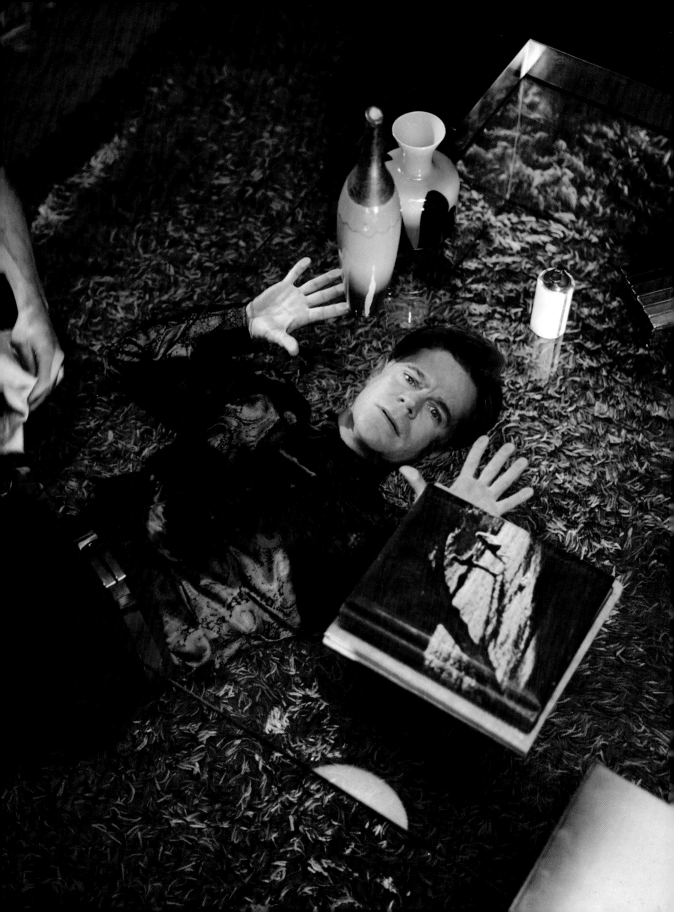

Leather

You've probably suspected this: Hollywood is really into leather—jackets, that is—and pants and vests. James Dean became a *Rebel Without a Cause* in his cropped leather jacket, and Olivia Newton-John electrified John Travolta in her painted-on leather pants in the 1978 hit *Grease*. Ever since then, virtually every Hollywood star has worn leather on- or offscreen. • The leather jacket, an enduring symbol of tough chic, is bigger than ever. In the past, every designer from Gucci to Ralph Lauren has sent enough leather down the runway to outfit every motorcycle gang from coast to coast. Leather pants (be warned, they can be hot to wear) and skirts are instant wardrobe updaters. The new item to own is the leather pea coat, which is equally modern and classic. You've got to spend a little more on leather and suede, but consider it an investment. Shop around in army/navy stores and vintage shops. Flea markets often offer great deals on leather. I like to shop on Melrose Avenue in LA or Orchard or 125th Street in NYC for funky leather pieces; I also suggest scouring the racks at your favorite boutiques, Barney's, Bloomingdales, and Saks. Here's what you should look for: Leather pieces should fit comfortably and be reasonably soft. Check out the buttons—if they aren't securely sewn on, that's going to be a pricey repair (unless you do it yourself). And while we're on the subject of caring for your leather garments, let me warn you: Dry cleaning is expensive. Keep your clothes in good condition by treating them with a protective spray, and dry clean them only once a season. • Suede and shearling (in bold colors) are also great ways to funk up a wardrobe.

In the thirties and forties, the appeal of the leather flight jacket was
fueled by World War II films starring Clark Gable and Spencer Tracy.

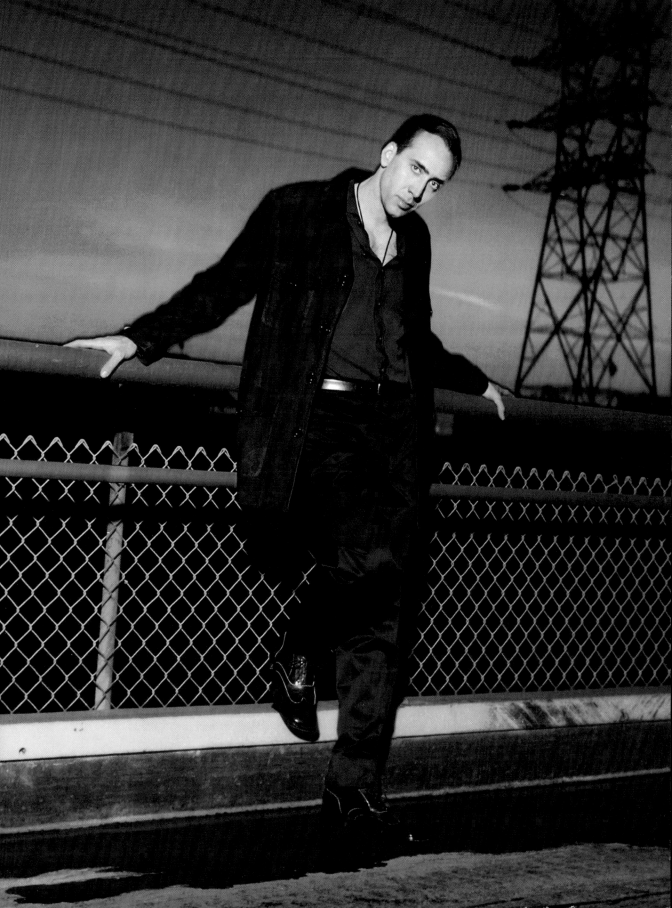

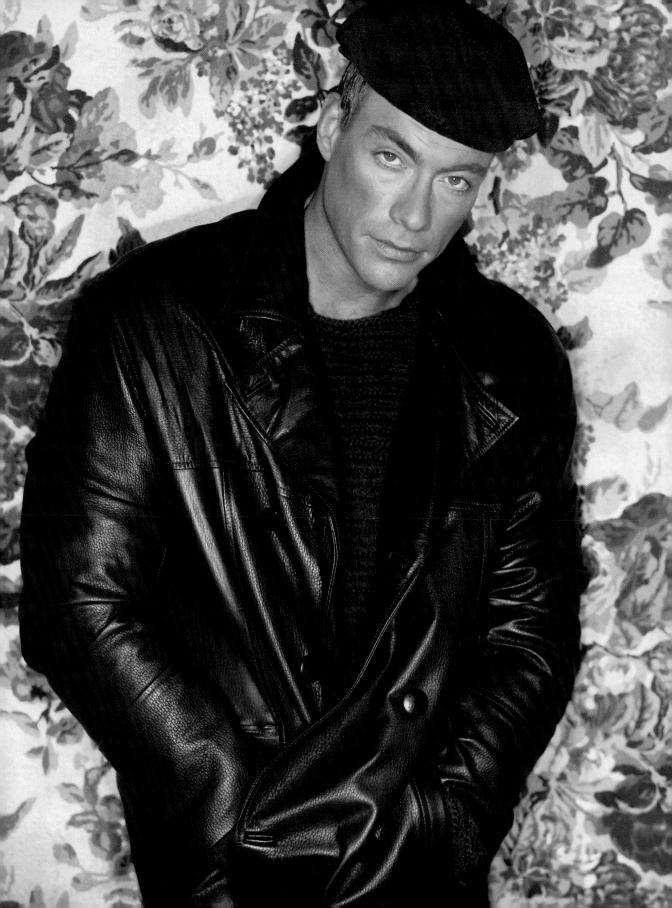

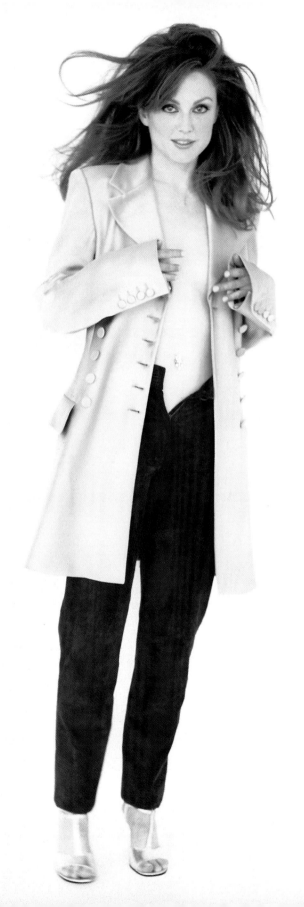

Slit

There is no skirting the issue—slits have been on the cutting edge of fashion in recent years. Designers have slit everything from mini dresses at Jill Stuart and Vivienne Tam to gowns at Armani and Ralph Lauren. Gucci even went one step further and sent pants with slits down the runway. • Adding a slit to a dress or skirt completely changes the way an outfit looks and feels. Slits don't just liven up the latest designs—they can breathe new life into an old skirt just hanging around in your closet. Take a classic slim skirt, slit it on the seam, have it restitched, step into a pair of your sexiest stilettos, and you're ready to rock. For a truly exotic look, buy a long slim skirt with a slit up each side. Sarong skirts come equipped with slits—at no extra charge—and coquettish schoolgirl kilts are another way to flirt. I think slits look sexiest on gowns that reveal just a hint of bare leg as a woman moves across the room. • We all know that the legs are the last thing to go, so when you want to show 'em what you've got, just give them the slit.

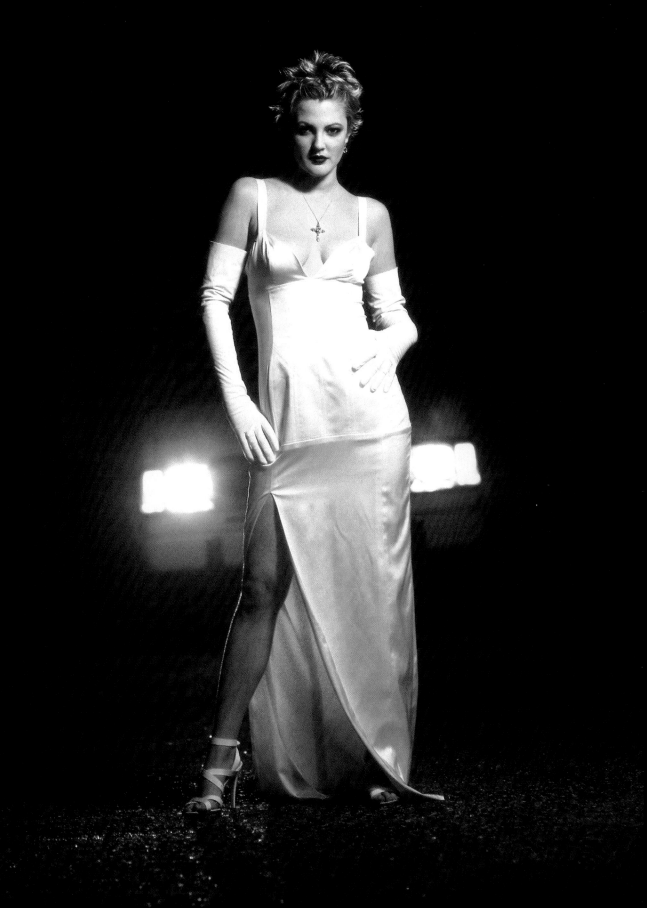

I think *Seinfeld*'s George Costanza was onto something when he once proclaimed that he wanted to "ensconce" himself in velvet. Not since the Beatles donned their velvet Edwardian suits has there been such a rush to be plush. Velvet makes color come alive—black grows darker, blue's more electric, and it's red-hot in crimson. Wearing panne velvet (velvet with a high-luster finish) is like being lit from within—you'll positively glow. • Velvet isn't just for evening anymore. Silk velvet and stretch velvet are incredibly versatile. One of the looks that brought Gucci back to the fashion forefront was the red velvet suit that defined Hollywood hip that season. Velvet has been showing up every-where. I think everyone should own something velvet, whether it's a regal robe or a suit (try one on—you'll feel great in it, I promise). One of the best and easiest ways to get velvet into your wardrobe is with a great velvet shirt (I love the ones from Country Road). • Designers like Donna Karan, Norma Kamali, and Blumarine have managed to make velvet look even more luxurious. Karan's "burned-out" velvet dresses combine the richness of velvet with the sheer sexiness of chiffon. Pamela Dennis adorns some of her velvet dresses with rhinestones for an extra bit of sparkle. So go ahead, ensconce yourself.

Velvet

One of the most famous velvet dresses ever made was worn by Vivien Leigh in *Gone with the Wind* when Scarlett O'Hara transformed Tara's green velvet drapes into a ball gown.

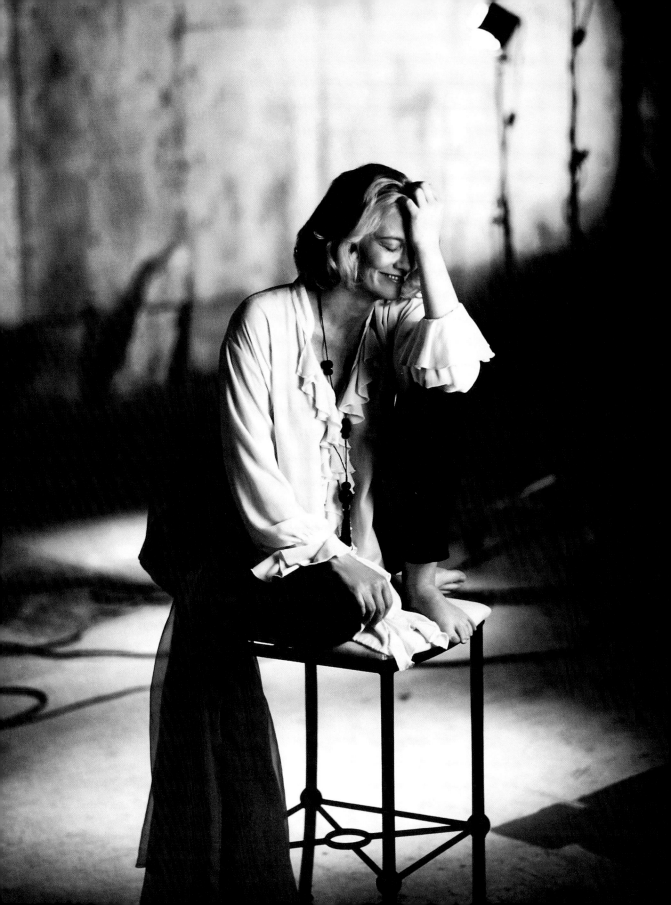

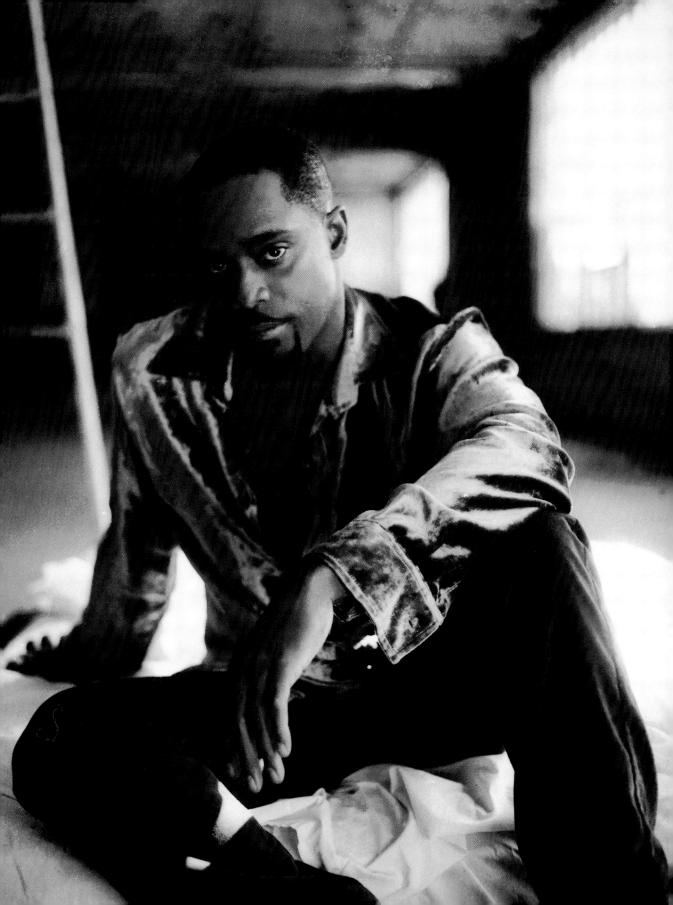

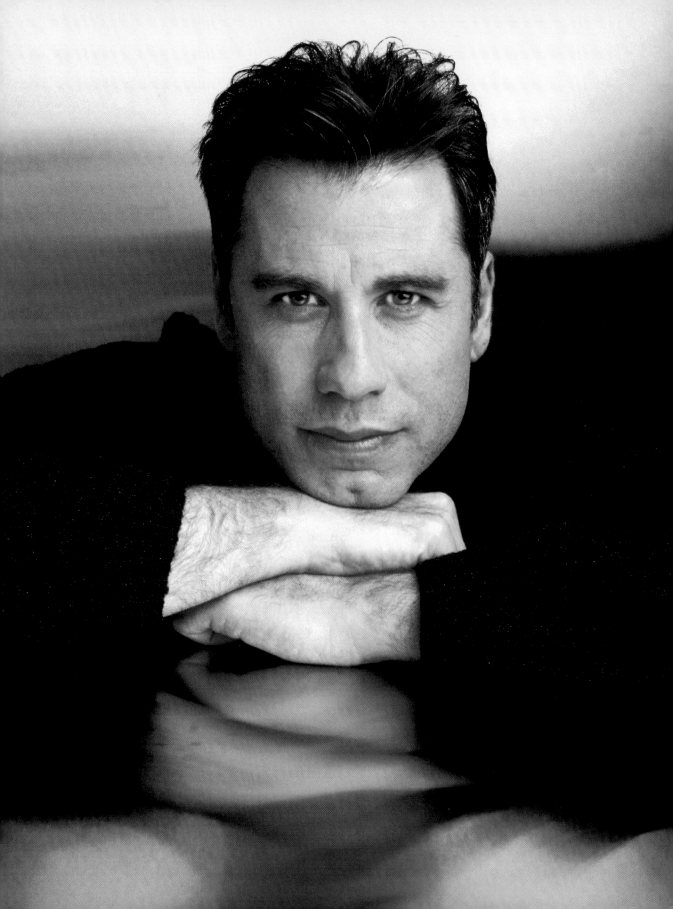

Sweaters come in all sizes, shapes, and colors—just like the people that wear them. I think everyone needs a great cardigan, a black turtleneck sweater (but that's a whole other chapter), and a bulky off-white pullover. Sweaters are incredibly versatile—they can substitute for a jacket, transforming a power-dressing look into something infinitely prettier without losing any of its polish. Everyone from Malo to the Gap carries a variety of sweaters; your tastes and your budget will determine what's right for you. • The most classic shape—the cardigan, in everything from cotton to chenille to cashmere—is a Hollywood favorite with actresses like Courtney Cox and Julianna Margulies. Once a staple of sorority sisters everywhere, the cardigan (particularly vintage style) has become the chicest way to cover up a slip dress or camisole. It also looks so modern draped over your shoulders or tied around the neck. A few years ago, Isaac Mizrahi put little cardigans over sweeping floor-length skirts—instantly redefining casual elegance. Big, roomy cardigans (steal one from your dad) are the perfect way to stay warm on a rainy day while you're curled up on the couch watching old movies. • Sweaters are great for layering. Twinsets are the most elegant way (think Grace Kelly) to do it; a casual wool pullover over a turtleneck is a great everyday look. On men, nothing looks better than a high V neck (my favorites are textured ones by Donna Karan) over a mock turtleneck or T-shirt. I wear both those looks often and love them, because I can just throw on a jacket over them and go anywhere.

In the forties, Lana Turner's curves showing under a tight sweater earned her the name The Sweater Girl.

sweater

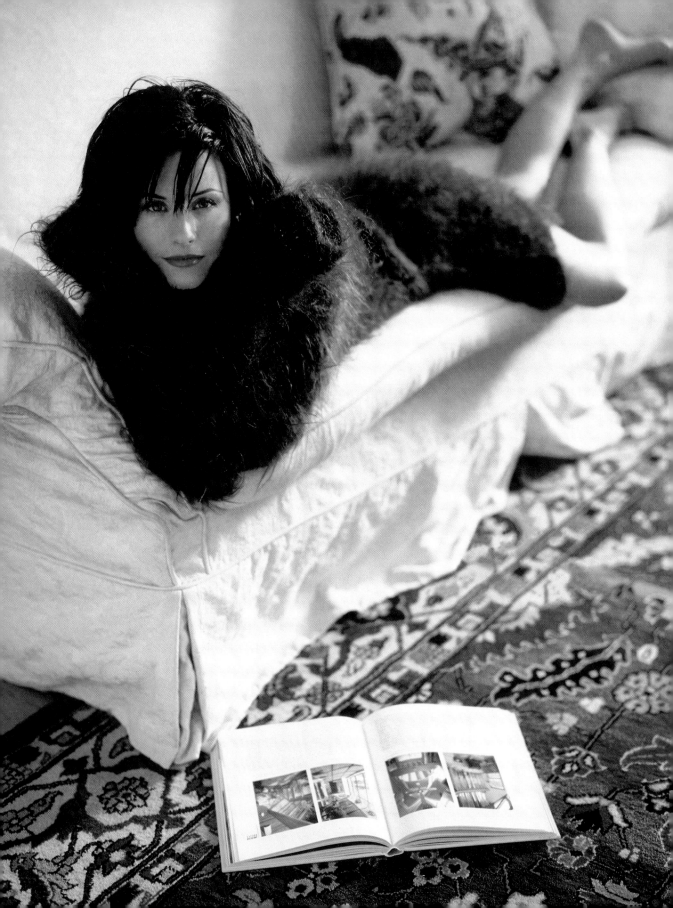

If you want to heed fashion's call of the wild, wearing something in an animal print is the way to go. There's a large family of reptiles: faux snakeskin, crocodile, and alligator that are lying in wait (with looks for the ultrahip in shiny patent leather on shoes, boots, bags, and jackets). Coveted by fashion's most ferocious fans, they may seem a bit hard to wear. Those hunting big game for the first time can try it in small doses. Animal-print accessories (especially shoes and bags) are timeless and look great worn with black, red, or cream. If you want to keep your animal magnetism a secret from everyone but your nearest and dearest, try a leopard-print bra and panties (look what it did for Mrs. Robinson). • For the photo shoot with Kathy Kinney, we reversed her coat to show the fabulous leopard print lining. (A surefire way to update a classic coat: buy some fun faux fur animal-print fabric and have a new lining sewn in. You'll look and feel glamorous as soon as you slip it on.) Coats are one of the best ways to wear animal prints, especially in one of the new faux furs. If you want to wear an animal-print dress, they look best in somewhat sheer, lightweight fabrics like chiffon. You might be surprised at how often you'll want to wear an animal-print blouse that can liven up a staid black suit or give an even hotter edge to a short fitted leather skirt. • Jada Pinkett's vivacious personality and terrific sense of style make her a natural to carry off the completely over-the-top Gucci zebra-print bikini top and hip huggers. So just go for it—you animal!

Animal

Print

Hats

Hats can be your crowning glory. Princess Diana single-handedly revived the British millinery business when she began wearing hats during her many public appearances. Hollywood has long had a love affair with hats. No one wore a fedora with more panache than Humphrey Bogart. Doris Day and Audrey Hepburn (along with Jackie Kennedy) made pillbox hats the chicest look of the sixties. • These days, head-turning looks in hats are funky and relaxed—but as stylish as ever. Baseball caps are worn by everyone from LL Cool J to Michelle Pfeiffer. They come in every fabric and every color and are the easiest and best solution to bad hair days. Another Hollywood favorite is the Kangol beret. I fell in love with them thanks to my dad, who wears them when he plays golf. One great look I really like right now is the wrap. Singer Erykah Badu wears tribal wraps in stunning batik prints beautifully. It's very interesting and hip. • And of course, if you want to feel like royalty for a day get yourself a crown. I was at a flea market with my friend Kathryn when she bought this incredible crown and I begged her to give it to me. I kept it for a long time, carting it from shoot to shoot, waiting for the right moment and the right person. When I worked with Johnny Depp on a *Premiere* cover, I knew I had found it. His aura and his energy just felt *right*. When he put on the crown, I just knew everything would come together. At that moment, he was crowned prince of Hollywood.

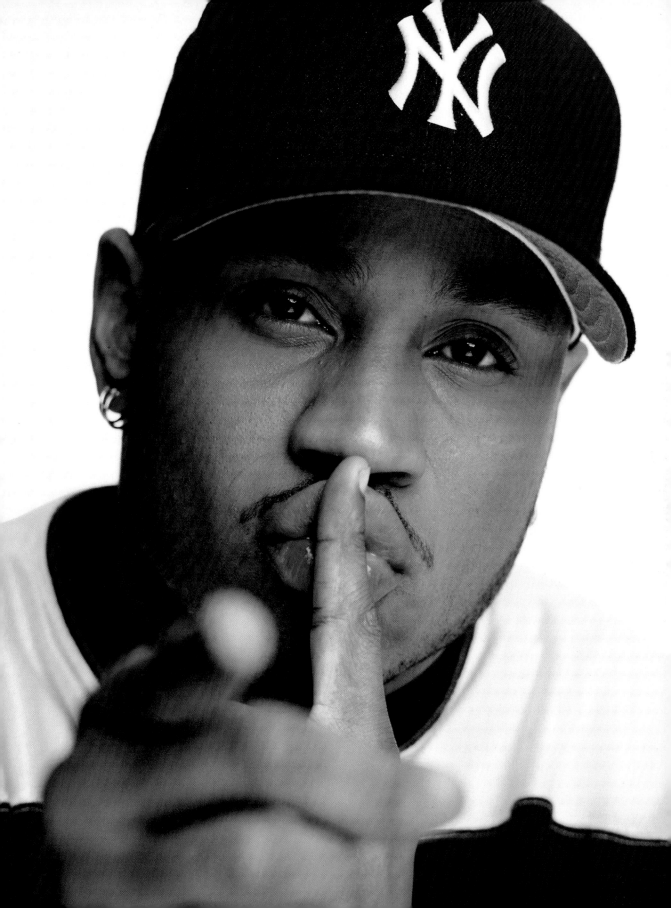

Put on a garden print and you'll feel yourself bloom. There's something very Doris Day about them. The best ones are feminine and fresh and remind me of antique wallpaper prints. The use of color can be what makes or breaks the floral and fruit patterns. I prefer them to be natural or antique or even like a beautiful watercolor painting. European designers like Alberta Ferretti, Anna Molinari, and Dolce & Gabbana are famous for theirs. The Dolce & Gabbana cherry-print dress showed up all over Hollywood before it even hit the stores. Even though it was a very distinctive dress, every actress who wore it looked different in it. Rita Wilson told me how fun she thought the pattern was. Isabella Rossellini really made the look her own when she wore it to the Golden Globes with lots of coral jewelry. These women are two great examples of how to take fashion and make it your own. They both have defined personal style. • People notice you in garden prints (so be careful when and where you wear them). And because they're so eye-catching, you can't wear them too often without people remembering when they saw them last—if you care about that sort of thing. The good news is they usually stand on their own—no accessories are needed—unless you want to have a kind of bohemian, hippie look. Find long skirts or baggy pajama pants, mix them with cut-off tank tops or camisoles, throw in some lace, a little Mideastern–style jewelry, and you've got the look. Some of my favorite garden prints are reminiscent of the sixties and have that *Laugh-In*, *Dating Game* kind of feel, they really pop and are fun to wear. • When it comes to garden prints, here's my best advice: If you're not sure about the print pass it up. Another one that's right for you is sure to spring up somewhere.

Floral

Lilly Pulitzer, whose designs blossomed in the sixties with the preppy set, made wild floral prints fashionable among Palm Beach society. The stylish women who wore them included the nation's First Lady, Jackie Kennedy.

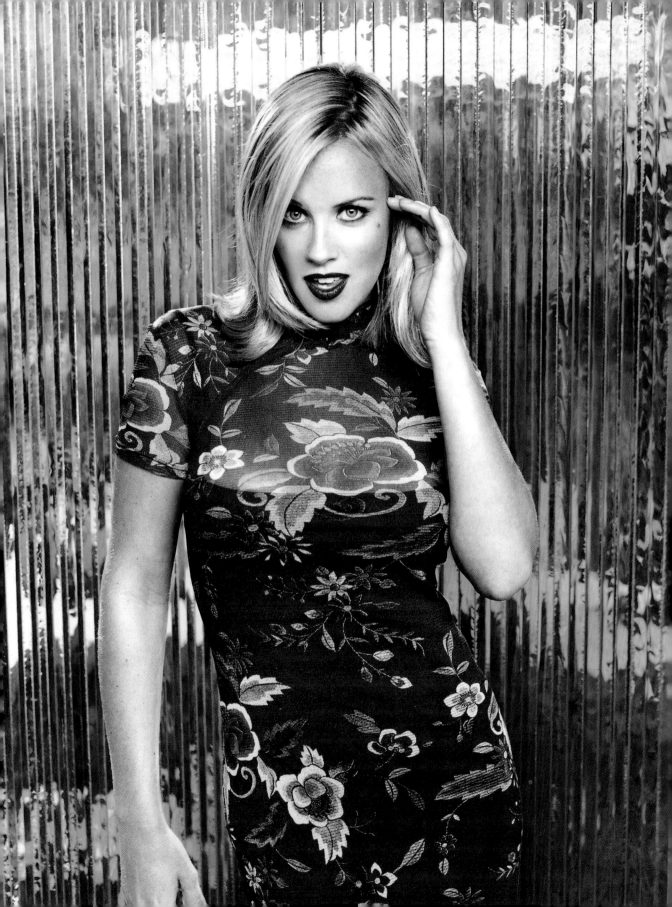

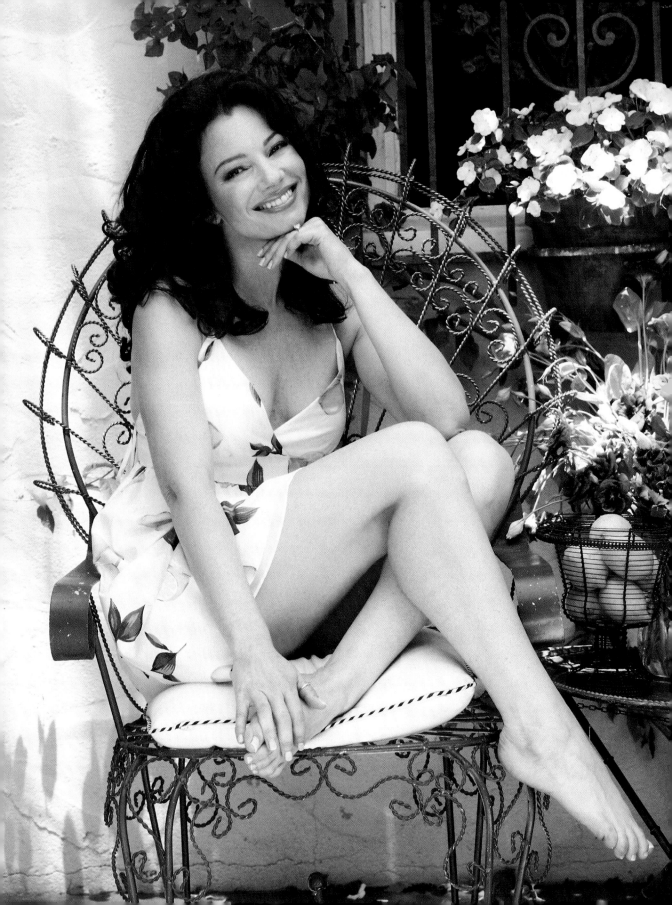

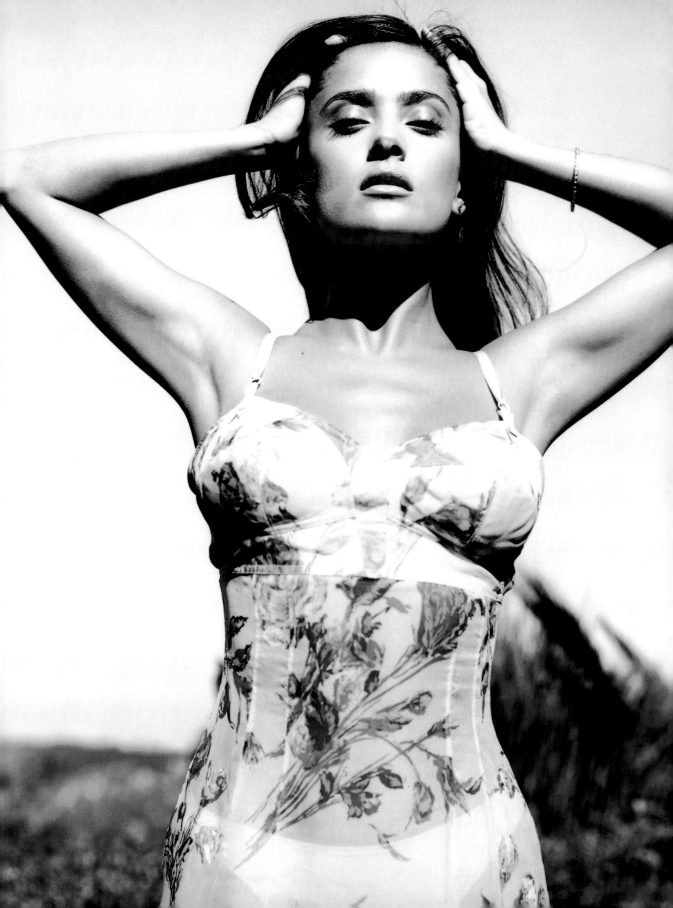

tank Top

There's something very sexy about the tank top. On men (like Jimmy Smits), they're really masculine and earthy. Maybe that's because so many of Hollywood's working-class heroes like Marlon Brando in *On the Waterfront* and Sylvester Stallone in *Rocky* did some of their most memorable work on-screen while wearing a tank top. On women (toned arms only need apply), a tank top can look very playful when skinny, meant-to-be-seen bra straps are peeking out on the sides. (A look sure to set many hearts aflutter is a lacy black bra underneath a basic white tank.) It can also be a purely innocent look when worn with a pretty little floral print skirt. From the timeless racerback white cotton tank to the pastel spaghetti strap tank to a metallic knit camisole—tanks have never seen so much exposure. When the mercury rises, throw a linen shirt or blazer over a tank top and you'll look perfectly presentable at the office or a restaurant. For urban appeal, pair a crisp tank with jeans and a leather jacket. • I live in tank tops. The biggest thing to happen to tank tops in years is the basketball tank. They have a massive urban street style and the most popular ones feature NBA players' numbers and names. I love the ones by Nike and Ralph Lauren, but you can pick them up at your neighborhood army-navy store or any Kmart or Wal-Mart. Everyone from Fruit of the Loom to Sulka to Calvin Klein to Dolce & Gabbana makes tank tops. Find the cut you like (the neckline and exposure you are comfortable with), and buy them in every color. When the heat is on, get those tank tops out of hibernation.

As Marilyn Monroe wrote to Grace Kelly on the eve of her wedding to Prince Rainier, "Every star deserves their right to sparkle." Wearing a beaded dress, jacket, or top (but definitely *not* all at once) is a sure way to shine. The flashes of brilliance that come from bugle beads, paillettes, rhinestones, sequins, and cracked-ice beading have replaced monastic minimalism in Hollywood. These days, when it comes to award shows and high-profile premieres, actresses are opting for dresses that are bedecked with beads. • Beading has long been a mainstay of many designer collections. Giorgio Armani has built a fashion empire on his elegantly beaded sportswear and dresses. Mark Badgley and James Mischka are one of Hollywood's favorite designing duos, because their camera-catching beaded numbers always look fabulous walking down the red carpet. And who could ever forget what Cher and Bob Mackie did for beading at the Oscars in the seventies (maybe some people would like to, but it's part of Hollywood fashion history). • Keep one thing in mind when wearing beading: Less is definitely more. The very best beaded looks stand perfectly well on their own, so leave everything else—except a great pair of diamond earrings—at home. And if you don't have the bravado to saunter into your sister-in-law's wedding in a beaded dress, try wearing beading other ways. I love to add one great beaded piece to a look—a sequined tank worn with a pinstriped suit. Try a satin jacket with beaded pants or a chiffon dress like Cameron Diaz's with delicate bunches of cracked-ice beading. You'll have to do some experimenting to see what looks and feels best on you. Some of the most beautiful beaded clothing can be found in vintage stores (or, if your grandmother shares your passion, why not raid the attic?).

Beads

The lavishly beaded dresses so popular in the films of the thirties were handmade in the costume departments of movie studios. Beaders took from six to eight weeks on one fully bugle-beaded gown, which could weigh twenty or twenty-five pounds when completed.

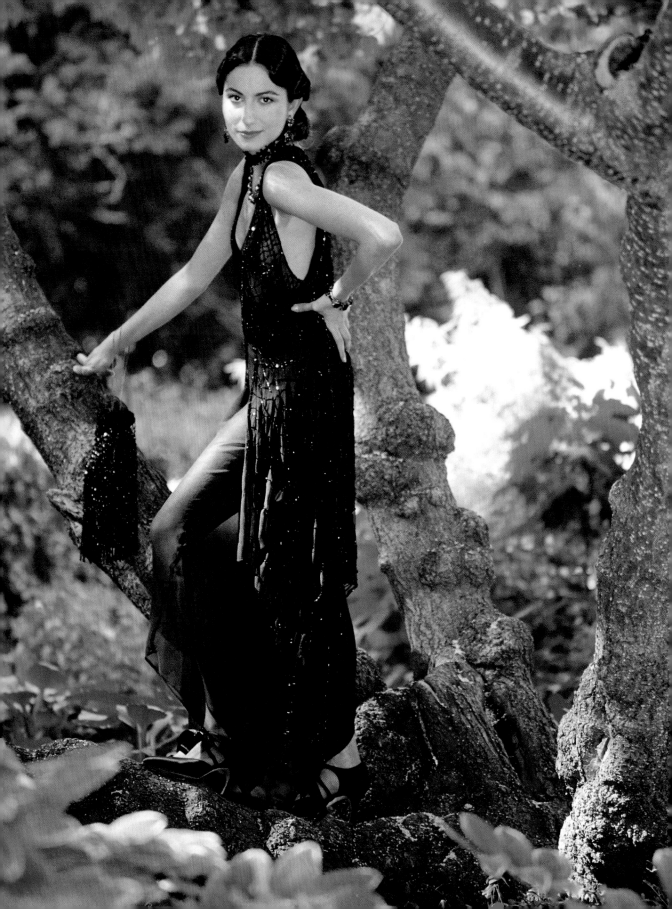

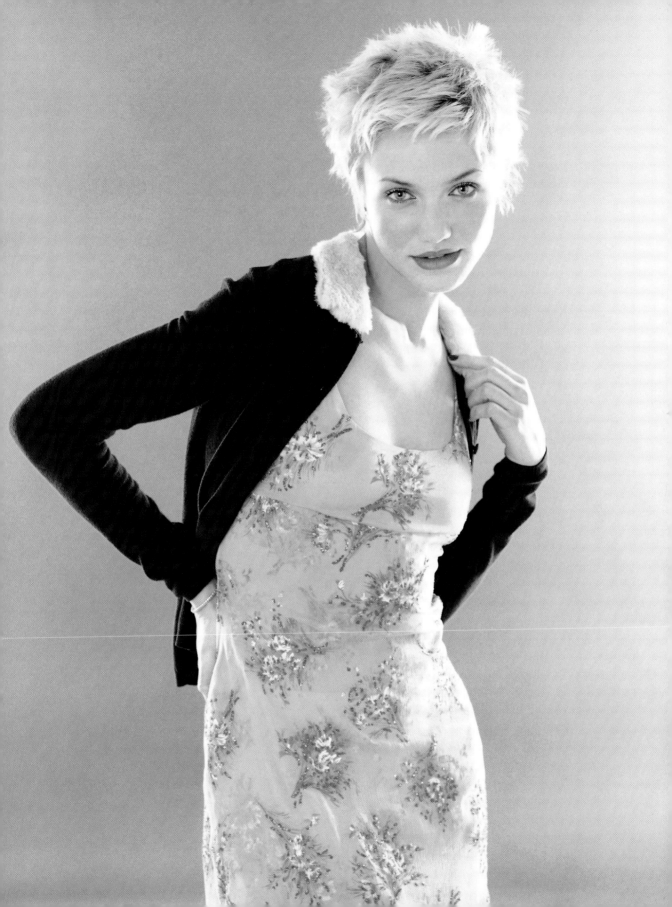

Okay, it's not easy to wear sheer, but it's not impossible. First of all, you've got to be really careful how you wear it. With a little bit of effort, it can be a sexy look. Overdo it, and it can really look cheap. It's all a matter of how you put it together. Rule number one: A little mystery goes a long way. • If you're going to wear sheer, invest in some great lingerie that's meant to be seen. A pretty lacy slip worn under a chiffon dress can look delicately beautiful. Layering a sheer shirt over a funky bra is a decidedly confident, in-your-face look that is both feminine and modern. For those that don't dare to go that bare, a sheer blouse under a suit is a terrific way to try out the trend. • Since sheer isn't exactly a look you'll want to wear every day (I hope), you might want to decide how much you want to invest. There's a lot of skin-baring fun styles available that range from $20 to $250, but be warned: Inexpensive synthetics can be uncomfortable when the weather turns sticky. Remember, when it comes to sheer good taste the object is to scintillate not scandalize.

Fashion's love affair with sheer clothes began in 1968, when Yves Saint Laurent showed chiffon tops over bare skin.

sheer

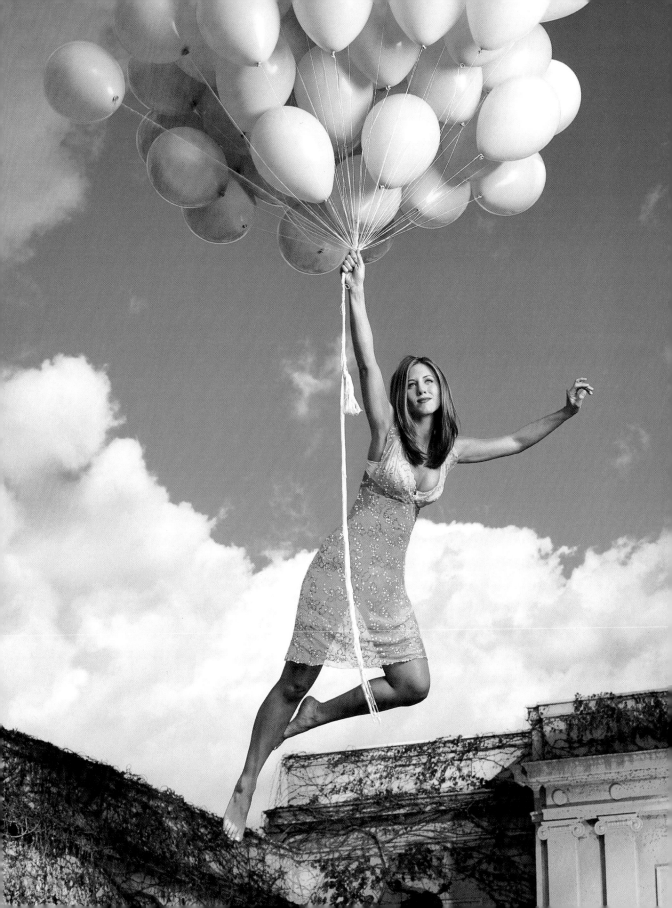

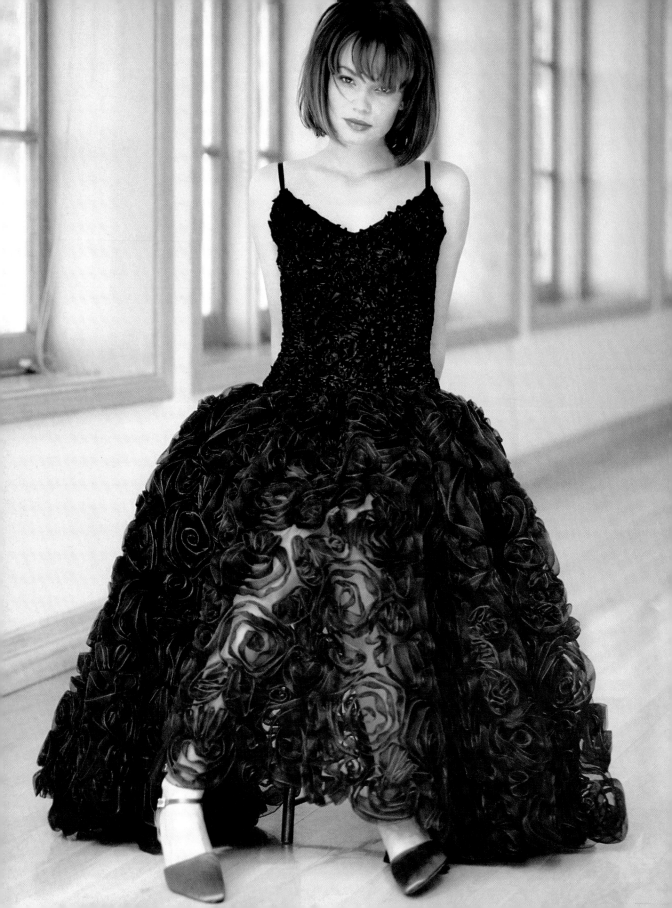

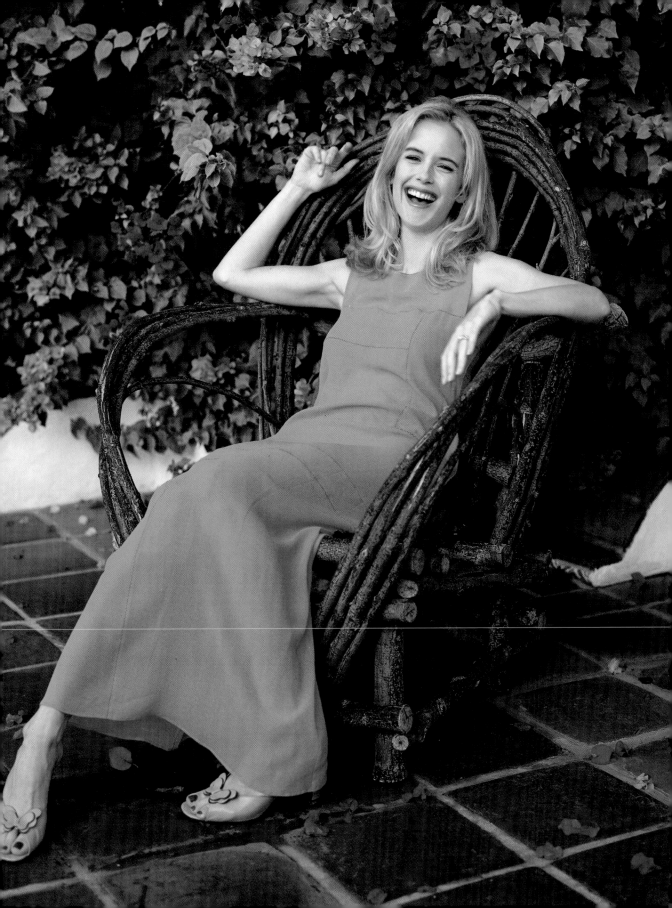

For the last several seasons, designers have decreed that the midriff is the new erogenous zone. From Donna Karan's strategically placed single button jackets to Gianni Versace, who gave us asymmetrical cutouts on many of his designs to reveal just enough of the midriff to be sexy, not cheap. Jordan Hill, Gwen Stefani, Fiona Apple, and a lot of the other rock-and-roll girls all love the look. It's a great way to push the fashion envelope. We pulled out all the stops (and the scissors) for Jada Pinkett, who revealed one of the fittest bodies in Hollywood at 1997's Academy Awards in her lime-green mesh Versace. (Belly chains are another way to accentuate the midriff that looks very sexy right now.) Lots of Hollywood actresses frequently bare their (nonexistent) bellies with halter tops, slinky camisoles, and tiny T-shirts, and I know I don't have to tell you that only those faithful to their fitness routine can carry this off. For a high voltage look recycle a bikini top or pretty designer bra and cover it with a little cardigan or vest for a look that is sure to thrill. It's become acceptable to have bra straps showing (the funkier the better) under a tank top. Jennifer Tilly's downtown diva look is one of my favorites at the moment. Sandra Bullock's revealing more than her superfit body—her completely original personality really shines through. It's a look best worn when you know you're going to be standing up—the tummy can do some peculiar things once you're seated. So take a chance and flex some fashion muscle, but dare to go bare at your own risk.

Carmen Miranda, the petite singer and dancer, wore midriff-baring styles and enormous turbans or basket-shaped headdresses—decorated with enough fruit to feed a family—that added inches to her tiny frame.

Midriff

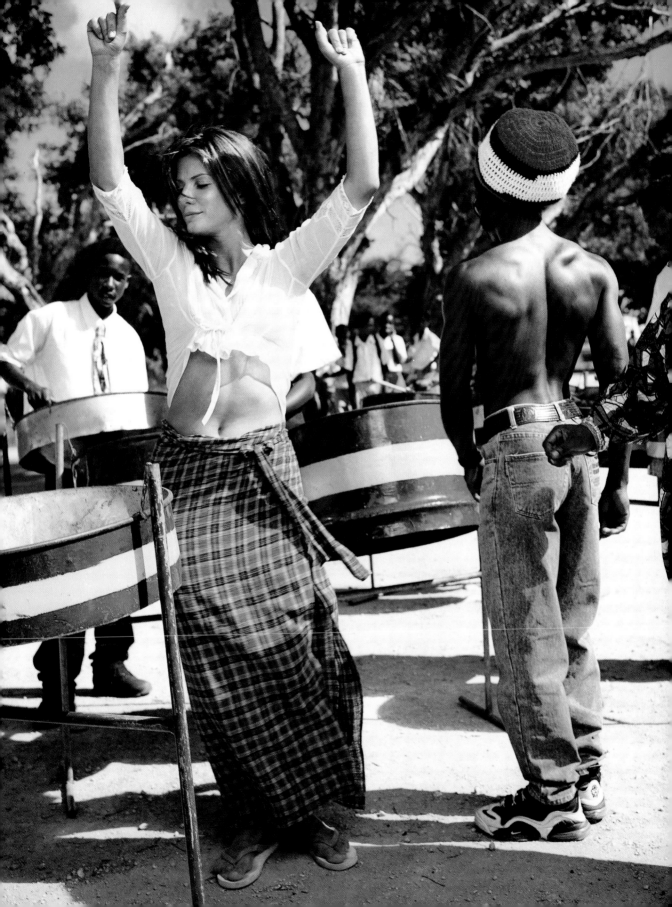

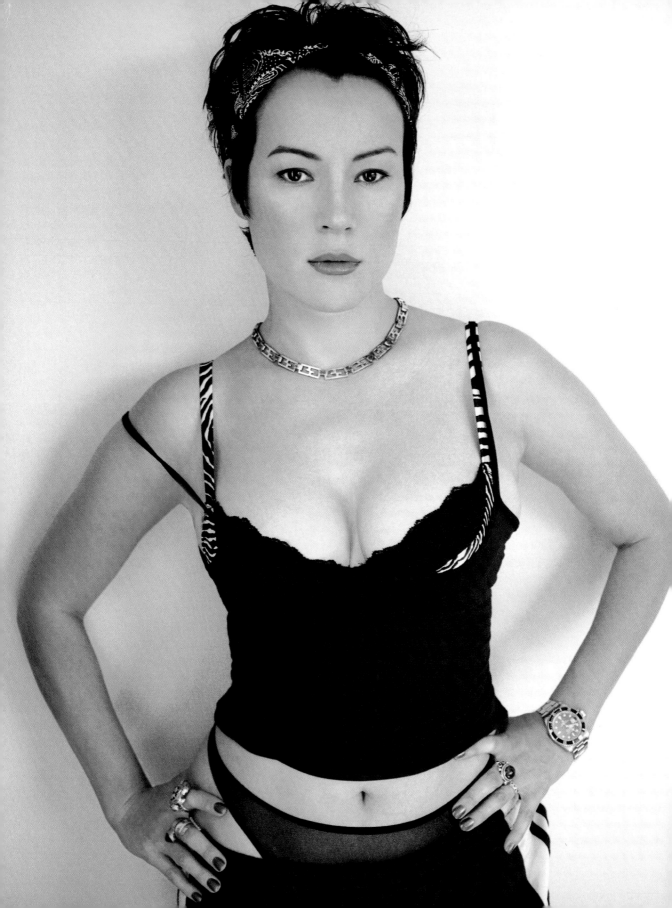

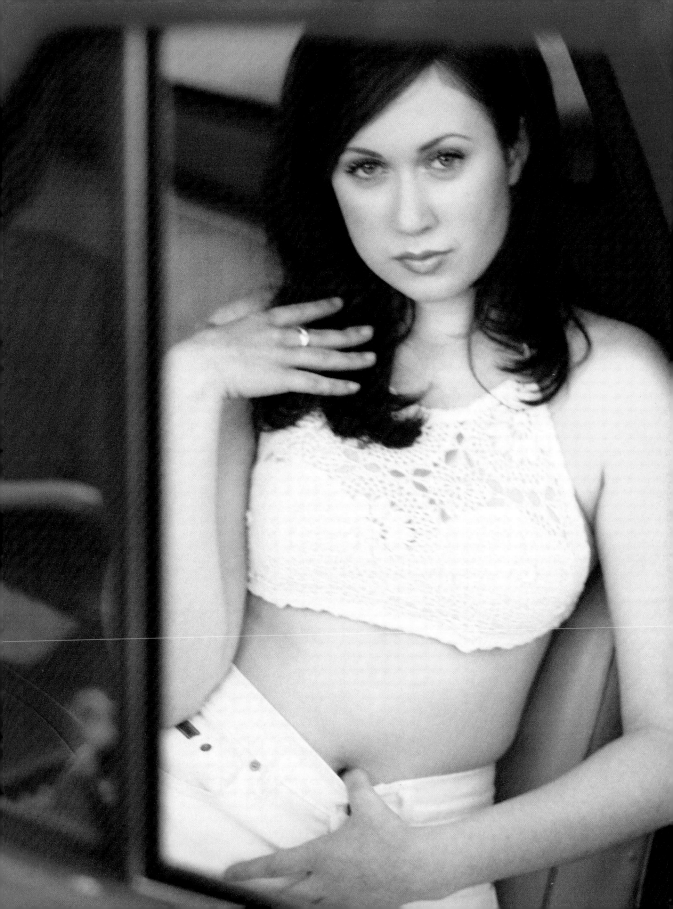

chinoiserie

Chinoiserie is a broad-based name for style reflecting a Chinese influence: beautiful embroidery, bold beading, intricate prints. A number of designers have helped popularize this look. John Galliano for Dior created the elegant chartreuse column of chinoiserie Nicole Kidman wore at the Academy Awards in 1997. Many actresses, including Sigourney Weaver, Claire Danes, and Winona Ryder, have worn some of the most recent chinoise-inspired designs by Miuccia Prada. Vivienne Tam is one of the newest designers to hit Hollywood's hot list who has always been tremendously inspired by chinoiserie. • I love the look because it's so exotic. It's a good fashion choice for women who want to create a look that's eye-catching, unexpected, and very chic. (If you're really feeling adventurous, wear your favorite chinoiserie pieces with gloves and a tiara.) You don't have to wear head-to-toe chinoiserie—try pairing a great top with a pair of sleek black pants or chinoiserie vest like the one Jennifer Beals is wearing with a skirt. Some women, like Patricia Arquette, whose beauty and style is so uniquely her own, can look fabulous in a Suzie Wong–inspired dress. It's a look that can also work for men. It certainly does for Samuel L. Jackson in his mandarin-collared Donna Karan jacket. (Donna, a master, has taken this collar treatment, which is older than the Great Wall of China, and made it mainstream for the nineties.) Experiment by trying on pieces in vintage shops, or visit Chinatown and pick up a pair of pajamas or a robe. Have fun with it.

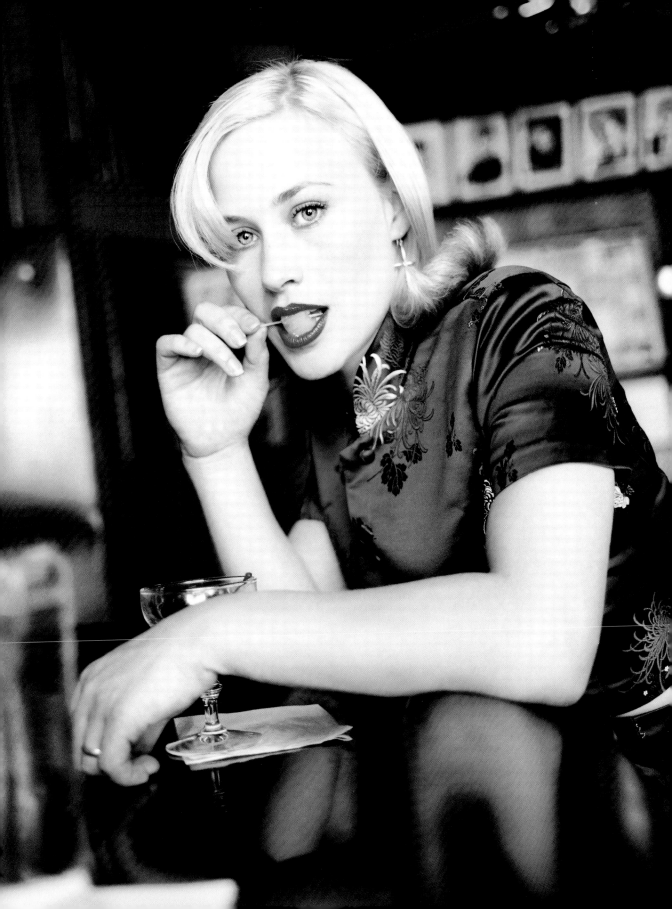

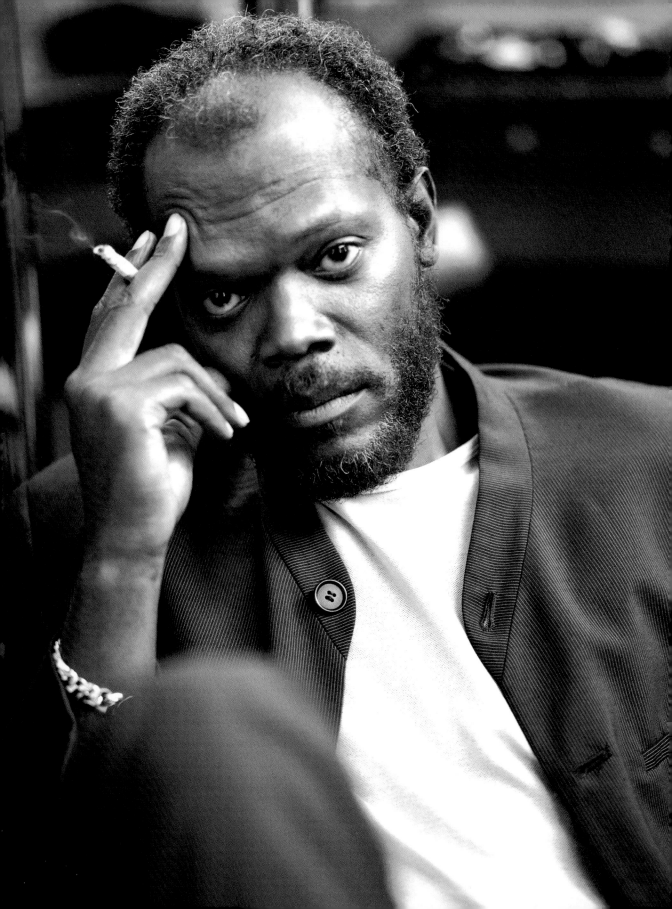

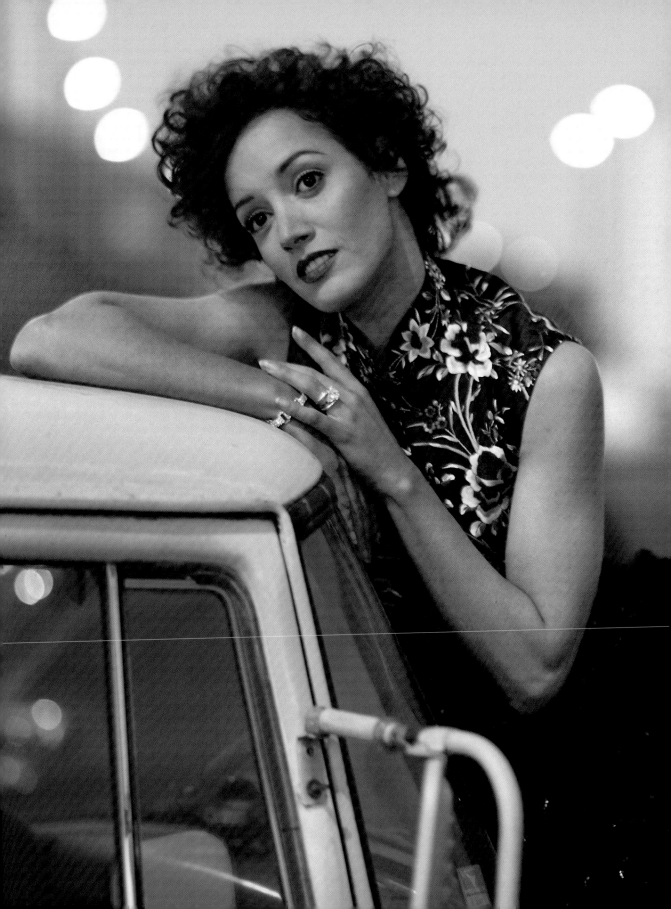

If you want to stay in step with the times, you've got to have great shoes. They're truly an essential element of style. They can make you feel taller, sexier, and more athletic. They can also make you feel mighty uncomfortable—all in the name of fashion. Some women believe you can never have too many shoes, and they stockpile their favorites so they'll always have the perfect shoe for the perfect dress. • To keep a leg up on the latest styles and stay on solid ground, my advice is to spend your money on classics in the finest leathers that you'll wear again and again (every woman needs one absolutely beautiful pair of black pumps). You can skimp a bit on the trendiest shoes—most times the most extreme styles seem dated after one or two seasons. Shoes have always been an important part of any look, and in recent years there have been more great styles to choose from than ever before. Shoes are a great place to add a bit of creativity to your look; try them in a wild animal print or sophisticated beaded style. Chunky platforms, breezy sandals, seductive stilettos, siren-y mules, classic loafers, funky boots, and the all-American sneaker can all have a place in your wardrobe. • A pair of rough and rugged boots can be worn as protection against the elements, but in LA they're worn for style. Diego Della Valle makes exquisitely feminine shoes that are a hands-down favorite among Hollywood's most well-heeled actresses. The same company makes the equally stylish and chic J.P. Tod's driving moccasin worn by everyone from John Travolta to Elle Macpherson. I also love Patrick Cox's quirky styles—he does some fabulous classics with a twist. Kenneth Cole is a great place to shop if you're looking for the latest styles that won't break the bank. • Nancy Sinatra said it best: "These boots were made for walking."

Shoes

Ferragamo used steel spikes in 1952 to lift the shoes as high as five inches—and the stiletto was born.

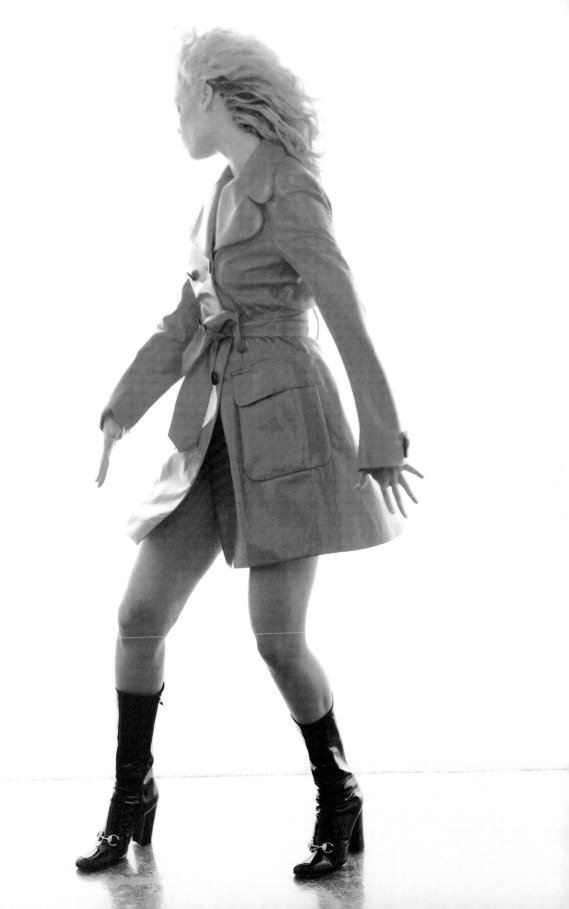

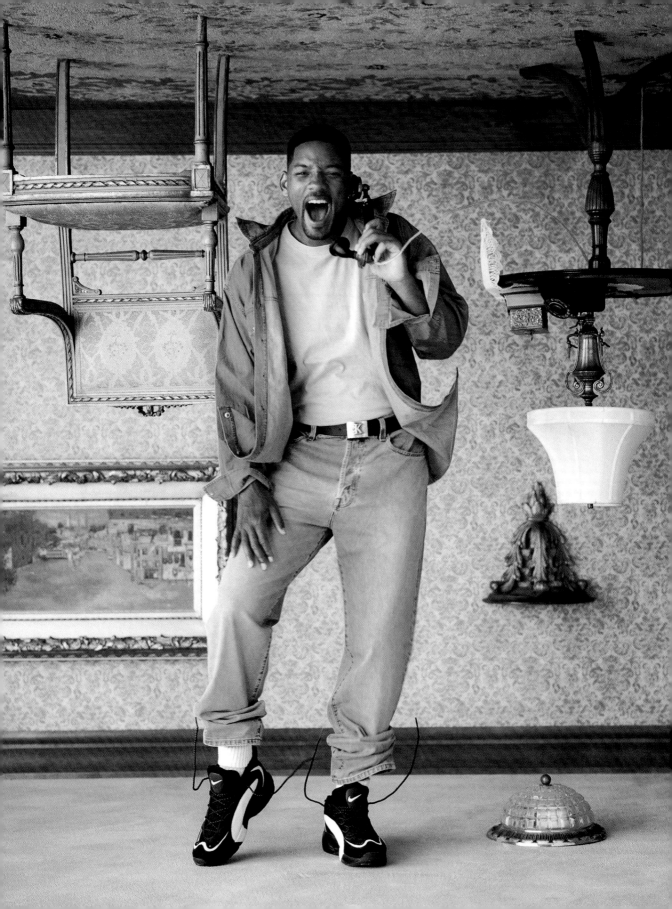

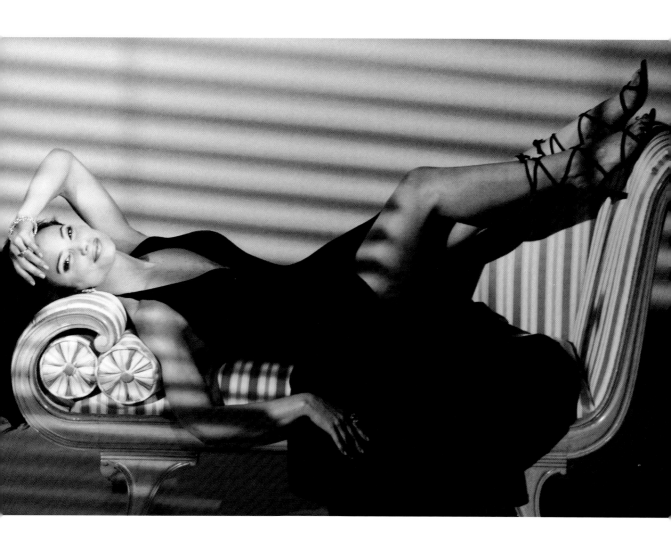

Let's face it, no one looks better in a tuxedo than James Bond. But that doesn't mean the rest of us should stop trying. Men have a lot of options these days—double or single breasted, two- or three-button styles. The idea is to find the one that feels and looks the best on you. For those of us who want to get a little creative, there's always the vest; find one in a great color, an interesting texture, or a fun pattern. Another way men can personalize a tuxedo is with a great shirt. It doesn't have to be the Lounge Singer of the Seventies look (but then again, what is old is new again). In Hollywood, lots of actors are also wearing a traditional shirt and tie in the same color, a look Richard Tyler has perfected in satin—he loves white on white with a tuxedo. If you're feeling particularly adventurous, try a velvet tux. Just make sure you've got the right decade, because when fashion recycles a trend, something always changes slightly. You don't want to be mistaken for a member of the Partridge Family. • Tuxedos aren't just for men. With menswear-inspired tailoring all over the runways these days, womenswear designers have reinvented, redesigned, and rethought the tuxedo. Sometimes it's simply a matter of taking an element from a classic tux and adding a twist. A tuxedo vest with nothing underneath is a very sexy look on women. If you've got great legs, consider a tuxedo-inspired mini coatdress (that could even be just the altered jacket from your husband or boyfriend's tux). Wide-legged tuxedo pants with an elegant pair of high heels are perfect for strutting into an important cocktail party. The tuxedo may be a look borrowed from the boys, but women are making it their own.

The name tuxedo, for a man's formal suit, arose from the wearing of this new style of jacket in Tuxedo Park, a wealthy and fashionable country club suburb of New York City.

Tuxedo

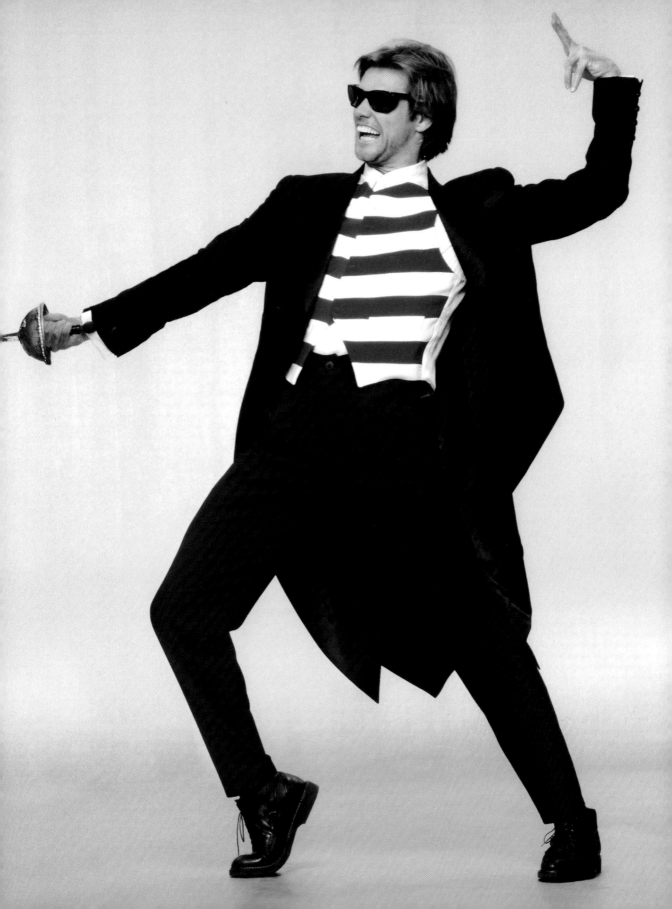

If the only thing you think of when you think of sequins is Las Vegas showgirls, think again. Designers like Valentino, Isaac Mizrahi, and Donna Karan have created absolutely breathtaking styles using sequins that are literally jewelry for the body. When you wear sequins, you are making a statement—they have a life all their own. I love black sequins. The way they reflect the light reminds me of the way the water of the Hudson River shimmers at sunset—it's one of the most beautiful sights there is. • Sequins are a great way to dress up a suit. Just add some to the lapels and the cuffs, and you've got the perfect outfit for an evening black-tie affair. Or wear a sequin wrap or scarf with your little black dress. You don't have to spend a fortune on a fancy designer label, either. Most good fabric stores sell panels of sequins—just take the dress to your tailor and have the edges finished. Here's another great way to add some sizzle with sequins: Buy a piece of stretchy fabric adorned with sequins and have a seam sewn up the back for a tube top that is perfectly dazzling under a jacket or with a short skirt. • Sure, sequins are an over-the-top look, but you owe it to yourself to feel simply fabulous. Do yourself a favor: The next time you're in a store, try on a sequined dress and see how you feel. You'll stand a bit taller, and you'll notice a slight sway to your walk. There now; I always knew you had it in you.

The word *sequin* is the French form of the Italian word *zecchino*, a Venetian gold coin.

sequins

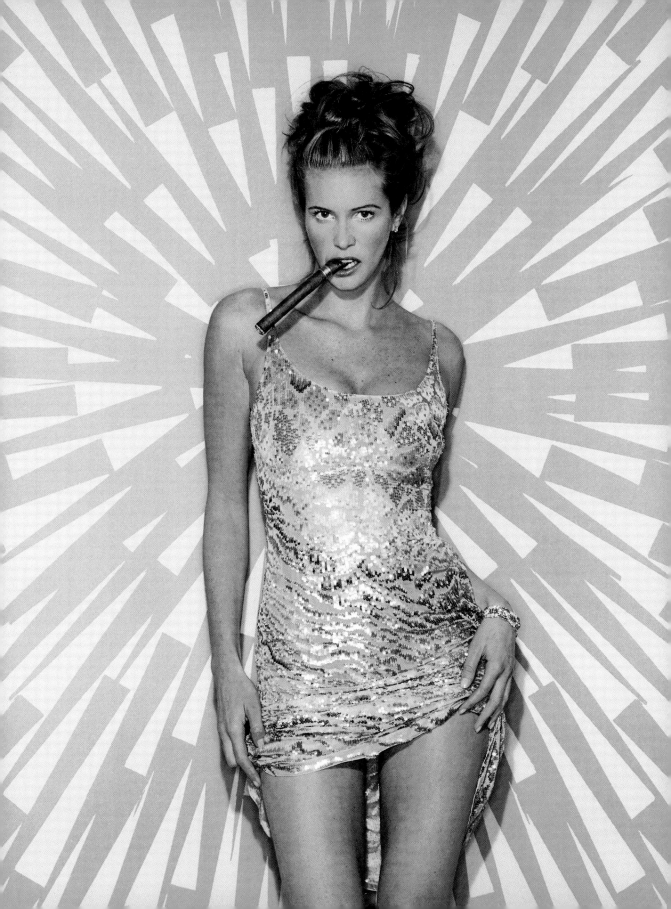

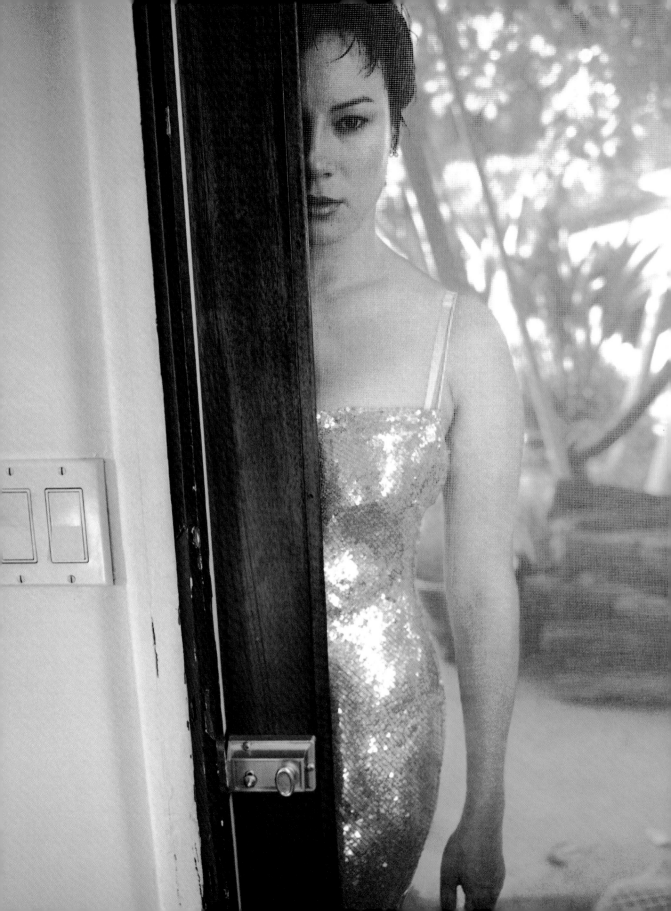

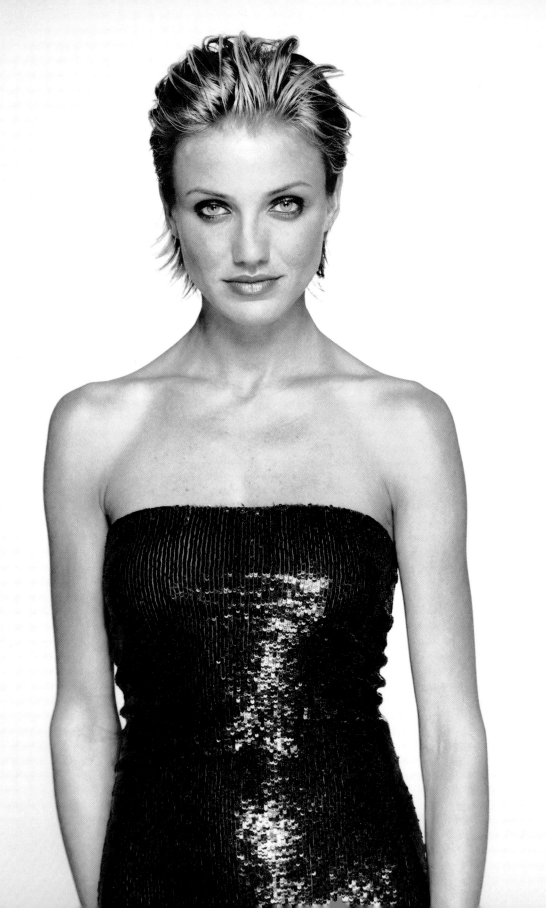

Lace can give you a wonderfully romantic look, but these days there are lots of lace pieces that can add a really hip touch to your wardrobe, too. Lace shirts are great for women—I love them thrown over a camisole, slip dress, or tank top. For years, most laces were as simple as black or white. But now you can buy lace in many beautiful colors, or make them move over when you show up in metallic lace. Lace pants with a nude lining or funky bikinis underneath are a really downtown look that sets you apart from the crowd. Sometimes touches of lace are enough, like trim on cuffs or collars. In my Aunt Rita's day it was wrong to have your slip dip below your hemline. But now it's the nineties and the look is very right. • Hollywood has hooked into crochet these days. Women love the crochet styles of Alberta Ferretti, Vivienne Tam, and once again Dolce & Gabbana. Crochet and lace are both very girl-next-door looks with equal parts of sugar and spice and everything nice.

Lace

In 1968, model Jean Shrimpton appeared in an ad wearing a beige Chantilly lace dress with a ruffled collar and cuffs, designed by Bill Blass. Public demand was so great that Maurice Retner Ltd. put the design into mass production.

Two hundred women were employed for eight months making the lace that covered Queen Victoria's wedding gown in 1840. Once the dress was finished, the designs were destroyed to prevent reproduction.

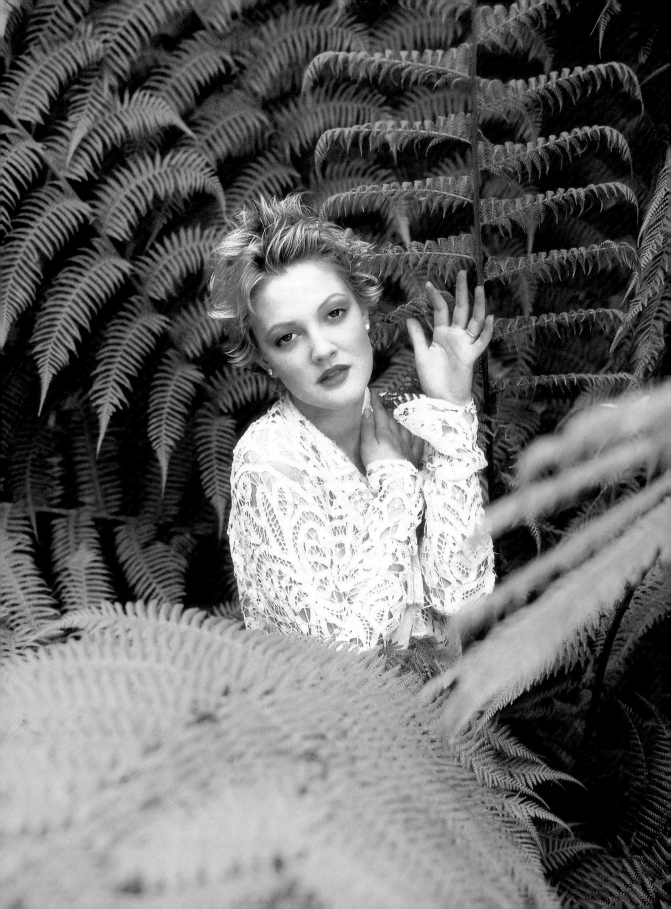

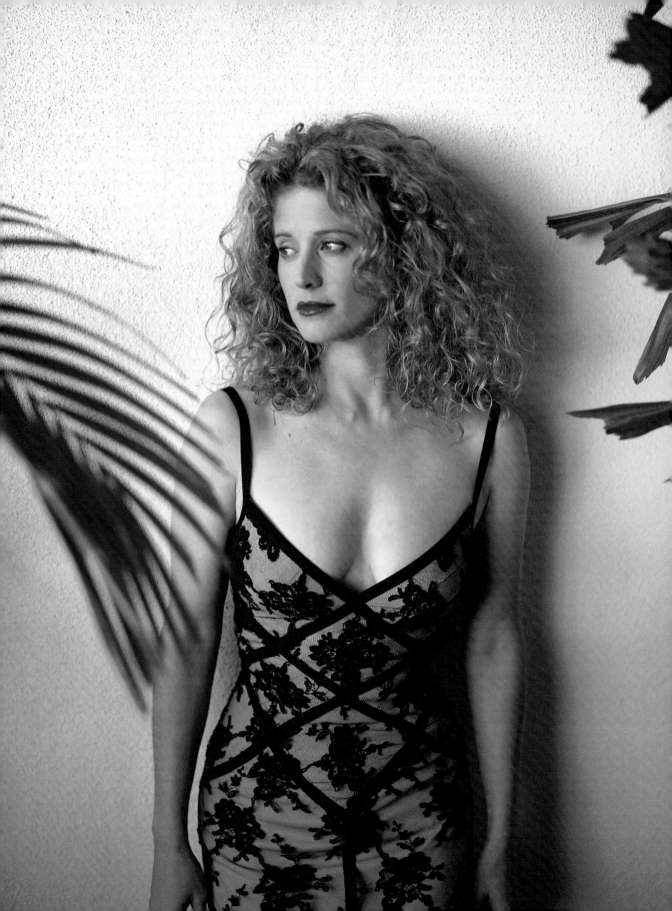

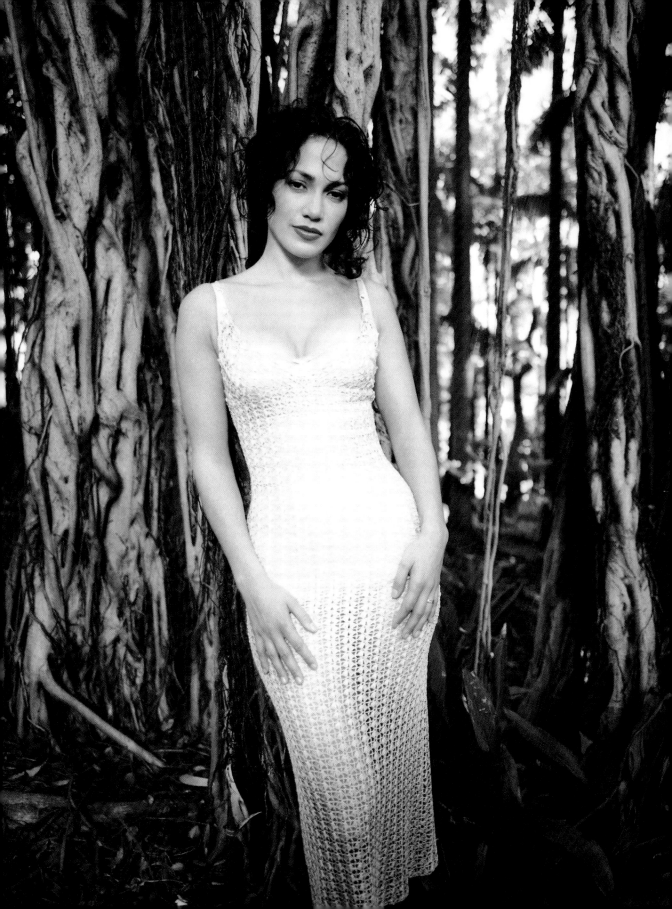

Metallics

Metallics have always been a Hollywood favorite. The world's grandest fashion show got its name from a little man dressed in gold. But even in Hollywood, all that glitters is not gold—there are also polished platinum and burnished bronze. Today it's not just about the lamé or mesh of the sixties and seventies—it's about all of that and more. • When you're going for all-out glamour, there's nothing that will make your star shine more than a metallic hued dress. Kim Delaney is positively luminous in her gold matte silk shantung Pamela Dennis dress and Jodie Foster causes sparks in her chinoiserie-inspired tank top and pants. For men, a fifties-inspired sharkskin suit is a funky choice for stepping out on the town. Sequins are another way to wear metallics (just remember to keep the silhouette simple). When you're dressed in head-to-toe gold or platinum, your outfit will be eye-catching enough. Also, one metallic piece at a time mixed with solid colors is a guaranteed blockbuster—just think of copper with brown, black, or purple. Push platinum with white, black, or pastels. And go for the gold with jewel tones, like ruby and emerald. • Use metallics to punch up otherwise blasé accessories. A fashion classic for years in the Hamptons, Florida, and Greece have been strappy gold sandals with a white dress in the summer. (Tom Ford loves this look for Gucci, as does Alexander McQueen for Givenchy.) And when you tire of carrying a black evening bag and white isn't right, try platinum or gold for something different. Or sling a woven straw bag awash in metallic color over your shoulder for a cool and casual daytime tote. Go for the shine.

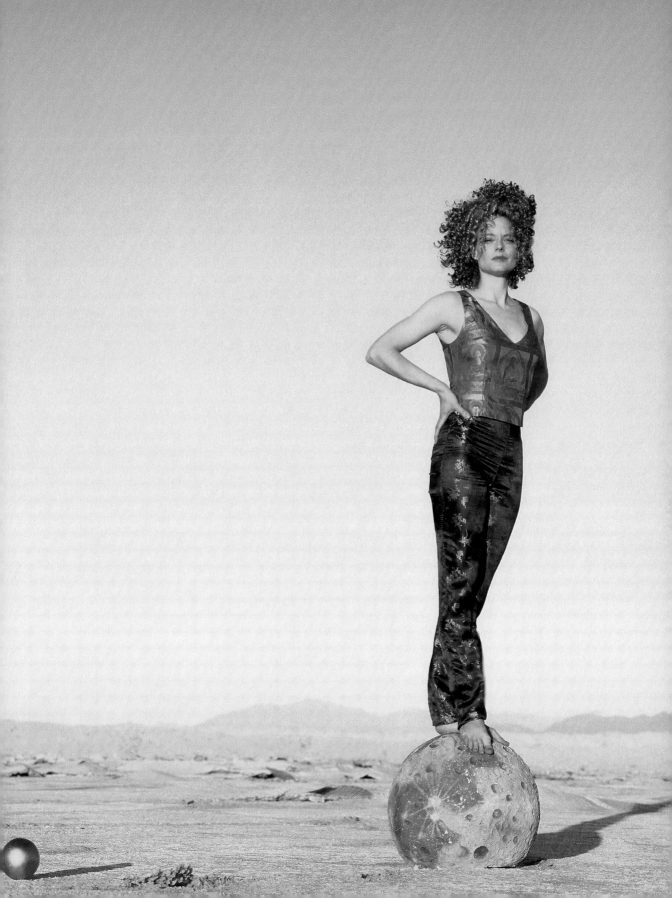

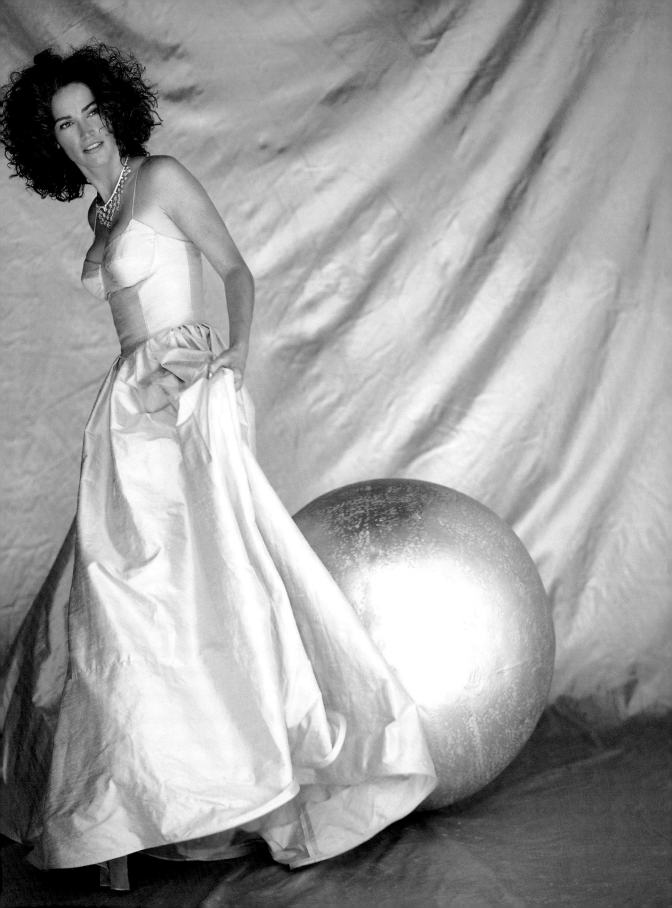

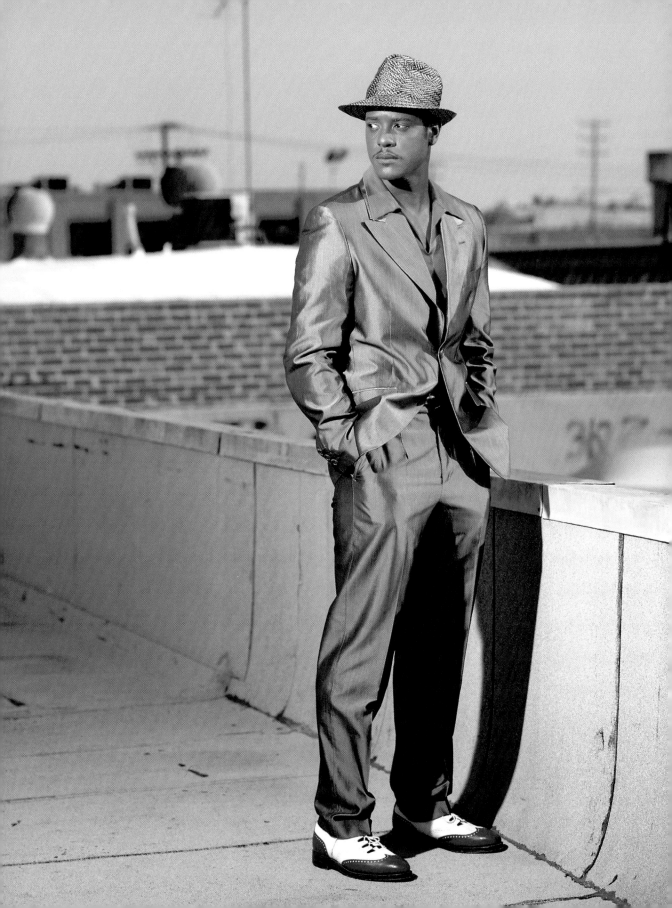

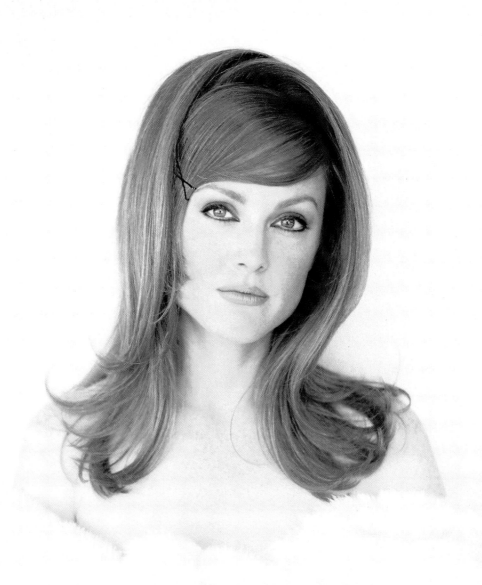

Amidst all the controversy over wearing real fur, Hollywood has definitely decided that faking it is in. Designers like Dolce & Gabbana have done great things with faux fur—trimming the collars and cuffs of coats and sweaters with great-looking fakes. With the state-of-the-art technology that's being used to manufacture faux furs, it's nearly impossible to tell what's real and what's not (these days, most actresses will most definitely be wearing faux fur).

• Aside from being politically correct, faux fur is a very affordable way to dress very glamorously. A sure way to dress to impress is to throw a faux fur stole over any simple dress. For a really sophisticated, urbane look, throw it over a cashmere turtleneck and jeans. Color is the word in faux fur today, so if you're feeling a bit bold, go for the orange wrap or electric-blue coat. A faux fur skirt can be lots of fun (look for eye-catching ones in leopard and pony prints). But do be careful. To avoid looking like Wilma or Betty, choose one with a shorter pile that won't add width to your hips. • Some other great ways to wear faux fur: Take an old suit and shorten the sleeves to three-quarter length and add faux fur to the cuff for a real fifties-inspired look. Or have your tailor make a detachable fur collar that will instantly dress up a black cardigan. If you really want to surround yourself in fabulous faux fur, have a spread made for the bed or cover an old chair. Just remember—faking it has never been more fun than with faux fur.

Many of the earliest "fun furs" were worn by London's young trendsetters in the sixties. The hipsters favored the fakes over the status hides worn by the rich.

Faux Fur

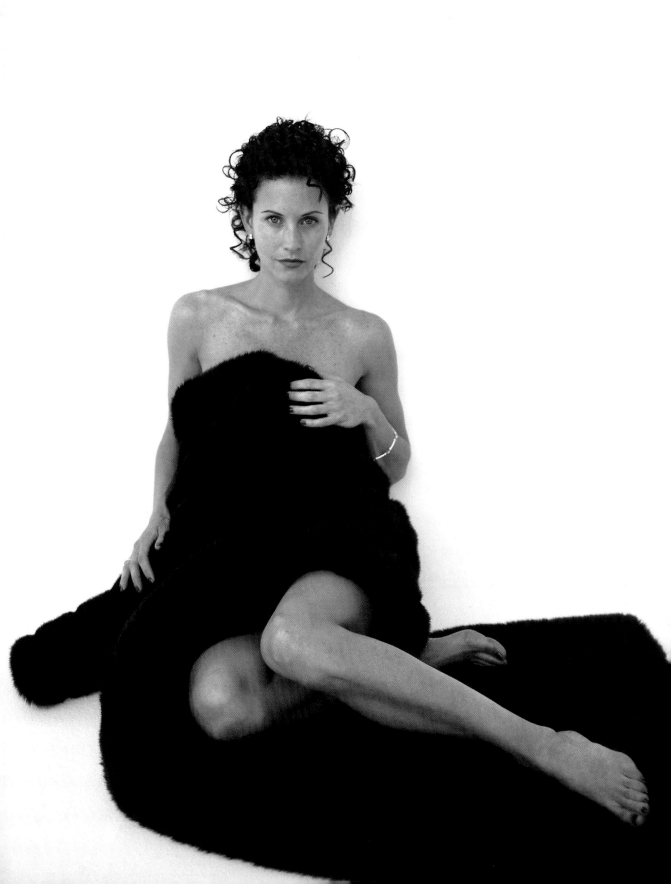

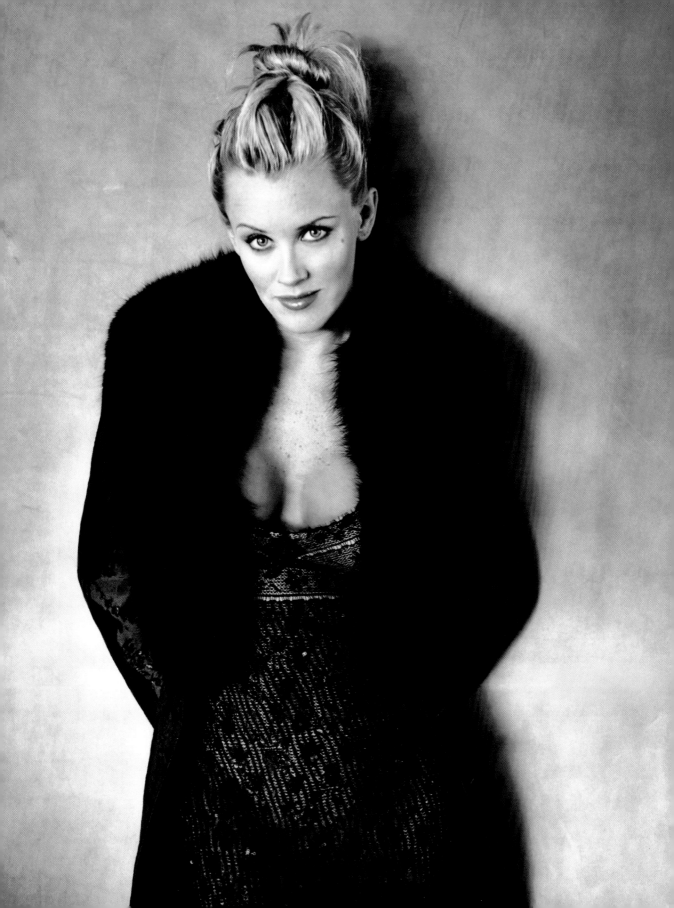

It's in. It's safe. It's slimming (but it's not camouflage). It hides a multitude of sins. Black is the preferred color of choice of fashion editors, actors, and models and an absolute essential in every wardrobe. Any woman on the path to chicness needs a great little black dress (think Audrey Hepburn in *Breakfast at Tiffany's)*. Invest in a classically tailored black suit and wear it to the office, wear it to a cocktail party (add stiletto heels), wear it to a romantic dinner (add a lace camisole)—just wear it. • Black is seasonless. In the fall, match a pair of classic black wide-leg trousers with a skinny top for an afternoon jaunt through the park. In the winter, heat up a Heidi Weisel cashmere cardigan with a black leather skirt for a round of holiday parties. In the spring, pair a cotton mock turtleneck from the Gap (you can even wear it to the Oscars, à la Sharon Stone) with jeans for a pulled-together casual look. Even in the summer, you can sex it up with a black slip dress against tanned skin (or flawlessly pale skin for those of you who shun the sun). Black is a classic yet sensual color for lingerie or lingerie-inspired looks. A fresh way to wear black is to hit it with another strong color—just look how Courtney B. Vance catches your eye in black pants and shirt and a stark white leather jacket from DKNY. For a more subtle color mix I love navy and gray with black (yes, you can wear navy and black together). • Wearing black from head to toe is anything but mundane. Layer different fabrics for contrast, like a woolly sweater with satin pants, or a fitted velvet top with a long sheer skirt. That old black magic is where it's at.

Rita Hayworth wore a Jean-Louis black satin gown in the 1946 film *Gilda*. It became an integral part of Hayworth's character as she danced to "Put the Blame on Mame, Boys." Years later, Demi Moore wore the same gown to the opening of the Beverly Hills Planet Hollywood restaurant.

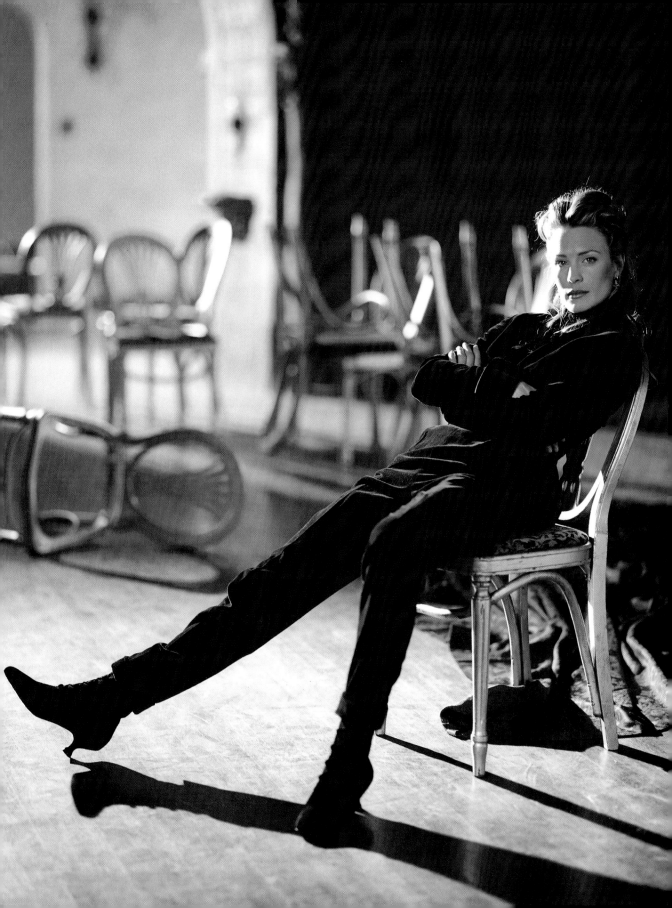

In Asian culture, red is used for wedding dresses, since it is not only [...]
off demons, but was worn as the color of royalty and aristocracy during th[...]

Red

Minnelli red. Reagan red (remember those Adolfo suits?). Drop-dead red[...]
color of divas everywhere (Faye Dunaway always looks stunning, but she[...]
'em dead in red), red is not for the fashion faint-of-heart. Paloma Picas[...]
lipstick has become her trademark. Valentino is widely known for many [...]
lar red dresses he has sent down the runway (the man knows a thing or [...]
ing to thrill). In a killer red dress, you'll speak volumes about your style [...]
word. It's monochromatic dressing at its most dazzling. • A clearly pass[...]
(look at the heat Salma Hayek generates in the red satin dress she wore[...]
photographed by Firooz Zahedi for *InStyle*'s "What's Sexy" issue), red i[...]
in anyone who wears it. I love how a red shirt looks under a black suit a[...]
orange worn together literally make someone look as if they're on fire. [...]
extremely elegant when it's paired with a rich chocolate brown or navy. [...]
it's a fabulous color for accessories. A great pair of red shoes, gloves, o[...]
bag can add impact to any outfit. • If you want to leave people with a l[...]
sion, wear red. I'll never forget the fabulous red Givenchy coat Audrey [...]
Charade. (She loved it so much that she kept it after the film and litera[...]
She accessorized it with a fabulous animal-print hat—that outfit sent s[...]
into stores all over the country in hopes of emulating her smart, sleek s[...]

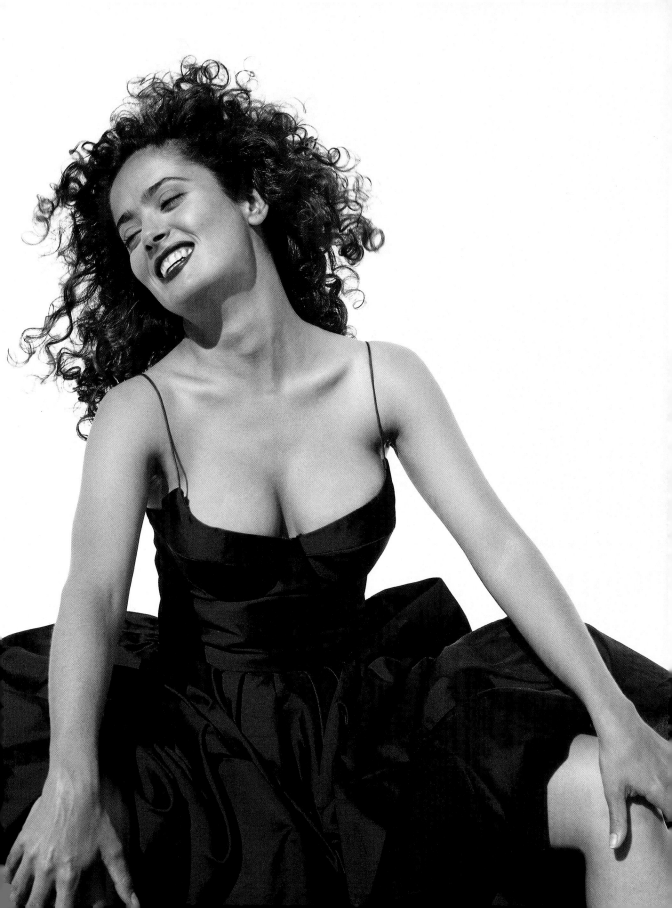

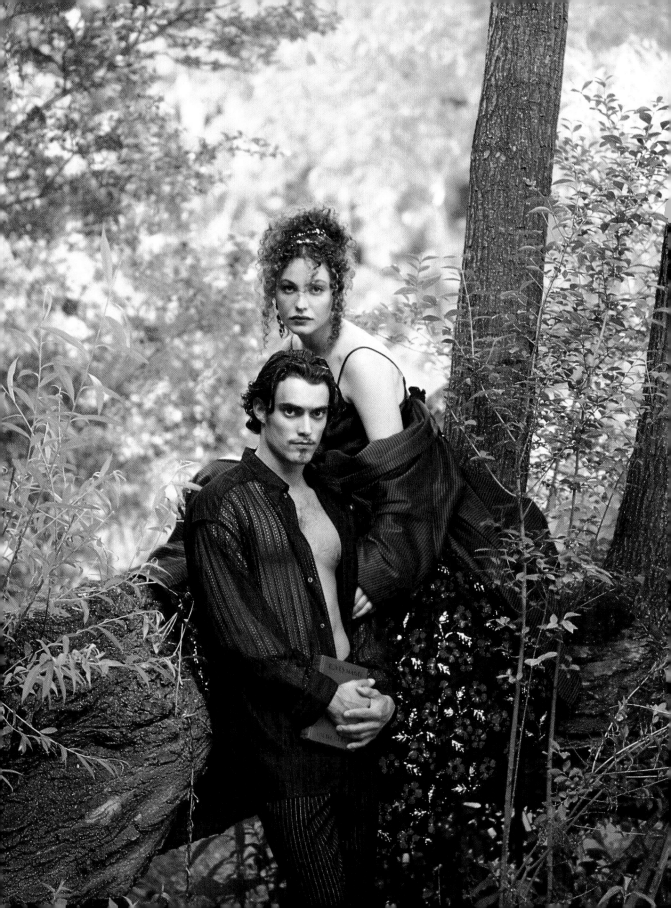

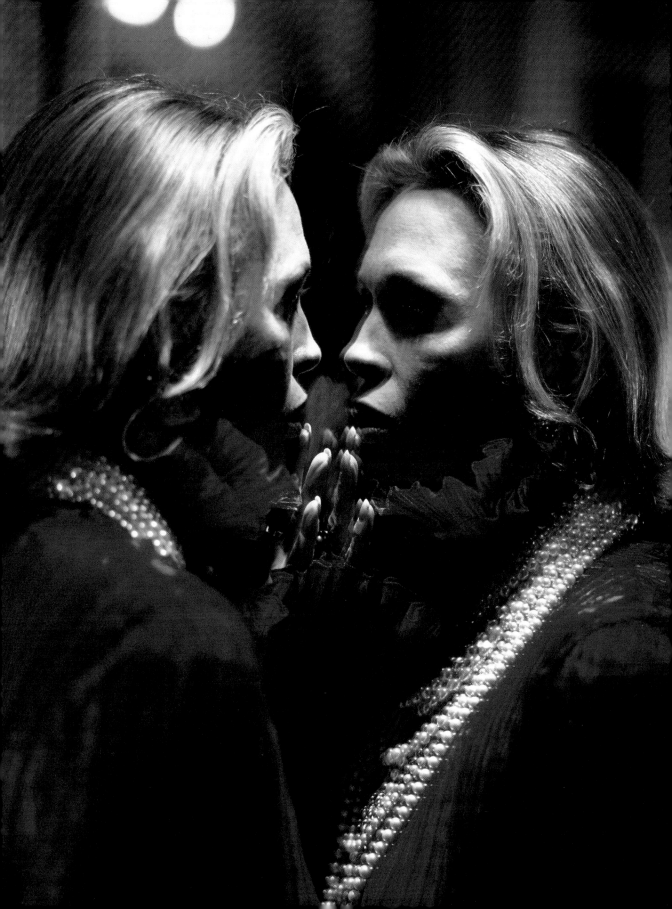

White is clean, crisp, and cool. Nothing looks as fresh as a great white shirt worn under a suit or with jeans. The white T-shirt, an American classic, is a wardrobe staple that can be bought anywhere from Giorgio Armani to the Gap. Buy your favorite in bunches. You can wear white with navy (think a navy blazer with white pants). A simple white strand of pearls adds just the right touch to a sweater twinset or a timeless sheath dress. If you want to feel perfectly dressed for a warm summer day, slip into a white linen suit. That outdated fashion axiom that says white should never be worn before Memorial Day or after Labor Day may not be true anymore, but be careful where and when you wear head-to-toe white (you don't want to look like a doctor unless you are one or play one on television). White Warning: Don't ever wear white hose. • Don't underestimate this hue's versatility. When Diego Uchitel photographed the cast of *Chicago Hope* for *TV Guide,* I dressed all the actors in white. Everyone wore the same color, but the different pieces (an Emporio Armani cardigan and tennis skirt from Banana Republic on Jane Brooke, and Donna Karan and DKNY on Christine Lahti) helped bring out each person's unique personal style. Sometimes it's not what you wear, but how you wear it. The best thing you can wear is a dazzling white smile, and you don't need my help for that.

White

In Ancient Greece, white was a symbol of joy and was often worn on festive occasions, including weddings. The bride wore a new white tunic, its pristine condition symbolic of her virginity.

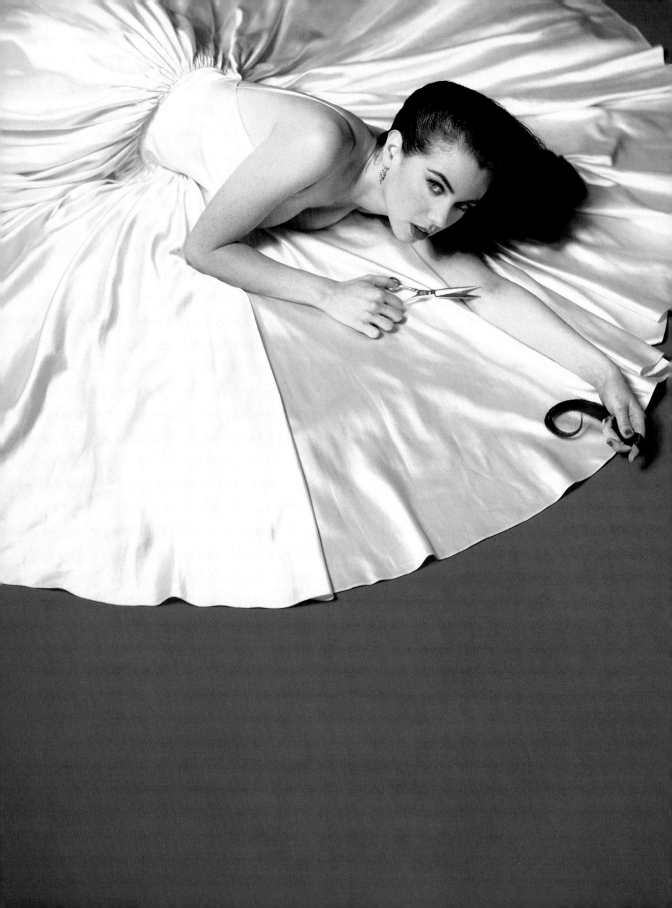

Remember the scene in *Funny Face* where Audrey Hepburn descends a staircase followed by a cloud of billowing chiffon? (You should!) So many of the actresses I work with love the ethereal beauty of chiffon (Vanessa Williams and Sandra Bullock are big fans). I think dressing in delicate layers of chiffon (a fabric woven from twisted fibers of rayon, nylon, or silk—my favorite kind) is one of the most feminine looks there is. Ever since sheer has become such a big look for day, lots of lighter-than-air chiffon designs have been floating around Hollywood and the design studios of Calvin Klein, Valentino, or even Libbie Lane—with her vintage fifties floral prints. • I think chiffon looks particularly alluring when it's mixed with different textures (nothing looks richer than a silk chiffon skirt or pair of pants with a cashmere twinset). The good news is you don't have to spend a lot of money on chiffon. You can buy a delicate dress from your favorite designer (like Heidi Weisel or Betsy Johnson), or if you're watching your pennies, you can buy a length of chiffon at a good fabric store. Stitch up the edges, and you'll have an elegant wrap that will set you apart from the crowd. My favorite chiffon looks: one sheer chiffon slip dress layered over a slightly more opaque one, and floral-printed chiffon styles worn with little cardigans. For the sheer pleasure of it, do yourself a favor and buy yourself something dreamy in chiffon.

chiffon

Marilyn Monroe's white chiffon halter-neck dress from *The Seven Year Itch* was bought in 1955 off the rack.

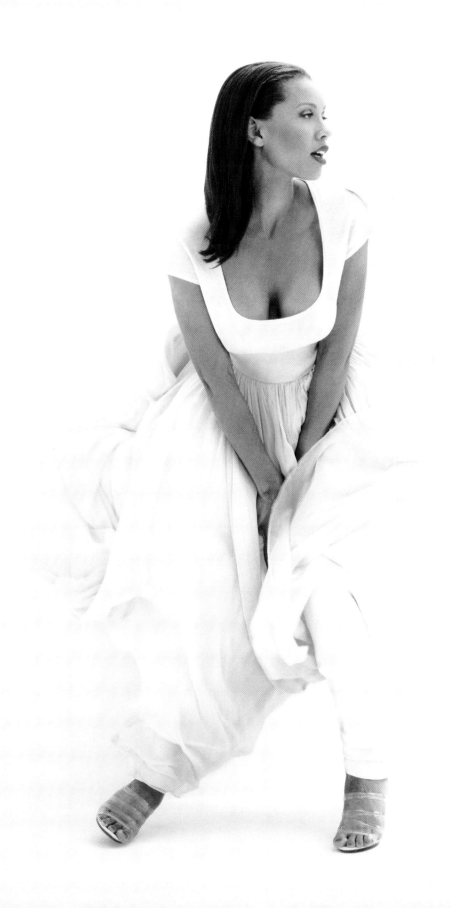

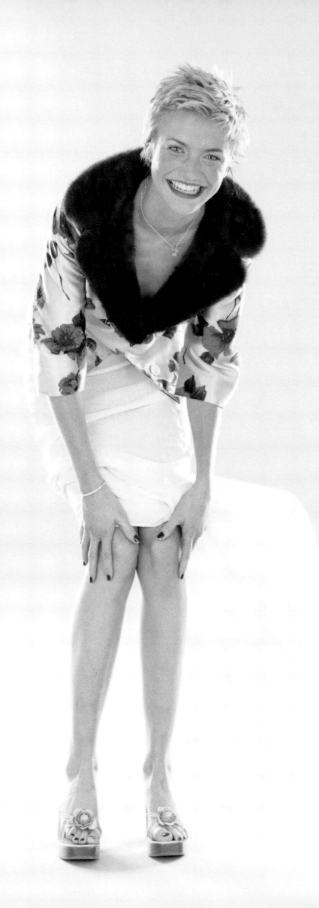

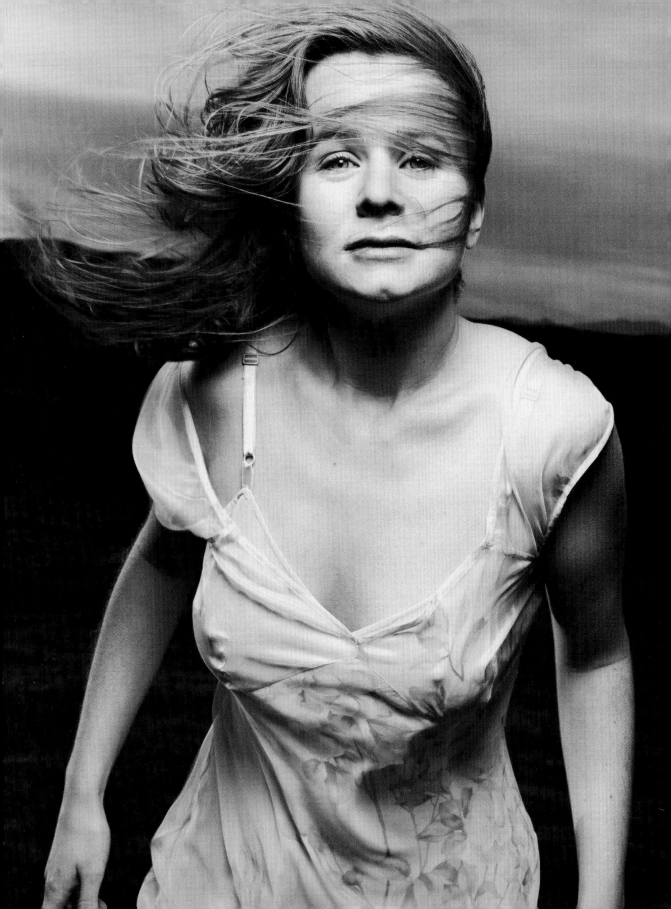

If you want to dress to impress, a suit is the way to go. When it comes to getting serious about style a suit says that you mean business. Everyone needs at least one good suit in a color (navy, black, or gray) that gives you the freedom to wear it outside the office. The great things about suits is that on the hanger, they have a uniformlike sensibility, but off the rack, they take on the personality of the wearer. Téa Leoni in her classic Ralph Lauren man-tailored pantsuit can hardly be mistaken for your uncle Bob. Joan Chen's uniquely feminine beauty is only enhanced by her three-piece suit. I recommend that you invest in a well-made (and possibly expensive) suit. If you buy a cheaper style, make sure you spend the money to have it tailored to fit you perfectly. • Richard Tyler has Hollywood all sewn up because of his exquisite tailoring and his strong suit is—the suit. They (especially this light blue leather one on Samantha Mathis) can make you look serious or sexy—or both, if you wear them with killer high heels. • Recently designers have redefined the power suit of the eighties by resurrecting shoulder pads and giving it a sexier edge. Pantsuits are bigger than ever and an absolute essential if you live in a cooler climate or spend most of your day getting in and out of taxis. If you've got great legs, nothing beats a suit with a short slit skirt. Ralph Lauren, Paul Smith, and Romeo Gigli all do great men's suits. Just remember: No matter what designers may be touting as the next big thing, the best thing you can do is just make sure you suit yourself.

Suit

The trend toward women adopting items from men's wardrobes began to grow when women were called to replace men in factory jobs during World War II.

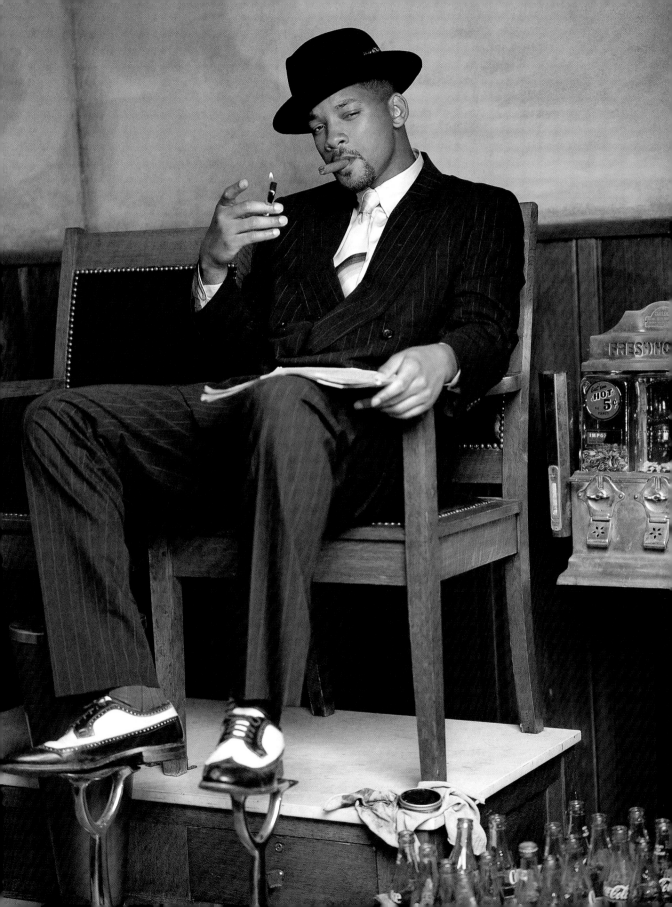

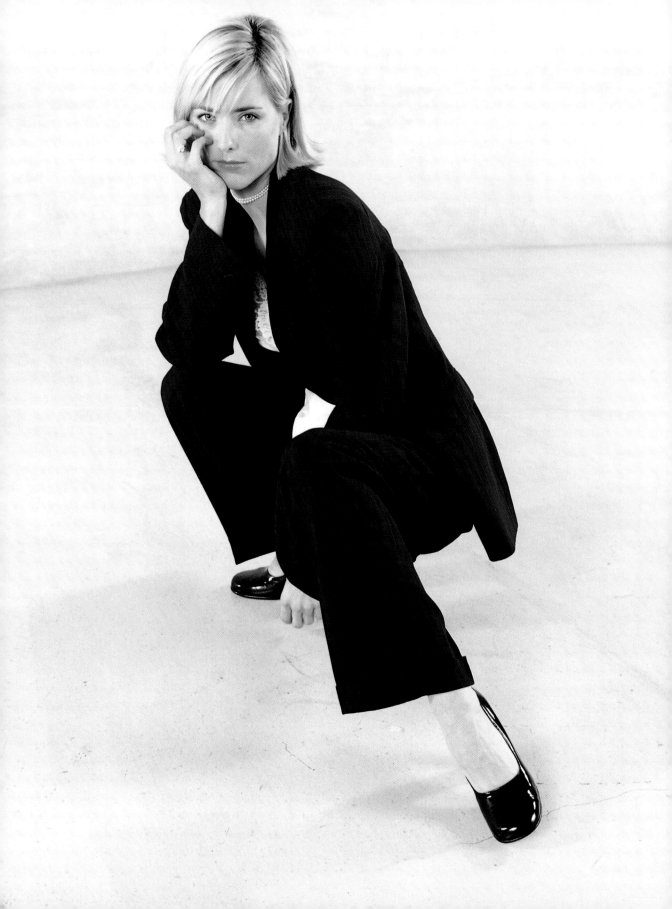

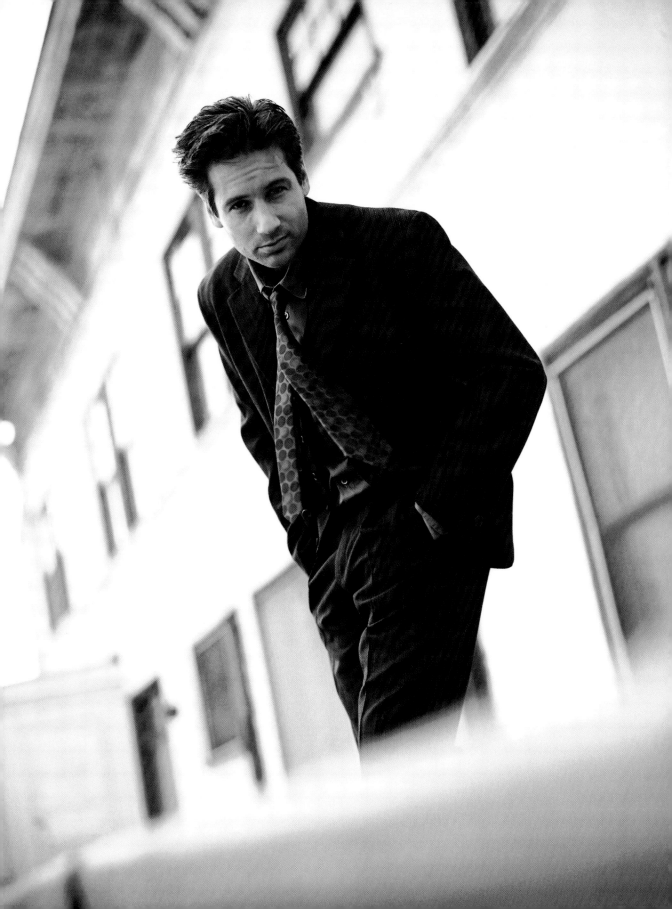

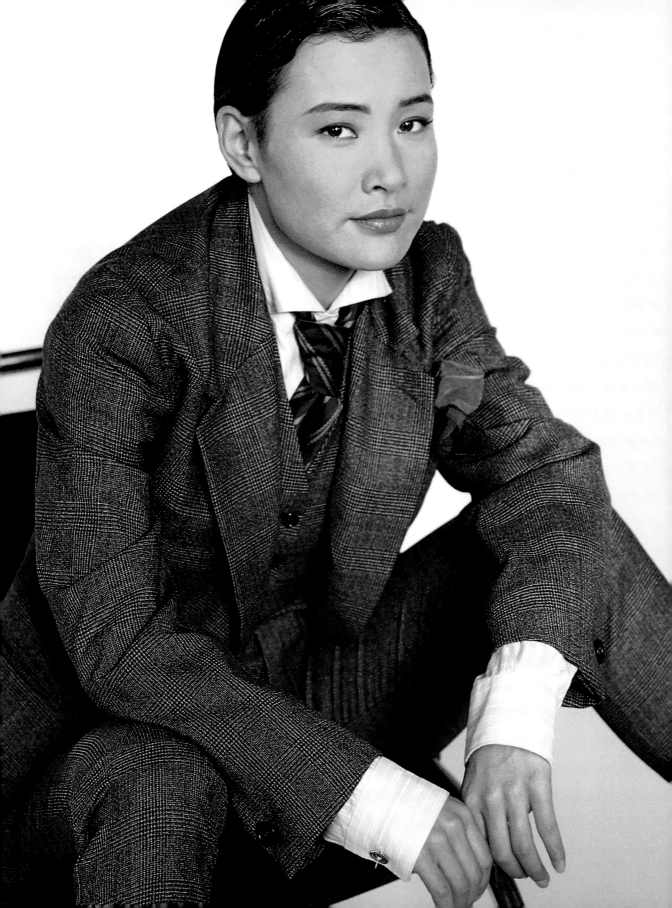

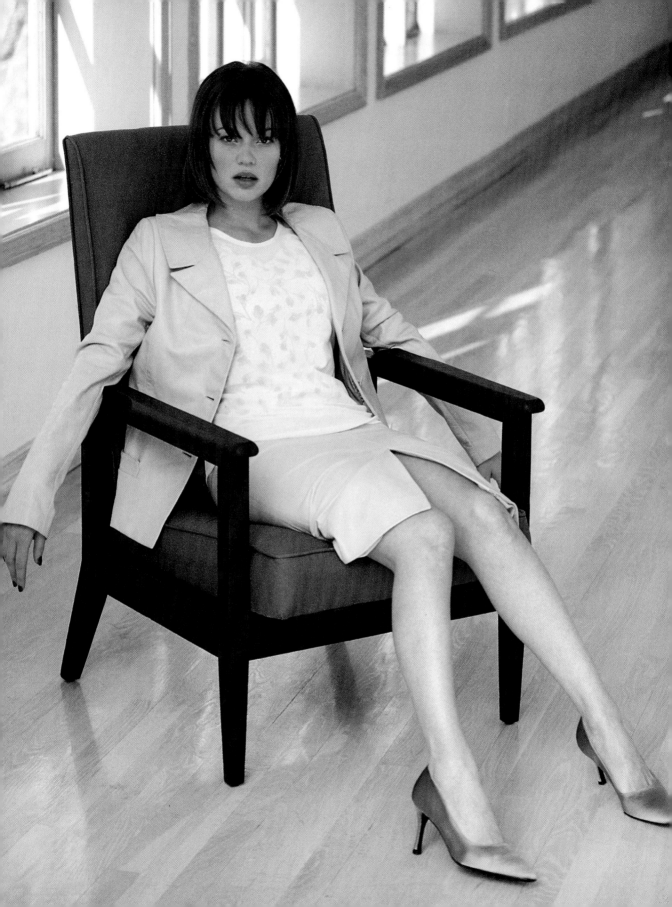

Although sometimes it's hard to tell the difference, a slip dress is not the same as a slip. Elizabeth Taylor turned up the heat in *Cat on a Hot Tin Roof* in her slip, and lots of Hollywood actresses (everyone from Fran Drescher to Kim Delaney) have poured their considerable charms into designer lingerie–inspired creations. Fear not: You can wear the slip dress someplace besides the boudoir or a Hollywood premiere. These days you can wear the unpredictable slip dress to the supermarket, the beach, or out to dinner. It is the right cardigan, shoes, jewelry, and bag that set the pace for this adaptable must-have item. • Slip dresses can make you look vulnerable or voluptuous. They come in velvet, satin, chiffon, silk, and even cotton (an essential element for no-fail summer

dressing). They can be short and flirty or long and luscious. Some of the most glamorous slip dresses are cut on the bias (which means the fabric is cut on a diagonal, giving it an elegant draped effect). The lightest chiffon slip dress can be layered or worn as a lining under another dress. If you're looking for a one-of-a-kind find, try the vintage shops. While you're there, pick up a shawl or cardigan to throw around your shoulders. • It's the spaghetti straps on a slip dress that separate the style from other dresses. I love delicate little trim on the straps and neckline of really feminine slip dresses. The exposed neckline and bareness of the slip dress make it the ideal choice for women who have beautiful necks and shoulders. You don't need much with a slip dress—just a tiny understated antique necklace or a pair of drop earrings. The shoe you choose can set the mood for your look: A strappy sandal lends an air of Hollywood glamour; slide into a pair of flip-flops if you want to feel like a funky diva. • When you wear underpinnings as outerwear, the right underwear is essential. If you're really curvy, find a seamless bra that offers good support or go for some truly long-line styles with bras built right into the dress. As for lithe, lean bodies try a nude bodystocking—or go as bare as you dare.

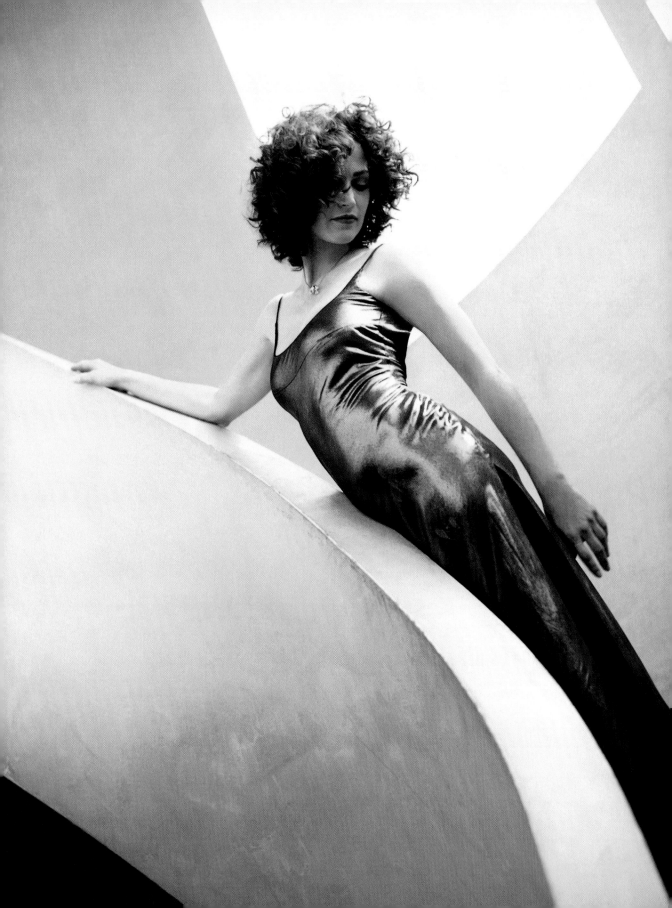

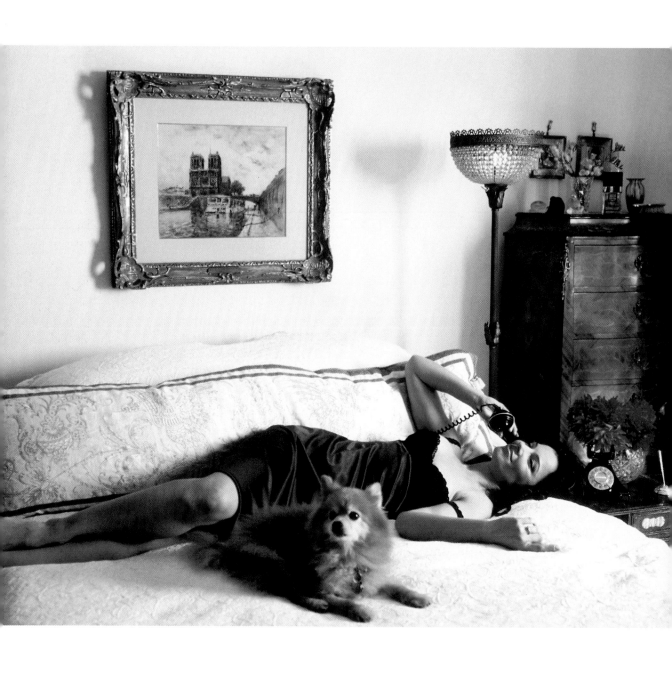

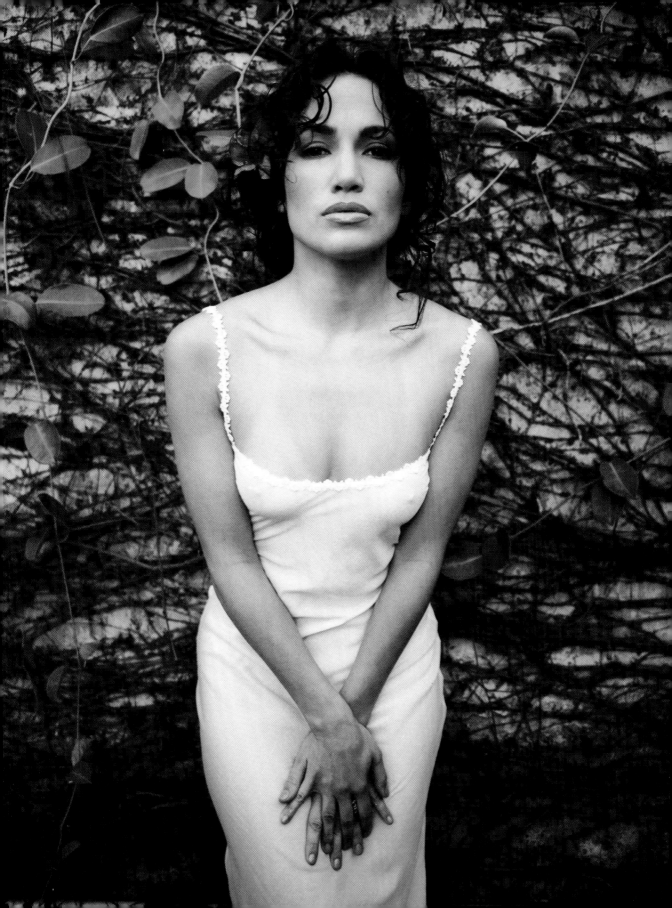

Favored by both rock stars and royalty, brocade has a split personality that has helped make it an essential element of nineties style. Brocade is a fabric that's woven with an embossed pattern—usually with metallic thread. An eclectic mix of brocade pieces—like the ones Chris Robinson is wearing—is the quintessential rock-and-roll look. A velvet dress embellished with brocade can look Elizabethan. If you're not planning to go on tour anytime soon, this nonpattern pattern looks best when worn one piece at a time.

• One of my favorite brocade looks is an evening coat or jacket worn over something in velvet or satin. Romeo Gigli is known for his brocade designs and so is Todd Oldham (whose signature faux brocades in bold patterns have been worn by Julia Roberts and Susan Sarandon). Brocade pieces can be pricey, but stores like Bloomingdale's and Macy's that carry a lot of varied styles at different prices are a good place to look for that must-have addition to your wardrobe. My advice is: Buy the best you can afford—if it looks skimpy, skip it. Brocade is definitely a look when you're "puttin' on the glitz," but beware—the plushest looks are also the warmest. Save your heaviest brocade pieces for cooler weather or climates. Because of the texture of the fabric, a light touch is often the best way to wear brocade, unless you want to look like your aunt Helen's sofa.

Brocade

The term "brocade" is taken from the Latin word *broccus*, meaning "projecting." Brocades were originally created by hand in China and Japan as early as the twelfth century B.C.

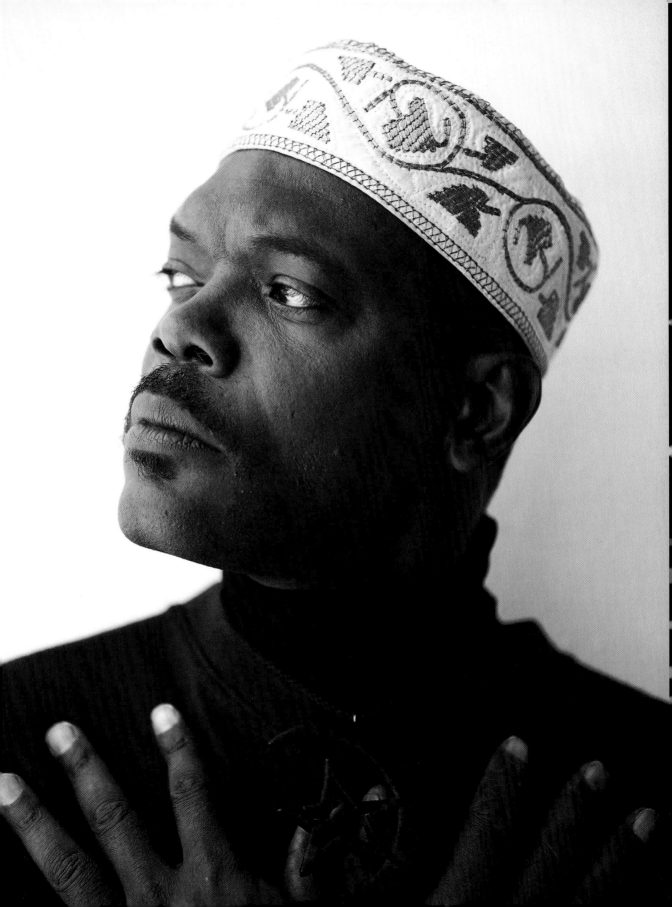

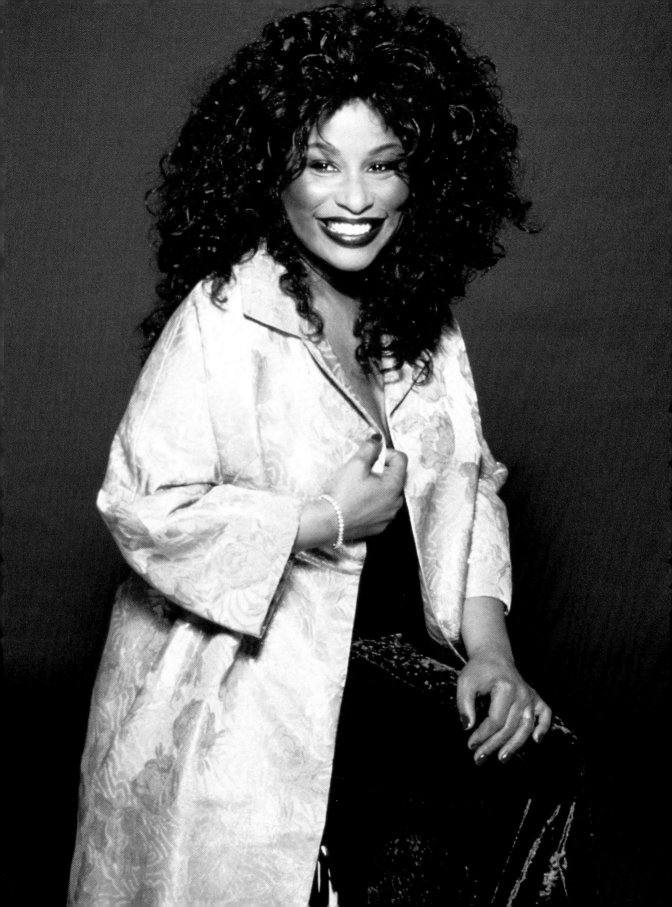

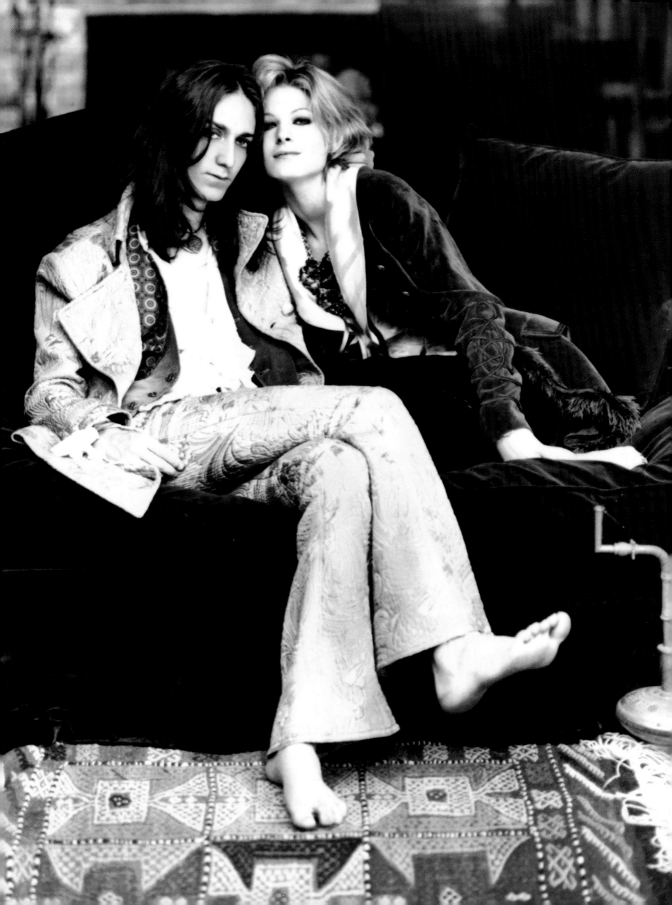

If a coat is doing its job, it keeps you feeling warm and looking cool. Even in LA, where the temperature rarely calls for protection from a chill, coats are an important element of style. Giorgio Armani, Donna Karan, and Calvin Klein all do great coats. The item to own in Hollywood is the pea coat (it was Coco Chanel who first declared the classic in navy an essential element of style in the twenties). Today, actors and actresses are sporting leather versions that define nineties style (as David Duchovny so aptly demonstrates). • You can have a variety of coats in your wardrobe. A classic water-repellent trench will keep you fashionably dry. Burberrys and Brooks Brothers make the best ones. A short, sexy version in white or black will look great over short cocktail dresses. If you have to trudge through cold winters, a long, double-breasted camel-hair coat (make it cashmere if you can afford it) will help you do it in style. Another evening look: a velvet coat that can double as a dress. I love the fifties-inspired three-quarter-length coats in bold colors and featherweight fabrics. For a bit of added élan, wear it falling off your shoulders (weather be damned!).

In the eighteenth century, black velvet strips were sewn on the coat collars of French nobility as a sign of mourning for the death of Louis XVI. In the fifties, the coat with the velvet collar became stylish in England. It was named the chesterfield, after the 1852 Earl of Chesterfield.

Coat

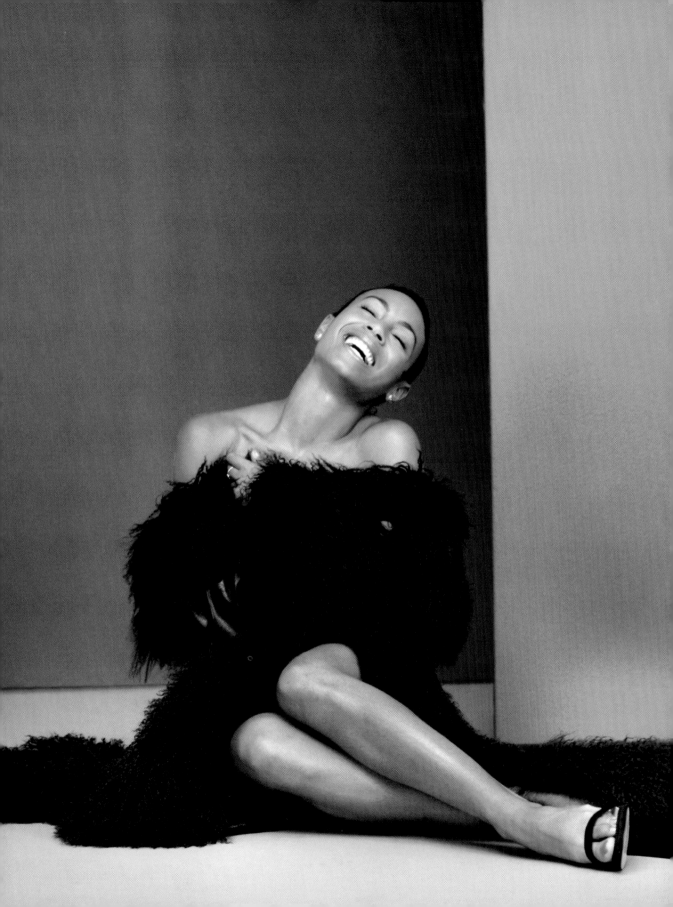

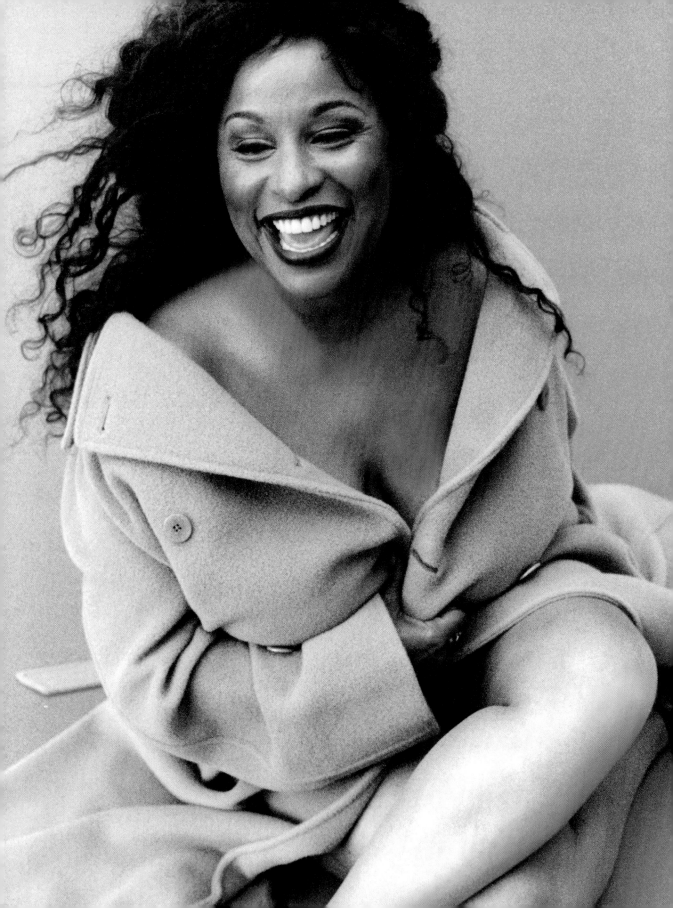

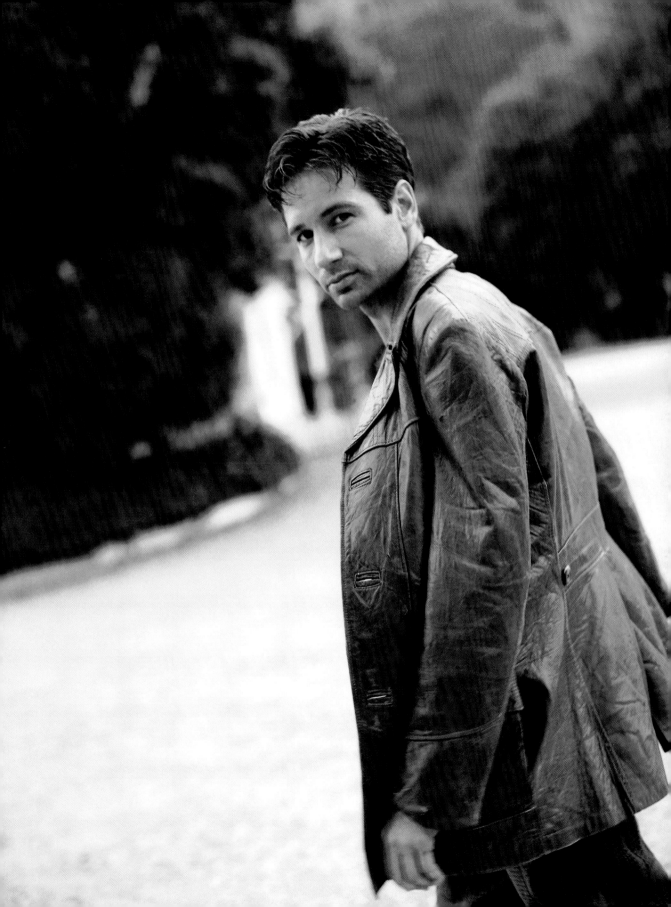

THE
PHOTOGRAPHERS
PHOTOGR

FIROOZ ZAHEDI

In my opinion, a person's sense of style stems from their self-confidence and self-respect. This way they don't have to go crazy dressing in the very latest fashions. They can stick to the same clothes and hairstyles for a long time without boring themselves—or anyone else—as long as their personality shines through. This does not necessarily mean they have to wear classic clothes—they can also choose outrageous colors and cuts as long as they show confidence and consistency in their choices. Audrey Hepburn and Jackie Onassis are prime examples of "classically" stylish women. Both of them never wore anything extremely trendy, and they always kept in shape. Mick Jagger is someone who has a more colorful style. I admire people like Robert De Niro and Jodie Foster—who have a real strength of character. They wear clean, classic fashion that does not try to compete with their immense talent as actors, and their clothes never distract you from their center. They are both people of great style and consistency.

Elizabeth Taylor has always stood behind her decisions with great confidence. Recently, when she had brain surgery and had to cut off all her hair, she decided to let it grow back but just a little in its natural platinum color. She looks amazingly beautiful and dignified.

You have to develop your own look. It can be a Gap T-shirt with an Armani jacket. If your choices complement you, you'll impress people with that. That's when what you wear is really part of you.

DAVIS FACTOR

I grew up in a family that invented makeup, so we noticed what women looked like—the clothes didn't matter. I think style is something everybody has. One thing may be really stylish to you and not to me. Style really depends on the person—like the saying goes, it's in the eye of the beholder. As a photographer, I like to see certain styles, but I also like to explore.

I'm a Levi's and T-shirt kind of guy. I've got fifteen Armani suits hanging in my closets that I don't wear because I never wear suits anymore. But I just bought a new Ralph Lauren tuxedo that I love. I went and saw every tux, and this one's a classic—it's the most stylish thing I own.

To me, one person who has great style is Richard Gere—the guy has got more of an aura than almost anyone I've ever seen. He showed up for a cover shoot for *Movieline* the other day wearing jeans and a T-shirt and had great style without even trying. It's kind of strange that a lot of people I shoot couldn't care less about what's new and what's happening in fashion, and then they try something on and they look great. One of the most difficult things about stylists—except for Phillip, because he really gets it—is that they have to understand it isn't about putting a celebrity in the latest clothes, it's about creating a vibe—the essence of who they are.

My late Oma [German for "grandmother"] on my father's side, Gertrude Holz, who lived to be a hundred and two, has great style. She was born in Germany in 1893 and studied at a commercial art school in Berlin, which was very unusual for women to do at that time. She always had meticulous style and wore very stylish, hand-tailored items. She worked for Simplicity Patterns in the late forties and used to tailor a lot of her own clothes.

My late grandfather on my mother's side, my Zadie [Yiddish for "grandpa"], Joseph Plotkin, was a tailor in Worcester, Massachusetts, and made suits and coats for the women in town. They picked from different styles, which were featured in a catalog called *Advanced Tailored Woman*. My oldest sister, Bonnie, used to wear great clothes in the sixties. My dad, who worked for the Atomic Energy Commission, had a very no-nonsense way of dressing, kind of like *Dragnet*. It probably came from his days in the navy. I remember the steel-toed boots he would wear to work—I had a pair when I was in junior high. I think being in the Boy Scouts also influenced my sense of style. I still like to wear green a lot—it's my favorite color. I can remember when I was in elementary school I had a pair of plaid shorts, and my mother told me I couldn't wear striped shirts with them or it would clash. It's funny the things we remember.

GEORGE HOLZ

ANDREW MacPHERSON

I think celebrities are the heroes and heroines of the stories of our time, the modern equivalent of the gods and goddesses of the temple of Delphi and, as such, these are the men and women who enter the dreams and psyche of their generations as archetypes. I think Catherine Deneuve has great style because of her constant grace and elegance. I love k.d. lang because she is crisp, sharp, and bold. Tom Waits has redefined the term "elegantly wasted." Bono has shown the world no pair of sunglasses can be too big. I think John Galliano embodies the ultimate expression of creativity and eccentricity.

Growing up in London in the late sixties and early seventies, I was constantly exposed to the fashions of the moment. My mother had a small dress shop on Beauchamp Place where I spent many afternoons thumbing through *Vogue, Harper's,* and all the magazines—tearing things out, making collages, and generally soaking it all in.

The two most stylish things I own are my Morgain pocket knife from Paris because it is exquisite, perfect and functional and is equaled only by my Swarovski binoculars, which exceed their beautiful design by their eye-enthralling performance. Professionally I like crisp, clean, and essential styles that accentuate the person in question and of course help give you an interesting image. Personally, I always try to see who it is behind the front, where the interesting stuff is. Style is the shop window of the person, but how many times have you been lured into a shop by the window, only to walk out moments later disappointed?

In simplest terms, style is what defines you. It's such a broad term: our clothes, mannerisms, food, women I love, my hobbies, what I read, my heroes, my family, sex, fingernails, my closest friends, work, muscles, my enemies, monkeys (I love monkeys), not being into computers. It's all that and everything else. It never ends, and it's always changing. Everyone I've ever met has affected my sense of style. As far as television and film goes, it's impossible to single out one show or film that affected me, but Jackie Gleason does come to mind. He was a class act—did things his own way no matter what anyone thought. He had grace and charisma and was an impeccable dresser.

The most stylish things I own are my Polaroid 110B Land Camera and a favorite thing of mine: a beautiful antique silver ring given to me by Amanda Plummer. People always ask about it. Who has great style of my family and friends? Me.

MICHAEL TIGHE

ART STREIBER

Growing up I loved *Gilligan's Island*—all the colors of the style rainbow are represented on that show from the Professor's white button-down and khakis to Ginger's killer dresses to the Howells' yachting attire, and, finally, Mary Ann's innocent farm-girl denim. Big, bold, brightly lit colors inspire me. To me a beautiful photograph is composed of amazing light, a spectacular moment, nice composition, and a brilliant idea.

I became a photographer because I didn't understand what people did for a living if they went to an office. Why do I shoot celebrities? Glamour, glamour, glamour. Celebrities, actors that is, can give the camera so much in so little time. I think Jodie Foster, Michelle Pfeiffer, Elle Macpherson, Harrison Ford, Giorgio Armani, and Robert De Niro have great style. Phillip brings "everything" to the shoot—clothes, props, ideas, fun, and his own wacky wardrobe. His sense of style and knowing what the subject will look great in is an incredible asset.

My own sense of style has been influenced by the Italians. I lived in Milan for four years and came to understand the Italian sense of simple elegance. The most stylish thing I own is my Barneys private-label leather jacket.

I think Lauren Bacall and Katharine Hepburn have a very classic sense of style and Sharon Stone is always very current in her style but she does it tastefully. Chris O'Donnell dresses in a very classic way that's flattering. Val Kilmer has got lots of flair and I like Robert De Niro's and Daniel Day-Lewis's style. I think Rupert Everett is very stylish. I did a photo shoot with him at least ten years ago for *GQ* and was blown away by him—he wears clothes very well.

Who influenced my sense of style? Growing up, I loved *The Avengers* and Emma Peel—she looked so sleek and classy, but she was so very sexy. I've always thought my mother had a great sense of style—she always looks great in a very *Town & Country* sort of way. I had a party ten years ago where I asked everyone to come in ball gowns, and she loaned me this incredible Valentino dress from that very stylish Jackie O.-Camelot period. It was stunning—and that was Louisville, Kentucky. She was always brave in her fashion choices. I don't own anything like that. As for me, my most stylish possession is my green Jaguar convertible.

EJ CAMP

CATHERINE LEDNER

Style is what you make it. Everyone has their own unique way of being—that *is* their style. You simply can't dress someone up and give them style; it comes from within. My father and grandmother both had great personal style. I think Winona Ryder has a simple, clean style. She's never a fashion victim. The same holds true for Gwyneth Paltrow. I like Liam Neeson's style—he's very earthy and manly.

I suppose it is more *what* rather than *who* has influenced my sense of style. Popular culture has undeniably influenced my changing sense of style. I love the Victorian era and all the buttoned-up elegance of the period. So what if the clothes were tight and covered everything? Women were so elegant then.

DOUGLAS KIRKLAND

My wife and most of her girl friends have great style— a certain *je ne sais quoi.* So do Meryl Streep, Marilyn Monroe, Sophia Loren, Marcello Mastroianni, Paul Newman, and Orson Welles. Coco Chanel, Jeanne Moreau, Audrey Hepburn, French women in general, and my French wife in particular have all influenced my sense of style. When I was growing up,

SANDRA JOHNSON

My first "real" assign-ment was to photograph Steve Guttenberg for this sort of fly-by-night agency I used to work for. They would have me accompany a journalist to press junkets and then at the inter-view's conclusion, convince the celebrity to sit for a quick photo session, which they would then syndicate. I was so nervous that all I could talk Guttenberg into was sitting in a chair in front of some nasty wallpaper for a half a roll of film. A few years ago, oddly, I was assigned to shoot him again and got him into a skin-tight silver rubber short ensemble. One of us got a little braver over the years.

I remember working with Phillip on a session with Ellen DeGeneres, and, as usual, everything that could go wrong did. I had never met him before, and he showed up with racks of fabulous designer clothing—suits with specific labels requested by someone on Ellen's team. Phillip takes her to look at the wardrobe choices and finds that these are the designers she *doesn't* like, in addition to which, the clothes are all the wrong size. Someone had given him a lot of bad information. Ellen was very apologetic about the confusion. Phillip managed to save the day by running home to pull his electric-blue shirt out of his own closet, and Ellen loved it. Ever since this shoot, I have seen her in this sort of color and fabric over and over.

I loved the pictures in *Life, Look,* and *National Geographic.* Professionally, I've been inspired by the work of Irving Penn, Avedon, Salgado, and Mary Ellen Mark. I'm drawn to things with a mysterious and provocative style (the best assets in women). Personally, my own style is casual, because I don't pay attention to myself.

237

MARK HANAUER

Cary Grant had style, but
so did Lou Costello. It's all
style. Phyllis Diller has style—
she put herself out there doing
something else. It's to her
credit she did what she did by
really taking a chance. Then
there's the kind of style that's
about classic good taste—the
kind Isabella Rossellini has
and Cary Grant and Jackie
Onassis had. My wife, Pauline
Leonard, has great style.

My sense of style has been
influenced by World War II—the
fascism and all the black
shirts. My family are German
Jews, and I look at that
period of history as bizarre and
surreal mostly because it's so
close, yet it's so far away.
That period is very black-and-
white to me and that has to
do with the sadness and graph-
icness of the period.

Richard Avedon and Irving
Penn were the first photogra-
phers that were a great inspira-
tion to me. Since then Man Ray
is a great inspiration. Whenever
I feel a little lost, I just open a
book of photographs and look.

My first four years as a fashion photographer were spent in Milan, where I learned about style, fashion, and design. When I returned after seven years in Europe, and my European clients found out I had moved to LA, they began to commission me to photograph actors for their magazines. I started to prefer celebrities over fashion photography—it became a challenge to express myself through the photographs of celebrities.

I think Sophia Loren has a seductive European style and mystery. Catherine Deneuve has a cool aloofness that epitomizes Parisian style. Grace Kelly had that royal dignity that set her apart from all others— she was surrounded by mystery. Robin Williams has a comedic style that only he can carry off. Sean Connery characterizes the sixties with a strong, masculine, debonair style. I think Steve McQueen had great style. My 1969 Triumph motorcycle (that was once owned by Steve) is my most stylish possession.

WAYNE STAMBLER

BONNIE SCHIFFMAN

It's hard to put what style is into words, but you can definitely recognize it when you see it. It comes from deep inside. My mom, Esther, has great style and so does my friend Cathy Eng. I like the silliness of the styles of the fifties, like the poodle skirt. My sister had one, and I'll never forget it. The forties had great style—the movies were the best—and I love all the color of the sixties. Every character on *I Love Lucy* had great style—even Fred. Maybe this helped me become drawn to shooting celebrities. The show still has an effect on me today, and I can still catch the *I Love Lucy* show on a daily basis—now that's amazing.

STEVE DANELIAN

Style is a personal expression—through clothes—done right. I love my family and my friends—they all have great style in their own way. The most stylish things I own are old family photos. I think everyone and everything has influenced my sense of style. I don't know what I'm inspired by until I'm inspired by it. It could be anything. I like simple things because life is complicated enough. I don't have time to

MICHAEL LAVINE

On a conscious level, I try not to be influenced by anyone's style in particular, but if I step back and look at myself I'd have to say that my fashion sense is rooted in the anti-fashion indie rock scene of the late eighties. You know, T-shirts and jeans, which was later exploited and marketed very poorly as the grunge look.

Star Trek was by far my favorite show when I was a kid. Even though all of the planets looked the same, and all the aliens spoke English, and Kirk and company beat a million-to-one odds every episode, it was still such a great show—very thought-provoking and very stylish. Well, I don't go around wearing space suits, but I am pretty much of a sci-fi freak.

I grew up in Denver during the seventies, and my mom and all of her friends were hippies, so I had a bit of the commune, food co-op, and alterna-school lifestyle thrown at me. But by the time I was in high school I was pretty wrapped up in the mainstream pop culture of the times. We smoked a lot of pot and were into things like sports and rock and roll. Richard Linklater's *Dazed and Confused* was a great expression of those times. That was my life.

complicate my wardrobe. Less is definitely more.

I think Sophia Loren has great style. Watch her in one of her old movies and you'll understand why. Audrey Hepburn had great style because she had a classic sense about her. And I love Jodie Foster's confident and understated style. I think Clint Eastwood has great style—he is "Clint Eastwood." Cary Grant was very dapper, and Robert Downey Sr. has style—anything he wears becomes an extension of himself.

JON RAGEL

Style starts with personality and presence—it's also how you put your wardrobe together. You can be dressed in the swankiest threads and not have a clue how to carry it off. Even the best stylist can't help someone without personality or presence. Who has great style? You mean besides Phillip? My friend Jeannine Braden. She is the owner of a great clothing store and is a little style queen. She mixes vintage with new and comes up with a great wardrobe. A lot of her inspiration comes from the fifties. Her apartment is decorated in the same fashion.

As for celebrities, I think Isabella Rossellini is always so elegant in the way she dresses and carries herself. Sandra Bullock has a presence and is so incredibly genuine that no matter what she is wearing it looks fabulous and full of life. Anne Heche has a very funky style. It's her own creation that's a little vintage and a little new—it works well together. When she is dressed in an elegant evening gown this girl looks sexy. She's got incredible style dresses up or down. Harvey Keitel is a guy who looks cool no matter what he wears. Now, that's style. Dennis Hopper is another one who has undeniable style no matter what he is wearing. I can't explain it, he's just got it.

Style means having a
distinctive point of view. Divine
had great style because she
wasn't afraid, so does Mary
Tyler Moore, RuPaul, Ziggy
Stardust, and Lypsinka. Frank
Gifford had great style in
the sixties when he was on
Password. The most beautiful
thing I ever saw was Divine
in *Pink Flamingos.* It derailed
me. What makes a beautiful
photograph? Retouching.

ALBERT SANCHEZ

BLAKE LITTLE

True style comes from a strong and definite point of view—it's timeless, transcending wardrobe and trends. Style comes from the soul and influences every aspect of a person. I photograph celebrities because they're most often vibrant, creative, interesting, and inspiring. They make the best subjects.

Amanda Plummer can wear anything and make it her own. She's an actress, a chameleon, and an androgynous beauty. Geena Davis's sense of humor is even greater than her startling height and stunning beauty. I worked with Patricia Arquette when she was eighteen years old. I still remember the purity of her honesty, openness, and vulnerability. She is the sexiest person I've ever photographed. I'm drawn to Samuel L. Jackson's integrity, intensity, and focus—and because he understands what works for him. Jack Nicholson is uncompromising and lives life by his own rules. Liam Neeson has great style because of his sensitivity and introspection. He canceled our first photo shoot after a half hour at my studio—he didn't "feel" right. He came back the next day and sat for one of the best portraits I've ever taken. Liam is a true artist and gentleman.

Style is knowing and liking yourself and expressing how you feel by the way you wear your clothes, cut your hair, and hold your body. It is *not* copying the way someone else looks to the detriment of the comfort and joy you feel. I think Cameron Diaz has great style because she's the generic beauty—tall, long-limbed, and blond. She's like a modern, funky Hepburn—really pared down and unobvious. P.J. Harvey has great style because she's not afraid to change depending on how she feels; she isn't afraid to make a mockery of the typical idea of female sexuality. Perry Farrell is unafraid of expressing himself—he's just as at home in a suit as he is as a crazy shaman witch doctor when he's onstage. They're both different facets of his personality and both valid. Steven Tyler has great style because he knows who he is. I heard this story from a stylist. She had to look through Steven's wardrobe with a photographer who was criticizing Steve for having all the feathers and flounces and trying to get him into something else, and he said, "This is who I am." God, why would he want to be dressed in Helmut Lang when he has his own style? He's also cool because he still dresses up as he gets older—no boring old silk shirt for him.

KATE GARNER

Style is what you dress love up in. Style invites you in—to a home, to a person. I'm more concerned about who people are than what they look like. I take pictures from the inside out, not the outside in.

My sense of style has been influenced by Bobby Short, Louis Armstrong, Carrie Donovan, Kim Gross and Jeff Stone, James Taylor, Duane Michaels, Mabel Mercer, Tom Waits, Al Green, George Gershwin (I feel related to him), Duke Ellington, Danny Kaye, and Karl Lagerfeld, because he was the first fashion designer I was really friends with and he was so great to me.

As far as celebrities with great style, I worked with Yasmine Bleeth recently and something about her drove me crazy—maybe it was her serious, sly smile. Ann Magnuson is sad and sweet and has the most beautiful chest. Amanda Plummer has great style because she always seems naked. Diane Keaton looks sexy even in pants (I've always had a crush on her). I love the way Bryan Ferry moves. Tom Waits is dark and rough, dark and scary, and dark and melancholy. Denzel Washington is the most handsome man alive—he always looks like he's in soft focus—he's got a really dreamy quality. And I love Al Green—his clothes dance one way and his soul another.

GEORGE LANGE

PIETER ESTERSOHN

I started collecting photography (Steichen, Penn, Turbeville) when I was fifteen. Then at nineteen I interviewed some great legends for *Interview* magazine. Collecting was always the area that compelled me. I wasn't pushed to take the images until later.

When I shoot celebrities, I usually find they'll play with you—they want the image to be great just as much as you do. It's not just about the clothes, it's about them, where they live, who they love. It can be very acknowledging to have a whole team committed to making you shine, even if it's only for 1/125th of a second.

I love the French actress Dominique Sanda. She's andro-gynous yet very feminine at the same time. In *1900* she had drop-dead chic. Marlene Dietrich represents the vanity that's so sexy with women, which never works for men. She really conceived her image. It was very personal and creative.

I travel all over the world for work and my inspiration for style comes from the drape of a garment in an Egyptian market as well as what one sees on the via Montenapoleone in Milan or Fourteenth Street in New York City.

When a great sense of style is present in someone who really knows and expresses the truth of themselves, it can knock you off your feet. There's real impact.

GWENDOLEN CATES

Style is intangible and innate. Catherine Deneuve has it—she's elegant and classic. So does Diane Keaton, who is always tastefully original. Gabriel Byrne has great taste with European flair without looking like he tries too hard. David Bowie is imaginative and creative with his style. Tom Wolfe is the definition of debonair. My style has always been influenced by my mother, who has always had classic and beautiful taste. The most stylish thing I own is an original terra-cotta Roman oil lamp, which was a gift from my aunt. It had been in her family for a long time after its discovery on their property, which is on the site of a formerly Roman town in northern Provence. It's a bit of history that I can hold in my hand. I loved the film *Lawrence of Arabia* for its drama, flowing caftans, and magnificent vistas. I am still moved by vistas and magnificent caftans!

RENEE COX

Style is innate to an extent. It's also about being courageous enough to wear clothes or represent yourself the way you want to. It's a very individual thing. It's about how one carries oneself and for me, it refers to physical fitness. The first element of style is the body itself and then it becomes a hanger for the clothes. The other great thing about style is that it lets you reinvent yourself by what you wear, like Madonna has done.

I've been collecting fashion magazines since I was nine years old. Aside from

LISA BEVIS

my mother, my sense of style has been influenced by Lena Horn, Dorothy Dandridge, and Pam Grier because I'm a tomboy at heart. In all those black exploitation films of the seventies she showed that women can be strong and intelligent as well as sexy. It was about how she carried herself— she was beating up the drug dealers, yet at the same time she looked great in halter tops. My whole thing is about the empowerment of women.

Style is bringing art into one's day-to-day existence, it is the expression of one's artistic soul. I love the exquisite chameleon quality of changing one's identity by altering one's style. Phillip Bloch has great style. He has the unique quality of being able to start trends, and he is the only person I know who can put on any ol' thing and it looks *fabulous* on him!

Being a photographer, I am a voyeur of fashion. When I see a beautiful coat I don't want to buy it for myself; I want to photograph it on someone else. When I shoot men's fashion I want you to be able to feel the material against their skin and smell the combined perfume of men through the clothes. As for my own personal style, I feel most whole in a black turtleneck and black leather jacket.

BOB FRAME

I was born in the late fifties, and I love the simple, stream-lined clothing from that time. I also like the clothes of the sixties because it was the first time we saw really body-conscious clothing and a sensuality that didn't exist before. There was no one to rival Diana Rigg as Emma Peel in *The Avengers*. I was young when it was on, but I knew she was the coolest thing on television. It affected me because I still try to strip things down to the essence—the simpler the better—streamlined, modern and edgy.

The most stylish thing I own is my Prada shoes. I love great shoes—I always notice people's shoes. It's a great barometer for figuring someone out—it's very telling.

S tyle is a five letter word. Slim Keith, Gertrude Stein, Diana Vreeland, Pier Paolo Pasolini, Jean Marais, and Bijan (just kidding!) have great style. My style has been influenced by everything from Prince's performance of "Head" on *Saturday Night Live,* David Bowie's performance of "Boys Keep Swinging" on the show, to film clips with costumes by Edith Head. The most stylish thing I own today is a queen-size white rabbit fur blanket from the seventies bought in a Paris flea market.

JAMES WHITE

JEFFREY THURNER

Courtney Love has great style because she can cover the whole fashion gamut. Renee Zellweger does too because she knows it's okay to wear sweats out in public. So does Nancy Reagan—it's a royalty thing like Princess Di and Jackie O. As for men with style, Jeff Goldblum can wear anything—he's a real clotheshorse. Dominick Dunne wears the same suit with a different tie. And George Hamilton is one of few people who always looks good in a smoking jacket.

My style has been influenced by 1920's Hollywood and Southern California in the seventies because I grew up there. When I was a kid I thought dressing like David Cassidy on *The Partridge Family* was the way to get the attention of all the girls. These days the most stylish thing I own is my Armani tux.

I shoot a lot of rock-and-rollers and actors; it's a good mix for me. I try to deemphasize the idea of style and fashion and focus on who they are. I think in most cases for me, it's all about simplicity and keeping it really clean. When I'm working I'm going for an idea that represents the person. A photo that is "styled" is exactly the opposite of what I'm looking for. I typically take my shirt off and throw it on someone. The other way to go is costuming and that is very tricky. One of my favorite things is when people pull things from their own closet. But I like a certain flamboyance in fashion, too. I think Courtney Love is great. I've always liked her sensibility—it's very much about her. She knows what she looks good in and definitely makes a look her own. I love to see people do their thing. She's a perfect example of someone who doesn't overdo it. She can wear a designer dress but it always seems like it was made with her in mind. It's always great to see what Mick Jagger does. I think all the Stones have their own style, as do the guys from U2 and REM in a weird, mixed up kind of way. When I saw *The Fifth Element*, that was really fun to watch. I liked the futuristic, over-the-top Gaultier clothes in the film, but I can't really say I was influenced by it. I remember watching *Leave It to Beaver* as a kid—I hate to say I was influenced by that show but people have accused me of wearing really boring clothes.

MARK SELIGER

HAIR & MAKEUP ARTISTS

HAIR & M

Enzo Angileri

As a little kid in Sicily and Milan, I used to watch old black-and-white movies with Italian movie stars. I always knew I'd be a hairdresser. I used to chop family members' bangs—often with tragic results!

Later I moved to LA and met Demi [Moore] when she was promoting *Ghost*. She asked me to do *A Few Good Men*. Can you imagine? Me, the little guy from Sicily who watched the movies, was now going to work for them? I said "sure!" I never take it for granted; I'm so grateful for what I have today.

Style for me means elegance. Elegance is something you're born with, even if you're wearing nothing. It's a body language. Style gets help from the outside element—a scarf, a strong haircut— but it has to be carried in a certain way.

My biggest beauty secret for hair is many jars of Vaseline; it's the antithesis to dry hair. It makes hair shiny. Of course, it has to be used in the right amount. To create texture, I found that Vaseline is just the right consistency. I also suggest rinsing hair with bottled water to take out your water's hardness (the calcium).

A look is born with the right combination of stylist, hair and makeup artist, and photographer. The environment also influences you. I put five hundred dollars' worth of flowers in Fran Drescher's hair for the Golden Globes, an idea that came from a fashion shoot I had worked on earlier. I engineered this three-dimensional support using chicken wire, the strongest bobby pins, and green floral Styrofoam. My biggest fear was that it would fall apart in front of a journalist!

Terri Apanasewicz

Style really comes from inside. It's more of a presence than a presentation. It's knowing how to put yourself together appropriately for different occasions. And, really, you just get better with age. Life doesn't end at twenty-five; women don't come into their own until they reach thirty. Then, you can only be better than you've ever been. In my terms, I make sure women not only look great, but feel great from head to toe.

Barbara Eden's "flawless" makeup in *I Dream of Jeannie* wasn't my only influence, but it was a big one. Growing up, I always knew I was going to be in show business, but I never would have thought I'd be working with movie stars, traveling around the world and making in a day what I used to make in a month.

One trick I think is great is to use Anbesol on the skin around the eyebrows before tweezing. It's numbing, and it really helps the pain.

The stylist is very important. They create the images and the trends. It's not about a name or a certain piece; it's about how it's all pulled together.

I consider myself very fortunate. Remember, you have to go home every night to the lights in *your* mirror. Be careful, and remain centered and true to yourself.

Oscar Blandi

My father was a great [hair] cutter. You always have a hero in your life. My father was my hero. He changed all these women. You'd see the transformation. I wanted to be like that. He was hard on me—you always are hardest on your children—but he gave me the right push. He was the best teacher. I feel capable now to change people if I want to.

Style to me is a word with a million different avenues. Today, everyone can be dramatic, or down-to-earth, real or fake. Style is behind fantasy, it's surrounded by the clothes, the makeup, the hair.

Phillip Bloch's creativity is to make a statement. He can make you very glamorous, very sexy. I always consult with him. Whether it's a beauty shot, a head shot, everything has to be combined to be connected—the makeup, the hair, the styling.

Before I create any look, I texturize the hair, which is important to make the hair available to how I want to style it. Whether it's straight or kinky, it has to be strong and soft. I use a natural product, one that is alcohol-free, so it won't damage the hair, and to help keep the elasticity.

You have to treat your hair right, use oil treatments, vitamin treatments. You have to treat your hair like your body, and it's like exercising the body. Every six weeks you have to get a beautiful trim. And don't overuse the same product. Alternate products to revitalize the hair and bring back its pH level. It's important to give your hair protein and vitamins.

Eric Ferrell

Hair was my first love. I started doing makeup after Roberto Leon got me started. Now I'm doing more makeup than hair. It's unbelievable, but I lost inspiration for hair; makeup was new and fresh. I like makeup more. It's more like sculpture with hair and it's constantly moving.

I get inspiration by street fashion, by the club kids, these things they think up, or a sculpture or a flower or a building. I'll get an inspiration for a color or style. I also follow what the designers are doing and then put a twist on it.

Style comes from inside. It reflects your mood. Of course, it needs to be flattering to them, to their frame and figure and physically. Not everyone should follow the trends. I take into account what looks good on them. Or is conducive to their personality.

The eye area is a big problem. Celebrities sleep so little and have so much stress. I love to take two chamomile tea bags, steep for 15 minutes, pop them in the freezer and then put them on the eyes.

To cover up, I don't like to use a lot of cover-up—it cakes up—so I put a thin layer of foundation, take a light powder, then dust it on and build it up naturally to fit the skin tone.

The first thing to make an impression on me was *I Love Lucy*. As long as I can remember, it was her eyes, her eyebrows, her overlined lips, and the skirts with the capri pants. Veronica Lake made a major impression on me, too.

Sam Fine

It's a huge inspiration to know you're not doing the same thing every day—it's a different look, a different face—there's something new and exciting to look forward to. Living in the nineties, style means something different than it did in the thirties or forties. Style means individuality.

I've always been artistic; I was an illustrator. But I thought I needed to have a career that I could enjoy as well as making a living. Makeup is just a different canvas for me.

Make sure you're rested. If you're relaxed, it shows in the face and eyes.

Phillip helps to translate what I do into a total vision. Without the clothes, without the hair, I'd be nothing. We're all just pieces of a puzzle. First and foremost, you think about your client. You can't forget you're a hired hand. Everything you do has to be tailored to the individual.

When growing up as an African American, there weren't a lot of role model images from my culture. Dorothy Dandridge was the black Marilyn Monroe (she had a tragic life and died of an overdose). She was one role model. My other icons were my mom and my three sisters. As the youngest and only boy, I watched my mom put on hair pieces, tweeze, apply base. It was magical. She sewed her own and my sisters' clothes. In-house experiences like that guide you into this glamorous lifestyle we lead every day.

Robin Fischa

Style to me is a reflection of an individual's personality or essence. It can be about the way someone carries oneself. Great style is more about you wearing the clothes than the clothes wearing you. Flatter the strong points and downplay the weak ones.

Style for the people I work with is extremely important. Since they are very much in the public, most of them have an image to uphold. Stylists like Phillip allow celebrities to discover a look that is comfortable and a perfect reflection of themselves. Once the outfit is set, that makes my job easier. I can effortlessly look at the individual and the clothes and figure out a color scheme that will complement the whole picture. A basic rule of thumb for me is "Less is more."

I love my job for the variety and freedom it can provide. Beyond technically doing a good job, the most genuine thing I have to offer is an opportunity to feel good about themselves. The goal is for someone to look at themselves in a new light. But even though they look good on the outside, it's what's inside that shines strongest.

Warm chamomile tea bags on the eyes to reduce puffiness.

Put ice on zits: don't pick them. Continue to use the ice, and they'll go down.

The perfect cure-all is teatree oil; it's great for the skin. Use it on fever blisters or for pimples, but dilute it with almond oil so it doesn't burn.

Also, Nu Skin, the liquid Band-Aid, for cuts or split lips. Spray it on, and then apply makeup after it dries.

Joanne Gair

To think I started as a teacher in New Zealand, painting my students' faces. Now I'm doing Demi Moore's makeup and scars in *G.I. Jane*.

I prefer to go with the flow of the music, for example, not watch the video. I see things pretty much in color. I see sounds in color. A lot has to do with the passion of the moment. With body painting, I might go in with a certain concept and then it might evolve differently. I think every teenage girl is influenced by playing dress-up. My family always had a dress-up drawer. And putting on clothes isn't the end; then you color in the lips and make up your face.

Less is more, particularly in a hot and humid environment. I'm a big believer in aloe vera gel. Put moisturizer on over it while it's still wet. It soothes the skin.

Traveling is my first passion. When you travel, you get a lot of inspiration from the different cultures, the different ethnic backgrounds. My house is full of icons from disparate cultures and religions. I love the energy behind discovery—that passion. Everybody in the business is a huge collector of research. Look at fashion; each time it comes around, it's a new flavor.

Style is an overall complement of what's going on. You begin with the wardrobe. You're basically painting a picture and making it fluid for someone to look at. It's all an illusion. It's coloring in.

Gucci

I did special effects for eight months in Los Angeles and then decided I couldn't stand the fumes. So I went into makeup. I had always wanted to be a makeup artist.

Style reflects a major change of trends. It's accepted, even if crazy. Style can portray an era or an image. It's all about creating this make-believe world, a made-up world that everyone believes is, or could be, real. I have to be inspired by the clothes. The hair and makeup artists and the stylists all have to complement each other; you have to get together and create that idea. But it all comes together if the clothes are good.

My favorite beauty secret is: Take care of the skin to the max. If you smoke, you can see there are problem areas, spots on the chin or on the sides of the face. Moisturize. You can also tell what affects your skin by your diet.

Bronzer is the number one thing to have. It makes you look sun-kissed and fresh. Or you can use berry lipstick stain on the cheeks.

For pimples, soak a piece of bread in milk and put it on your face—try to sleep with it— believe me, it works!

Looking and feeling healthy is your greatest beauty asset. You look more radiant if the skin is taken care of and you drink a lot of water. It's basic, but it's what works. Sometimes I put vitamin E oil on my cheeks and lips and forehead at night and morning and massage it in. Massage is another piece of good advice. Give yourself a five-minute face massage, and it will relax you—treat yourself.

Sally Hershberger

———

I grew up in a family where I never thought I would have to work. I actually wanted to design clothes. But my friends thought I should go to beauty school—I was obsessed with my hair. And I ended up working for the best hairdresser in LA. Olivia Newton-John took me on her "Let's Get Physical" concert tour.

My biggest inspiration is that you're allowed to be free to be creative. It's a non-reality. It really is fantasy. It's like being a kid. If I don't feel creative, I feel dead inside.

Style is how people project themselves to the world. Letting them know how they feel about themselves. It's not who you are, it's a projection of how people see you. It's kind of a false statement, too.

The Mod Squad was one of the more evolved shows on TV that I loved. I didn't grow up watching movies. I was really in my own movie in my mind. But stars who really influenced me were Jean Seberg, Edie Sedgwick, Joan Jett, The Pretenders, Deborah Harry, The Ramones. That was my inspiration. I was a Hollywood person.

Meditation. It makes you look younger. It makes you more vibrant, more alive than any other thing. It does something inwardly; you get those sparkly, shiny eyes.

Karen Kawahara

———

Style is a feeling, an inspiration. It tells your personality. Style can be of an era in time. The nineties reflects a new way of looking healthy, feeling more comfortable. People are not afraid of taking a risk.

I think style is something you're born with. I tortured my mother when I was young because I had to have a different hairdo for every outfit I wore. I had this little Swedish dress and my hair had to be braided over my ears when I wore it. Growing up on Cape Cod, I gave all my friends Vidal Sassoon haircuts with big kitchen scissors. I wanted to design. I redid the makeup and the hair of customers when I was working at Ann Taylor. Now I get to do what I enjoy the most and get paid for it. It's such a great feeling, when people end up looking so good.

As you age, it's important to remember how old you are. Even if you feel young. Those midriffs tops—you have to look at yourself and be critical. Does this work for me or not? Sometimes women continue a look from 20 years ago, and it's really time for a change.

A good beauty trick especially for winter: keep a tube of Vitamin E handy. Mix it with lipstick for a stain effect. When wearing powder and you notice dry patches, pat it on and blend it in. Mix it in with your blush, rub on with your hands for a healthy glow. It's perfect for wintertime.

One of the most important parts of a woman's face is the eyebrows. If they are over or under plucked or have a funny shape or the arch is too far in, you need to open it up. I think if women can get to a professional for that, that's very important. It changes the whole look of the face.

Jeanine Lobell

This is the third year we've been in the market with Stila, the makeup line I developed about five years ago. I didn't want to use my name as the label.

I didn't want it to be about me; it didn't feel right. I wanted it to be its own individual thing. In Italian, *stila* means pen; in French it's stylist. Hence, it came to mean writing your own style. Our whole philosophy is individualistic, to march to the beat of your own drum.

Style is a marriage of what's going on fashion-wise with your own twist on it. When somebody sees an outfit in a store window and buys the bag, the shoes, the dress—that's not personal style. To me, personal style is mixing your own corduroy Levi's from high school with bright red lipgloss and beefing the whole thing up. To me, that's the ultimate style.

At Stila we're working on skin care. I consistently tell people to use seaweed, algae-based products, things of the sea like deep-cleansing masks. La Mer cream is awesome (even if it's $100 for a tiny jar). I also do a lot of homeopathy and alternative medicine, working with Chinese herbs. Work on things every day, keep that maintenance thing up, it's a marriage of both.

Lutz

I am such a wild card in this business. When I was growing up in Hamburg, my whole family was into the arts. I was supposed to study painting, but I rebelled. So my family got me into the Hamburg State Opera, where I learned to make masks, wigs, create ballet and opera makeup. If I ever had to do it again, I'd become a gardener.

I finally quit the opera and traveled, doing makeup on editorial fashion shoots. In Paris I met a beautiful model from Michigan, escaped with her to the states, bought a Harley and drove cross-country. I never thought I would be a makeup artist. I am also a biker, a snowboarder, a surfer—to try to find a balance for all this.

Happiness is the biggest beauty secret I can impart. I live in nature in the middle of mountains with two big hounds.

I've always loved beautiful, natural girls. My philosophy is: Keep it as natural as possible. I see beauty in every person. In their eyes, their hands, the way they move. If you can get enough sleep and get your act together, beauty comes from the inside. It's like when you're in love, you just beam. It's that energy. We can't replicate that with product.

The stylist is tremendously important. He or she sets the basics when we walk into a photo shoot. I think stylists are so advanced. They create fashion. You then have to apply that to personalities. Celebrities are not just clothes hangers. Stylists teach a celebrity to be comfortable in their own image and explore fashion within their own personality, giving them options, ways to create their own identity.

My biggest inspiration is trust. It's an exchange. If they trust me, I can do more. It's a healthy energy. The beauty myth is based on philosophy and not on applied products. Beauty is making people more.

Richard Marin

One of my sisters was a model who was fourteen years older than I was, and she used to take me with her to work when I was about three or four. I remember everyone making such a fuss over her: the hair and makeup people, the massive amounts of clothing she'd try on. I remember how much I liked those people and how exciting I thought this business was.

Style to me is individual, how people present themselves. I don't consider a person who wears things by the book to have style. It's completely individual. And style affects everything I do. I take all my information from everything—the shows, movies, who's really hot and being watched, and then how people interpret that.

The most basic and most abused beauty secret is sleep and rest. It's the one thing people forget.

The other thing is water—drink lots of it!

I'm doing what I've always wanted to do. What kept me going is that I never gave up that dream. It is all a process, and it won't happen overnight. My advice for others is that you have to put something into it. You have to develop yourself as a person and what you think is style. Don't set any boundaries for yourself. Become a sponge. Know what's going on in the world around you, in society, in politics. Watch what everybody does and watch what you do, and develop your own look.

Carol Shaw

I was sure I was never getting into this business. I'd grown up in a salon. My father owned one; he dressed hair and my mother did nails. But it took having my own makeup done by a professional to see the "magic." I then branched out into freelance before eventually starting my own makeup line, LORAC. *That* is my personal beauty secret.

LORAC (Carol backwards) hit the market in 1993 and today sells in Fred Segal, Bendel's, and Neiman Marcus. The line, inspired by my sensitive skin, is special in that it's a treatment-based makeup. It's a balance between nature and science. But it's all about the skin. I think that's why people like me. I'm a stickler for detail when it comes to the skin. I make sure the makeup's flawless, but I make sure skin still looks like skin and feels good.

LORAC has lipsticks (named after the stars I work with like Demi [Moore] and Nicole [Kidman]) with skin rejuvenators, eye shadows with botanicals that soothe, and loose powder with encapsulated jojoba to reduce pores.

You're only as beautiful as you feel. It starts inside. I think exercise is first on the list. I love yoga. I love riding my bicycle. It keeps me feeling good.

What inspires me? When I was younger I was a hippie. The movie *Lipstick* with Margaux Hemingway influenced me. To me she was so breathtakingly beautiful; I was fascinated. Now, it's the women I work with who are so truly inspiring. They are so talented and most are mothers. Their inner and outer beauty and courage motivates me.

Collier Strong

My biggest inspiration has been the desire to create a fantasy, an illusion, magic!

Style means so many things. It's an interpretation of my mood, a reflection of my desires as well as of things I've done and wish to do. There would be no such thing as style without artists. Style bridges the conscious with the unconscious.

My beauty secret is self-confidence. I became a makeup artist because I was aware of the impact makeup had on a person's self-confidence. What could be more gratifying?

Nature, I believe, can have the most beautifying effect on us. So my favorite natural beauty secret is to get outside, and I don't mean to the mall! Go to the beach, the park, or the desert, anywhere. Just GO!

The most profound image that influenced me as a child was this picture of Elizabeth Taylor taken by Scavullo in the seventies. I was eleven and thought I'd been around. She was wearing a billowy purple top and her eyes were done in grays and purples with lots of black eyeliner. Her hair was big and jet black. Skin flawless with pink cheeks. Eyes like crystals. But it was her lips that sent me running—because I didn't have a bike—to the cosmetic counter.

Her lips were outlined in this bright tangerine orange, the brightest, I was sure, permitted by law. Then artfully filled in with the hottest hot pink that could be found approved by the FDA. I knew there was an unmentioned agreement between the liner and the lipstick, to share the space as long as they both had equal screen credit. And as if to seal this treaty between the two, a thick coat of clear lip gloss was applied so heavily I kept watching and waiting for it to drip off.

Well, to say the least, I was mesmerized, amazed, hooked, destined to reproduce such spectacle as often as I could for the rest of time. Unfortunately, by the time I got to do Miss Taylor's makeup, she had already outgrown her rainbow sherbet phase. Damn her!

Lori Jean Swanson

I have been lucky to have traveled a lot. The colors of nature, the style of other cities and countries, peoples in different places—the Latina with the long waterfall of hair and eyeliner . . . the grandma in the market wearing far too much makeup with her blue hair—these things have inspired me.

Gardening can inspire me, too, from amazing flowers to a simple weed—plants in landscapes with color combinations never considered. My cats will remind me how to shade a person's nose. Or friends will remind me of a hairdo I haven't thought of in ages. Clothing definitely inspires me. Most of all, it's a person's spirit, heart, and good soul that are the greatest inspirations.

Style has always been a part of my life. My personal style is sort of mixed up. I rarely look pulled together. A friend once told me that even when I do look really put together, he knew there must be a rip or safety pin somewhere. If my clothing is some-

thing by a designer, then my hair is a mess . . . if my hair is styled, then my clothing is secondhand. . . . I have never felt comfortable looking too complete.

Generally, celebrities are quite stylish. They tend to be creative, imaginative, and very conscious of their image. If they don't feel so confident as a dresser, or with their hair or makeup, they hire us!

I never sought out a career in the entertainment industry. I ran my own clothing company in Los Angeles in the early eighties, but I always needed a little extra money, so I began doing makeup jobs on the side. I continued this way of life for years, until one day I realized that I enjoyed doing makeup more than designing clothing.

Stylists affect what I do in every way. We all work together as a team: wardrobe, along with makeup and hair, must all complement each other.

I believe beauty comes from within—be happy. And it's no secret; I am a water pig. Drink lots of water!

Garen Tolkin

I had a salon in my front yard when I was six or seven. Everyone on the block came to me for my haircut, my makeup, my clothing. I started in hair, cutting my way through college. At seventeen, I went to barber school, then got a cosmetologist's license.

My biggest inspiration was my uncle Mike, who was a gangster barber. He dressed impeccably and had great taste. When I was about seven, he took me to the Beverly Hills Polo Lounge and pretended it was my birthday. I was dressed up in my crinolines—and then I saw this woman come out of the hotel. Her face was flushed, her hair was messy, but she glowed, she looked so healthy. It was Ingrid Bergman, and she was magic. That healthy glow became my signature makeup look.

I like a nonchalant style. But style is everything—it's a gesture, it's a stance. It should be conscious. It creates an image that people respond to. I'm very sensitive to the effects of style. What I try to do is find out what

persona they want to project. Makeup should look accidental and spontaneous, even though it isn't. When creating a character for film or the theater I might put a subtle smudge under the eye to make a character look world-weary or enhance the cheekbones for a strong and virile look. Or I highlight the outer corner of the eye for a sophisticated and knowledgeable look.

One of my beauty secrets is Alive creme blush by Trucco by Sebastion. It creates that flush, which is highly influenced by my memory of Ingrid Bergman.

My second secret is witch hazel. There's nothing more refreshing than soft cotton pads on pulse points. Everyone perks up; their eyes brighten. I'll bring a gallon of witch hazel and maybe a bag of ice to press junkets just to keep people fresh.

The other secret is Freeman's Cucumber Mask, to keep people from picking at their skin. You put this on, let it dry, and then pick it off. It's highly gratifying.

CREDITS

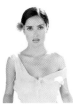

SALMA HAYEK
Photographer: Davis Factor; Publication: Spanish Harper's Bazaar; Hair: Ian James/Visages; Makeup: Kim Carillo/Heller; Dress: Alberta Ferretti

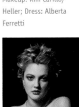

DREW BARRYMORE
Photographer: Timothy White; Publication: Movieline; Hair: David Cox/Celestine; Makeup: Joanne Gair/Cloutier; Diamond Jewelry: Van Cleef & Arpels

JENNIFER BEALS
Photographer: Bob Frame; Publication: Movieline; Hair: Philip Carreon/Profile; Makeup: Karen Kawahara/Cloutier; Ring: Van Cleef & Arpels; Earrings and Bracelet: Cartier

CASSANDRA WILSON
Photographer: Jeffrey Thurner; Publication: Esquire; Hair: Victor Vidal/Cloutier; Makeup: Karen Kawahara/Cloutier; Jumpsuit and Wrap: Giorgio Armani; Diamond Necklace: Unigem

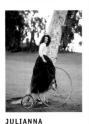

JULIANNA MARGULIES
Photographer: Jon Ragel; Publication: Entertainment Weekly; Hair: Chris McMillan/Profile; Makeup: Karen Kawahara/Cloutier; Skirt: Giorgio Armani; Sweater: Alberta Ferretti

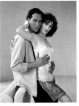

KIM DELANEY AND JIMMY SMITS
Photographer: George Holz; Publication: Entertainment Weekly; Hair: Yuki Sharoni; Makeup: Stephanie Fowler; All Clothing: Valentino

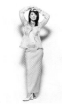

FRAN DRESCHER
Photographer: Firooz Zahedi; Publication: Mirabella; Hair: Chris McMillan/Profile; Makeup: Carol Shaw/Cloutier; Shirt and Skirt: Alberta Ferretti; Shoes: Calvin Klein

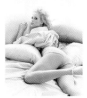

ELIZABETH BERKLEY
Photographer: Robert Erdman; Publication: Detour; Hair: Katerina Eltrhurdt/Cloutier; Makeup: Paul Starr/Smashbox; Blouse and Hotpants: Gianfranco Ferre; Shoes: Patrick Cox

JONATHON SCHAECH
Photographer: Naomi Kaltman; Publication: US; Hair: Shawna Clark/Cloutier; Tank: Sulka; Pants: Banana Republic

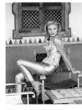

CAMERON DIAZ
Photographer: George Holz; Publication: LA Magazine; Hair: Johnathan Antin/Heller; Makeup: Robin Fischa; Top: Barney's Private Label; Pants: Byblos; Shoes: Kenneth Cole; Earrings: Jennifer Kaufman

JOHNNY DEPP
Photographer: Andrew MacPherson; Publication: Premiere: Hair: Gemal/Cloutier; Makeup: Beth Katz/Cloutier; Shirt: Paul Smith; Pants: Fresh Jive; Boots: American Rag

GABRIEL BYRNE
Photographer: Steve Danelian; Publication: Elle; Hair: Oscar Blandi; Makeup: Karen Kawahara/Cloutier; Shirt: Banana Republic

JULIANNA MARGULIES
Photographer: Jon Ragle; Publication: Entertainment Weekly Hair: Chris McMillan/Profile; Makeup: Karen Kawahara/Cloutier; Top: Alberta Ferretti; Pants: Escada Couture; Earrings: Harry Winston

CYBILL SHEPHERD
Photographer: Timothy White; Publication: Good Housekeeping; Hair: Howard Barr/Cloutier; Makeup: Augustinia/Celestine; Sweater: DKNY; Pants and Shoes: Donna Karan

FRAN DRESCHER
Photographer: Firooz Zahedi; Publication: Mirabella; Hair: Chris McMillan/Profile; Makeup: Carol Shaw/Cloutier; Shirt and Pants: Calvin Klein; Ring: Cartier

CAMERON DIAZ
Photographer: Kate Garner; Publication: Movieline; Hair: Chris McMillan/Profile; Makeup: Gucci Westman/Visages; Sweater and Scarf: Malo; Dress: Anna Molinari; Earrings: Magnum

MARK WAHLBERG
Photographer: George Holz; Publication: Premiere; Shirt: Gene Mayer; Glasses: Gucci; Hair: Frida Aradottir; Makeup: Barbara Farmer; Grooming: Joanna Uli

ELLEN DeGENERES
Photographer: Sandra Johnson; Publication: USA Weekend; Hair: Gemal/Cloutier; Makeup: Karen Kawahara/Cloutier; Jacket: Paul Smith; Shirt: Richard Tyler; Pants: Isaac Mizrahi

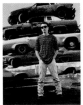

TIM ROTH
Photographer: Andrew MacPherson; Publication: Premiere; Hair: Jillian Fink/Smashbox; T-Shirt: Paul Smith; Pants: Ralph Lauren Jeans

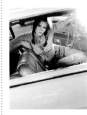

ELLE MACPHERSON
Photographer: Andrew MacPherson; Publication: Premiere; Hair: Daniel Howell/Cloutier; Makeup: Kim Goodwin/Cloutier; Sweater: Agnes B; Jeans: American Rag; Bra: Victoria's Secret

NICOLAS CAGE
Photographer: Andrew MacPherson; Publication: Premiere; Hair: Joe Coscia; Makeup: Allen Weisingor; Shirt: Paul Smith; Pants and Shoes: Gianni Versace

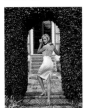

PATRICIA ARQUETTE
Photographer: Butch Belair; Publication: US; Hair: Brent Lavett/Celestine; Makeup: Roz Music/Smashbox; Dress: Richard Tyler

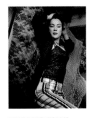

CAMERON DIAZ
Photographer: George Holz; Publication: LA Magazine; Hair: Johnathan Anton/Heller; Makeup: Robin Fischa; Vest: Romeo Gigli; Skirt: Richard Tyler; Shoes: Gianni Versace

JENNIFER TILLY
Photographer: Carlos Della Chiesa; Publication: Elements of Style; Hair and Makeup: Lori Jean Swanson; Pants: Traffic; Top: Katoni Adelli; Sweater: Jil Sander

CLAIRE DANES
Photographer: Mark Seliger; Publication: US; Hair: Chris McMillan/Profile; Makeup: Karen Kawahara/Cloutier; Bra: Dolce & Gabbana; Shorts: Calvin Klein

RIVER PHOENIX
Photographer: Michael Tighe; Publication: Spin; Hair: Mitzi Spallas/Cloutier; Shirt: American Rag; T-Shirt: Gap

TIM ROTH
Photographer: Andrew MacPherson; Publication: Premiere; Hair: Jillian Fink/Smashbox; T-Shirt: Paul Smith; Pants: Calvin Klein Jeans

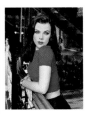

DEBI MAZAR
Photographer: Catherine Ledner; Publication: TV Guide; Sweater: Emporio Armani; Pants: Todd Oldham

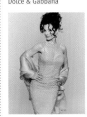

KEVIN SPACEY
Photographer: EJ Camp; Publication: Rolling Stone; Hair: Margaret Kamura/Cloutier; Vest, Shirt, Pants: Nino Cerruti; Shoes: Patrick Cox

TOBY BAILEY
Photographer: Mark Hanauer; Publication: LA Magazine; Hair: Lori Jean Swanson; Vest and Pants: DKNY

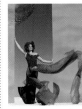

CAMERON DIAZ
Photographer: George Holz; Publication: LA Magazine; Hair: Johnathan Anton; Makeup: Robin Fischa; All Clothing: Dolce & Gabbana

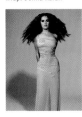

FRAN DRESCHER
Publication: People; Hair: Chris McMillan/Profile; Makeup: Carol Shaw/Cloutier; Gown: Giorgio Armani

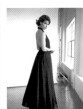

GINA GERSHON
Photographer: Jon Ragel; Publication: Elle; Hair: Ricjard Marin/Cloutier; Makeup: Lori Jean Swanson/Cloutier; Dress: Pamela Dennis

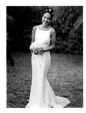

JENNIFER LOPEZ
Photographer: John Dulan; Publication: InStyle; Hair: Oscar Blandi; Makeup: Matthew Van Leeuwen; Gown: Escada

JODIE FOSTER
Photographer: Firooz Zahedi; Publication: Premiere; Hair: Enzo Angileri/Cloutier; Makeup: Paul Star/Smashbox; Gown: Gianni Versace; Wrap: Donna Karan

SALMA HAYEK
Photographer: Carlos Della Chiesa; Spanish Vogue; Hair: Serana Radelli/Cloutier; Makeup: Franchesca Tolot/Cloutier; Gown: Gianni Versace

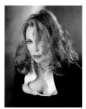

FAYE DUNAWAY
Photographer: Michael Tighe; Publication: Entertainment Weekly; Hair: Enzo Angileri/ Cloutier; Makeup: Gary Berkowitz/Cloutier; Dress and Shirt: Richard Tyler; Necklace: Mikimoto

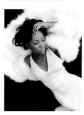

THERESA RANDALL
Photographer: Davis Factor; Publication: Esquire; Hair and Makeup: Sharon Gault/ Cloutier; Dress: Pamela Dennis; Feather Coat: Todd Oldham

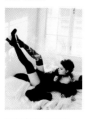

GEORGINA CATES
Photographer: Andrew MacPherson; Hair: Victor Vidal/Cloutier; Makeup: Melvone Farrell; Hotpants: Todd Oldham; Sweater: Emporio Armani; Stockings: Hue; Shoes: Patrick Cox

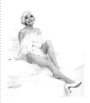

CAROL CHANNING
Photographer: Firooz Zahedi; Publication: Vanity Fair; Hair and Makeup: Eric Barnard/ Cloutier; Boa: Adrienne Landau; Gloves: Julian's Vintage; Diamond Bracelets: Van Cleef & Arpels

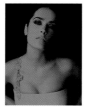

SALMA HAYEK
Photographer: Carlos Della Chiesa; Publication: Spanish Vogue; Hair: Serana Radelli/Cloutier; Makeup: Franchesca Tolot/Cloutier; Dress: Gianni Versace

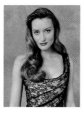

NATASHA McELHONE
Photographer: Wayne Stambler; Publication: Premiere; Hair: Richard Marin/Cloutier; Makeup: Kim Goodwyn/Cloutier; Bustier: Vivienne Westwood

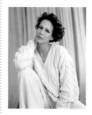

JAMIE LEE CURTIS
Photographer: Jon Ragel; Publication: Elle; Hair and Makeup: Eric Barnard/ Cloutier; Sweater: Malo; Pants: Isaac Mizrahi

CAMERON DIAZ
Photographer: Kate Garner; Publication: Vogue Australia; Hair: Ian James/Visages; Makeup: Gucci Westman/ Visages; Skirt: Genny; T-Shirt: Anna Sui; Sweater: Giorgio Armani

MATT LeBLANC
Photographer: George Holz; Publication: LA Magazine; Hair: Victor Joseph/Cloutier; Makeup: Robin Fischa; T-Shirt: Paul Smith; Shirt and Jacket: Calvin Klein; Hat: American Rag

MEGAN WARD
Photographer: Diego Uchitel; Publication: LA Magazine; Hair: Victor Vidal/Cloutier; Makeup: Beth Katz/Cloutier; Camisole: Nancy Sevrin; Skirt: Plein Sud; Slip Dress: X Collection; Earrings: Ted Muehling

JADA PINKETT
Photographer: Blake Little; Publication: Movieline; Hair and Makeup: Phyllis Williams; Dress: Prada; Diamond Jewelry: H Stern

CHRIS AND LALA ROBINSON
Photographer: Davis Factor; Publication: Sky Magazine; Hair: Kevin Ryan/Visages; Makeup: Kathy Jeung/Visages; On Lala: Shirt: Paperbag Princess; Vest: American Rag; Pants: Romeo Gigli; On Chris: Jacket: Dolce & Gabbana; Shirt: Julians; Pants: Aardvarks

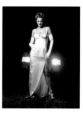

WILLIAM H. MACY
Photographer: George Holz; Publication: Premiere; Hair: Frida Aradotte; Makeup: Barbara Farman/Cloutier; Shirt and Pants: Gucci

NICOLAS CAGE
Photographer: Andrew MacPherson; Publication: Premiere; Hair: Joe Coscia; Makeup: Allen Weisinger; Jacket: DKNY; Shirt and Pants: Gianni Versace; Shoes: Patrick Cox

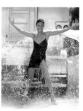

JEAN-CLAUDE VAN DAMME
Photographer: Randee St. Nicholas; Publication: Playgirl; Jacket: Giorgio Armani; Sweater: Emporio Armani; Hat: Kangol; Pants: John Bartlett

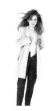

JULIANNE MOORE
Photographer: Firooz Zahedi; Publication: Buzz; Hair: Chris McMillan/Profile; Makeup: Lucienne Zammit/ Cloutier; Jacket: Emporio Armani; Pants: Alberta Ferretti; Diamond Belly Clip: Van Cleef & Arpels

DREW BARRYMORE
Photographer: Timothy White; Publication: Movieline; Hair: David Cox/Celestine; Makeup: Joanne Gair/Cloutier; Dress: Richard Tyler; Shoes: Manolo Blahnik; Jewelry: Sawyer Armstrong

JADA PINKETT
Photographer: George Holz; Publication: InStyle; Hair: Pierce Austin/Dawn 2 Dusk; Makeup: Klexius Kolby; Heller; Dress: Jill Stuart

MEGAN WARD
Photographer: Diego Uchitel; Publication: LA Magazine; Hair: Victor Vidal/Cloutier; Makeup: Beth Katz/Cloutier; Dress: Giorgio Armani; Shoes: Kenneth Cole

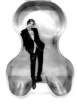

JIM CARREY
Photographer: Andrew MacPherson; Publication: Premiere; Hair: Jonny Hernandez/Fierro; Suit and Shirt: Richard Tyler; Shoes: Diego Della Valle

CYBILL SHEPHERD
Photographer: Michael Tighe; Publication: Entertainment Weekly; Shirt and Pants: Pamela Barish; Jewelry: Butler & Wilson

ROCKY CARROLL
Photographer: James Minschin; Publication: TV Guide; Hair: Robin Fischa; Shirt: Dolce & Gabbana; Pants: Todd Oldham Jeans; Shoes: Barney's

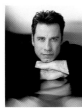

JOHN TRAVOLTA
Photographer: Andrew Eccles; Publication: USA Weekend; Hair: Sue Kalinowski; Makeup: Michelle Buhler; Sweater: Giorgio Armani

COURTNEY COX
Photographer: Sam Jones; Publication: People; Hair: Chris McMillan/Profile; Makeup: Beth Katz/Cloutier; Sweater: Richard Tyler

DAVID CHOCKACHI
Photographer: Randee St. Nicholas; Publication: Bravo; Hair: Yvonne Leupka; Makeup: Adam Christopher; Sweater: DKNY; Pants: John Bartlett; Shoes: Kenneth Cole

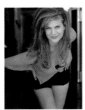

KRISTEN JOHNSTON
Photographer: Richard Reinsdorf; Publication: TV Guide; Hair: Robert Vetica/Heller; Sweater: Anna Molinari/Blumarine; Shorts: Traffic

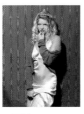

REBECCA ARMSTRONG
Photographer: Albert Sanchez; Publication: The Advocate; Sweater: Malo; Slip Dress: Josie Natori

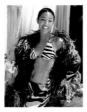

JADA PINKETT
Photographer: Andrew Southam; Publication: US; Hair: Louise Moon/Nubest & Co.; Makeup: Tracy Sundern/Makeup Forever; All Clothing: Gucci

KATHY KINNEY
Photographer: Alberto Tolot; Publication: TV Guide; Hair: Will Carrilo/Cloutier; Makeup: Antonella/Cloutier; Coat: Traffic; Dress: Forgotten Woman

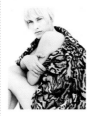

PATRICIA ARQUETTE
Photographer: Wayne Maser; Publication: German Vogue; Hair: Brent Lavett/Celestine; Makeup: Roz Music/Smashbox; Coat: American Rag

JOHNNY DEPP
Photographer: Andrew MacPherson; Publication: Premiere; Hair: Gemal/Cloutier; Makeup: Beth Katz/Cloutier

MATT LeBLANC
Photographer: George Holz; Publication: LA Magazine; Hair: Victor Joseph/Cloutier; Makeup: Robin Fischa; Suit: Calvin Klein; Shirt: Equipment; Hat: Kangol

LL COOL J
Photographer: Fergus Grier; Publication: TV Guide; Shirt: Tommy Hilfiger; Hat: American Rag

JENNY McCARTHY
Photographer: James White; Publication: Entertainment Weekly; Hair: Jonathan Autin/Heller; Makeup: Kathy Jeung; Dress: Vivienne Tam

FRAN DRESCHER
Photographer: Andrew Eccles; Publication: InStyle; Hair: Chris McMillan; Makeup: Carol Shaw/Cloutier; Dress: Cynthia Rowley; All Jewelry: Cartier

SALMA HAYEK
Photographer: Davis Factor; Publication: Spanish Harper's Bazaar; Hair: Ian James/Visages; Makeup: Kim Carrillo/Heller; Dress: Dolce & Gabbana

CREDITS



JIMMY SMITS
Photographer: EJ Camp;
Publication: People; Hair:
Lucia Male; Makeup: Mark
Sanchez; Tank Top: DKNY;
Pants: Donna Karan

CHRIS AND LALA ROBINSON
Photographer: Davis
Factor; Publication: Sky
Magazine; Hair: Kevin
Ryan/Visages; Makeup:
Kathy Jeung/Visages; On
Chris: Tank Top: Stussy;
Pants: Todd Oldham; On
Lala: Bustier: Dolce &
Gabbana; Hot Pants:
Todd Oldham; Shoes:
Vanessa Noel

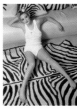

DREW BARRYMORE
Photographer: Timothy
White; Publication:
Movieline; Hair: David
Cox/Celestine; Makeup:
Joanne Gair/Cloutier;
Tank Top and Underwear:
Sulka; Jewelry: Sawyer

SUSAN HOLMES
Photographer: Diego
Uchitel; Publication:
Nordstrom; Hair and
Makeup: Brad Bowman/
Heller; All Clothing and
Shoes: Richard Tyler

GOLIE SAMII
Photographer: Pieter
Estersohn; Publication:
Detour; Hair: Gabriel
Saba/La Chapelle;
Makeup: Robin Fischa;
Dress, Bag, and Jewelry:
Julians Vintage; Slip:
Collette Dinnigan; Shoes:
Vanessa Noel

CAMERON DIAZ
Photographer: Kate
Garner; Publication:
Movieline; Hair: Chris
McMillan/Profile; Makeup:
Gucci Westman/Visages;
Dress: Jill Stuart;
Cardigan: Blumarine

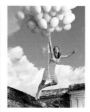

JENNIFER ANISTON
Photographer: Mark
Seliger; Publication: US;
Hair: Chris McMillan/
Profile; Makeup: Kim
Goodwin/Cloutier; Dress:
Anna Sui; Bra: Victoria's
Secret

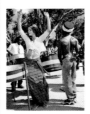

SAMANTHA MATHIS
Photographer: Richard
Reinsdorf; Publication:
Movieline; Hair: Chris
McMillan/Profile; Makeup:
Karen Kawahara/Cloutier;
Dress: Isaac Mizrahi;
Shoes: Diego Della Valle

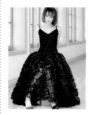

KELLY PRESTON
Photographer: George
Lang; Publication:
People; Hair: Edward St.
George/Cloutier; Makeup:
Kim Goodwin/Cloutier;
Dress: Alberta Ferretti

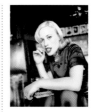

SANDRA BULLOCK
Photographer: Mark
Seliger; Publication: US;
Hair: Chris McMillan/
Profile; Makeup: Joanne
Gair/Cloutier; Shirt:
Julians; Skirt: Norma
Kamali; Shoes: Target

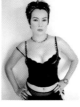

JENNIFER TILLY
Photographer: Carlos
Della Chiesa; Publication:
Elements of Style; Hair
and Makeup: Lori Jean
Swanson; Bra: Victoria's
Secret; Tank Top: Josi
Natori; Pants: Adidas;
Jewelry: Gucci

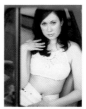

JORDAN HILL
Photographer: Randee
St. Nicholas; Hair and
Makeup: Terri
Apanasewicz; Top:
Vintage Wasteland;
Pants: Guess

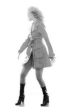

PATRICIA ARQUETTE
Photographer: Butch
Belair; Publication: US;
Hair: Brent Lavett/
Celestine; Makeup: Roz
Music/Smashbox; Top
and Skirt: Wendy
McCauley; Earrings: Ted
Muehling

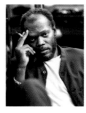

SAMUEL L. JACKSON
Photographer: Davis
Factor; Publication: Buzz;
Hair: Roz Music/
Smashbox; Suit: DKNY;
Shirt: Calvin Klein

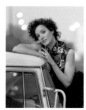

JENNIFER BEALS
Photographer: Bob Frame;
Publication: Movieline;
Hair: Philip Carreon/
Profile; Makeup: Karen
Kawahara/Cloutier; Vest:
Richard Tyler; Skirt:
Escada; Jewelry: Cartier

PATRICIA ARQUETTE — *(image only)*

ELIZABETH BERKLEY
Photographer: Robert
Erdman; Publication: LA
Magazine; Hair: Katarina
Ehrhardt/Cloutier;
Makeup: Paul Star/
Smashbox; Coat: Dolce &
Gabbana; Boots: Gucci

WILL SMITH
Photographer: Mark
Seliger; Publication: US;
Hair: Pierce Austin;
Makeup: Joanne Kovloff;
Clothing: CK Calvin Klein;
Shoes: Nike

FRAN DRESCHER
Publication: People; Hair:
Chris McMillan/Profile;
Makeup: Carol Shaw/
Cloutier; Dress: Carmen
Marc Volvo; Shoes:
Manolo Blahnik; Jewelry:
Harry Winston

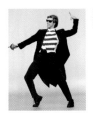

JIM CARREY
Photographer: Andrew MacPherson; Publication: Premiere; Hair and Makeup: Johnny Hernandez/Fierro; Jacket, Vest, Pants and Tie: Richard Tyler; Shoes: Patrick Cox; Glasses: Persol

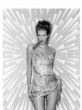

ELLE MACPHERSON
Photographer: Andrew MacPherson; Publication: Smoke; Hair: Oscar Blandi; Makeup: Jeanine Lobell/Smashbox; Dress: Valentino; Diamond Jewelry: Martin Katz

JENNIFER TILLY
Photographer: Carlos Della Chiesa; Publication: Elements of Style; Hair and Makeup: Lori Jean Swanson/Cloutier; Dress: Laurel

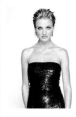

CAMERON DIAZ
Photographer: Kate Garner; Publication: Vogue Australia; Hair: Ian James/Visages; Makeup: Gucci Westman/Visages; Dress: Jennifer George

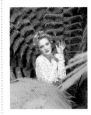

DREW BARRYMORE
Photographer: Timothy White; Publication: Movieline; Hair: David Cox/Celestine; Makeup: Joanne Gair/Cloutier; Shirt: Julians Vintage; Earrings: Van Cleef & Arpels

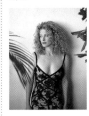

NANCY TRAVIS
Photographer: George Lang; Publication: Entertainment Weekly; Hair: Sid Curry/Profile; Makeup: Karen Kawahara/Cloutier; Dress: Herve Leger

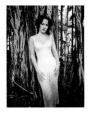

JENNIFER LOPEZ
Photographer: Jeffrey Thurner; Publication: US; Hair: Oscar Blandi; Makeup: Monica Blunder/Cloutier; Dress: Dolce & Gabbana

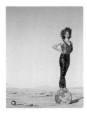

JODIE FOSTER
Photographer: Firooz Zahedi; Publication: Premiere; Hair: Enzo Angileri/Cloutier; Makeup: Paul Star/Smashbox; Pants and Top: Vivienne Tam

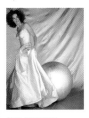

KIM DELANEY
Photographer: George Lang; Publication: Entertainment Weekly; Hair: Yuki Schroni; Makeup: Stephanie Fowler; Dress: Pamela Dennis; Diamond Jewelry: Van Cleef & Arpels

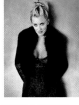

BLAIR UNDERWOOD
Photographer: Jeff Katz; Publication: Playgirl; Hair and Makeup: Vonda Morris; Suit: Dolce & Gabbana; Shoes: Polo Ralph Lauren

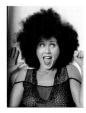

JULIANNE MOORE
Photographer: Firooz Zahedi; Publication: Buzz; Hair: Chris McMillan/Profile; Makeup: Lucienne Zammit/Cloutier; Faux Fur: Gucci

COURTNEY COX
Photographer: Cliff Watts; Publication: British Elle; Hair: Philip Carreon/Profile; Makeup: Beth Katz/Cloutier; Faux Fur Wrap: Pamela Dennis; Bracelet: Gumuchian Fils; Earrings: Lazare Kaplan

JENNY McCARTHY
Photographer: James White; Publication: Entertainemnt Weekly; Hair: Johnathan Antin/Heller; Makeup: Kathy Jeung; Coat: Pamela Dennis; Dress: Oscar De La Renta

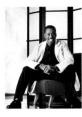

JENNIFER ANISTON
Photographer: Mark Seliger; Publication: US; Hair: Chris McMillan/Profile; Makeup: Kim Goodwin/Cloutier; Tunic: Vivienne Tam; Slip: Isaac Mizrahi

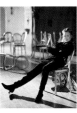

JULIANNE MOORE
Photographer: Michael Tighe; Publication: People; Hair: Garen Tolkin/Cloutier; Makeup: Kathy Jeung/Visages; Dress: Herve Leger

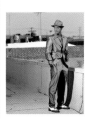

TED DANSON
Photographer: Michael Tighe; Publication: Entertainement Weekly; Hair and Makeup: Maria Carter; Suit and Shirt: Emporio Armani; Belt and Shoes: Armani

COURTNEY B. VANCE
Photographer: Blake Little; Publication: Ebony Man; Jacket: DKNY; Pants and Shirt: John Bartlett; Shoes: Kenneth Cole

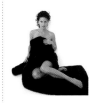

ROBIN WRIGHT PENN
Photographer: Michael Tighe; Publication: Buzz; Hair: Philip Carreon/Profile; Makeup: Beatrice Marot/Profile; Jacket: Richard Tyler; Shirt and Pants: Todd Oldham; Shoes: Sephane Kelian; Earrings: Devin McCleary

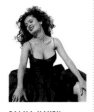

SALMA HAYEK
Photographer: Firooz Zahedi; Publication: InStyle; Hair: Philip Carreon/Profile; Makeup: Lucienne Zammit/ Cloutier; Dress: Pamela Dennis

TATIANA VON FURSTENBURG AND DANIEL S. WILKENS
Photographer: Pieter Estersohn; Publication: Detour; Hair: Gabriel Saba/La Chapelle; Makeup: Robin Fischa; On Tatiana: Robe: Geoffrey Beene; Slip: Josie Natori; On Daniel: Shirt: Richard Tyler; Pants: John Bartlett

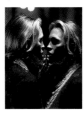

FAYE DUNAWAY
Photographer: Michael Tighe; Publication: Entertainment Weekly; Hair: Enzo Angileri/ Cloutier; Makeup: Gary Berkowitz/Cloutier; Shirt: Oscar De La Renta

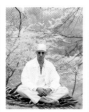

DAVID MARTIN
Photographer: Pieter Estersohn; Hair and Makeup: Robin Fischa; Jacket and Pants: Donna Karan; Shirt: Gasper Saldonna

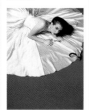

MIA KIRSHNER
Photographer: Firooz Zahedi; Publication: Premiere; Hair: Chris McMillan/Profile; Makeup: Lutz/Profile; Gown: Badgely & Mischka; Jewelry: Jennifer Kaufman

CAST OF CHICAGO HOPE
Vondi Curtis Hall, Hector Elizando, Christine Lahti, Adam Arkin, Jane Brooke, Thomas Gibson, Rocky Carroll, and Mark Harmon. Photographer: Diego Uchitel; Publication: TV Guide; Hair and Makeup: Barbara Farman, Helen Jeffers, Lori Jean Swanson/Cloutier; Brad Bowman/Heller; Clothing: GAP, Banana Republic, DKNY, Emporio Armani; Shoes: Hush Puppies

VANESSA WILLIAMS
Photographer: Firooz Zahedi; Publication: InStyle; Hair: Robert Vetica/Heller; Makeup: Karen Kawahara/Cloutier; Dress: Heidi Weisel; Shoes: Fredericks of Hollywood

CAMERON DIAZ
Photographer: Kate Garner; Publication: Movieline; Hair: Chris McMillan/Profile; Makeup: Gucci Westman/Visages; Jacket: Dolce & Gabbana; Dress: Richard Tyler; Shoes: Jill Stuart

EMILY WATSON
Photographer: Mark Seliger; Publication: Rolling Stone; Hair: Louise Moon/Nubest & Co.; Makeup: Lutz/ Profile; Dress: Dolce & Gabbana

WILL SMITH
Photographer: Mark Seliger; Publication: US; Hair: Pierce Austin; Makeup: Joanne Kovloff; Suit: Donna Karan; Hat and Tie: American Rag; Shoes: Diego Della Valle

TÉA LEONI
Photographer: Isabel Snyder; Publication: TV Guide; Hair: Robert Vetica/Heller; Makeup: Stephanie Carlan/Heller; Suit and Shoes: Emporio Armani

DAVID DUCHOVNY
Photographer: Jon Ragel; Publication: US; Hair and Makeup: Lori Jean Swanson/Cloutier; Suit: Hugo Boss; Tie: Barney's

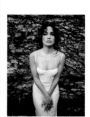

JOAN CHEN
Photographer: Raul Vega; Publication: USA Weekend; Suit: Romeo Gigli

SAMANTHA MATHIS
Photographer: Richard Reinsdorf; Publication: Movieline; Hair: Chris McMillan/Profile; Makeup: Karen Kawahara/ Cloutier; Suit: Richard Tyler; Shirt: Traffic; Shoes: Diego Della Valle

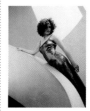

KIM DELANEY
Photographer: George Holz; Publication: Entertainment Weekly; Hair: Yuki Sharoni; Makeup: Stephanie Fowler; Dress: Richard Tyler

FRAN DRESCHER
Photographer: Andrew Eccles; Publication: InStyle; Hair: Chris McMillan/Profile; Makeup: Carol Shaw/Cloutier; Dress: Dolce & Gabbana

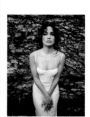

JENNIFER LOPEZ
Photographer: Jeffrey Thurner; Publication: US; Hair: Oscar Blandi; Makeup: Monica Blunder/Cloutier; Dress: Anna Molinari

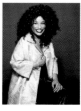

SAMUEL L. JACKSON
Photographer: Art Streiber; Publication: P.O.V.; Hair Christa Roby/Cloutier; Hat: American Rag; Sweater: Dolce & Gabbana

CHAKA KHAN
Photographer: Albert Sanchez; Publication: Essence; Hair: Valerie Spice Site; Makeup: Wendy Ann Rosen; Coat: American Rag; Velvet Dress: Anna Sui

ACKNOWLEDGMENTS

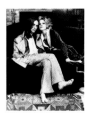

CHRIS AND LALA ROBINSON
Photographer: Davis Factor; Publication: Sky Magazine; On Chris: Suit: Sonda; Vest: Romeo Gigli; Shirt: Wasteland; On Lala: Jacket: Dolce & Gabbana; Pants: Todd Oldham; Shirt: Wasteland

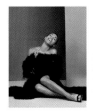

JADA PINKETT
Photographer: Blake Little; Publication: Movieline; Hair and Makeup: Phyllis Williams; Coat: Norma Kamali; Shoes: Diego Della Valle

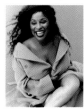

CHAKA KHAN
Photographer: Eika Aoshima; Publication: Interview; Hair: Sid Curry/Profile; Makeup: Wendy Ann Rosen/Cloutier; Coat and Shoes: Giorgio Armani

DAVID DUCHOVNY
Photographer: Jon Ragel; Publication: US; Hair and Makeup: Lori Jean Swanson/Cloutier; Coat: Traffic/Beverly Center

SYMPOSIUM CREDITS
p.17 Lauren Holly photographed by Scott Downie/Celebrity Photo

p.17 Jada Pinkett and Will Smith photographed by Roger Karnbad/ Celebrity Photo

p.19 Angela Bassett and Courtney B. Vance photographed by Paul Smith/ Retna Ltd.

p.19 Salma Hayek photographed by Janet Gough/Celebrity Photo

p.20 Roma Downey photographed by Miranda Shen/Celebrity Photo

p.20 Lea Thompson and Howard Deutch photographed by Lisa O'Connor/Celebrity Photo

p.21 Elizabeth Hurley photographed by Lisa O'Connor/Celebrity Photo

p.21 Kristen Johnston photographed by Janet Gough/Celebrity Photo

To all the photographers and celebrities who allow me to be me. Thank you for making dreams come true every day. The world is a more beautiful place because of you.

To all the people who put in a lot of hours and much love to make this book happen—my editor Amye Dyer; designer Paul Roelofs; and photo editors Cathy Eng and Laurie Kratochvil.

My family—I'm everything I am because you loved me. Rita, Ruby, Annette, Bella, Tibbie, Francis, Beth, Rose, Kaye, Caryl, Max, Harold, Lawrence, Jerome, Seymore. Richard and Marlene Bloch. My cuz's—Sandra, Cindy, Tammy, Eddie, Stanly, Stephen, Debbie, Abbie, Matthew, Jillian, Jeryl, Donald.

My chosen family—you're the ones who lift me up and never let me fall. I've been blessed with your love through it all. Gloria, David, Charles Park, and Sawyer Armstrong; Perrie, Mat, Madeline, and Catherine Halpern; Pieter Estersohn; Robin, Mickey, Olivia, Kia Fischa; Susan Krakower; Mary Beth Vishno; John Foliano; Elyse Richman; Ethan and Erica Silverman; Cindy Bier; Tania Martin; Peter Dunham; Andra Levinson; Lisa Bevis, Rafael Toledo; Rickey Massey, Monica Curtin, Susan Ashbrook, Glynis Costin, Stephano Disabatino; Koreen Kraft; Pamela Chess; Cliff Griggs; Tonio Jennifer; Ricky Lee; Stephanie Hamada; Elycia Rubin; Julie Feiten.

My work family: The Cloutier Agency, Chantal Cloutier, Madeline Leonard, Charnelle Smith, Joanna Flores, Bill Cloutier, Michelle Harris, Adrienne Novak.

My book families at William Morris Agency and Warner Books: Deborah Goldstein, Maia Irellio, Kristin Gamble, Harvey-Jane Kowal, Anna Maria Piluso, Amy Einhorn and Michele Karas.

Thank you for believing in me before I even knew what to believe in: Cyril Dequilfeldt, Donna Ginsberg, Cindy Frankel, Alison Cohen, Lisa Burd, Alma Dowdy, Cheryl Rice, Beth Levy Gregg, Iris Tomashaw, Mickey Wind, Rohnda Tannenbaum, Leo Henney, Andrew Zobler, Golda and Rene Berlin, Nicole Burdette, Mimi Jennings, Kathy Baker, Michelle Fielding, Francoise, Deesa, Patrick McMullen, Jean Pascal Levy, David Bozman, Katey Locke, Carmel and Charlie Limani.

You gave me wings and let me fly, with your faith I can reach the sky: Bernard Zamkoff, Eddie Locke, Diane Benson, Joyce Kuykendahl, Silvia Cassablanca, Pepo Uannini, Kathy Backer, Mimi Jennings, Tea and Julio and Lorella, Herminio Disabatino, Marion Greenberg, Joe Siff, Scia Scia Gambacini, Monica Dolphini, Tony Menenguzo, Javier Vallohnrat, Calvin French, Paul Haugnauher, Nobuko, Natasha, Luigi, Adelle, Nicoletta Le Regina de Jamaica, Pia Warwick, Carlo Capasa, Julia Amadeo, Luanna,

Valerio, Robert Ungar, Leslie Tong, Eddie and Elizabeth Celnick, Kathy Roher, Ann Crawford, Rip George, Morgan Yakus, Ilian, Karen Labby, Jessica Paster, Liza Anderson, Mila Lamprecht, Tom Handley.

Thank you for allowing me to sparkle amongst the brightest stars. *InStyle:* Martha Nelson, Maureen Griffin, Allyson Torrisi, Kate Bales-Moulene, Charla Lawhon, Lisa Gabor, Hal Rubenstein, Mary Jane Skarren, Alice Kim, Jean Cabacungan-Jarvis. *Premiere:* Chris Dougherty, Jennifer Martin, Jim Miegs. *Vanity Fair:* Elizabeth Saltzman. Vogue: Catherine Betts. *Elle:* Marin Hopper. *Detour:* Luis Barajas, Jim Turner and Rose Cefalli. *US:* Rachel Knepfer, Jennifer Crandall. *German Vogue:* Anja Schafer. *Entertainment Weekly:* Michael Kochman, Doris Brautigan, Alice Babcock, Pamela Hassle, Daryl Bowman. *TV Guide:* Julie True, Kerri Conaway. *Movieline:* Anne Volokh, Virginia Campbell, Heidi Parker.

I wish I could fill every garment bag and box you've ever sent me with love and gratitude and send it back to you. Diamond Information Center: Nadine Ono, Joan Parker, Cheryl Pellegrino, Meg Forehand and Carol Brodie, Wanda McDaniel, Samantha McMillen, Linda Gaunt, Duke Hagenburger, Christy Jordan, Nancy Lucas, Karen Hanley, Pamela Barish. Tenley Zinke, Stormi Stokes, Ann Fahey, Stella Ishll, Sarah Broach, Angela Mariani, Pillar Crespi, Barbara Valensise, Celeste Gregoire, Robin Gavan, Danna Faircloth, Justo Artigas, Susanna

Myers, Khristine Westerby, Nikkena Cruz, Katheryn Rosenbaum, Purdom Thomas, Natasha Grigorov, Laura Weisberg, Elizabath Fillmore, Rachel Dicarlo, Julie Luchs, Brooke Baldwin, Lisa Schiek, Stella Hall, Charlotte Sprintis, Liad Krispin, Elizabeth Harrison, Lara Shriftman, Greg Link, Sandra Graham, Holly Vogel, Betsey Johnson, Mark Jacobs, Kim Kassel, Lisa Focazio, Alexis Bequary, Jenia Molnar, Elizabeth Rogers, Molly Whelahan, Frankie Crocker, Marni Senofonte, Rachel Gottlieb, Katharina Bofinger, Mary Beth Schmitt, Markus Ebner, Ed Filapowski, Julie Mannion, Ann Waterman, Christy Hood, Christine Notaro, Anna Deluca, Fraser Conlon, Patty Cohen, Ralph Lauren, Betty Ann Gwathmey, Lisa Krupnick, George Kolasa, Julie Schindler, Theodore Alano, Barbara Kramer, Quohnos Mitchell, Adrienne Landeau, Angela Britzman, Ali Taekman, Brandusa Niro, Libbie Lane, Danae Webster, Pam McMann, Greg Mills, Michelle Stein, Lisa Lawrence, Neil Lawrence, Lisa McCauley, Brook Magnaghi, Dawn Brown, Sheila Parham, Billy Davey, Nina Santisi, Owen Davidson, Alex Melendez, Jeannette Cantone, Conn Brattain, Kim Vernon, Michael Nash, Ann Doyle, Elisabetta Rogiani, Mandie Erickson, Karen Erickson, Gaspar Saldanha, Ellen Carey, Paul Smith, Heather Rich, Kim Davison, Lisa Trafficante, Margaret Schell, Pam Stein, Tom Handley, Christina Ambrosino, Leah Forrester, Francesca Leoni, Nicole Simpson, Cheryl Dunbar, Diego Della Valle, Jeff Supalo, Sidney Fuller,

Claudio Castiglioni, David Cohen, Neketa Newell, Tracy Hardey Grey, Vanessa Noel, Hillary Heard, Becky Cash, Cheryl Calagari, Kristen Hoppmann, Cindy Whiteside, Jennifer Kaufman, Martin Katz, Julie Boghossian, Cricri Solak-Eastin, Armand Espinola, Lisa Labrado, Sarah and staff at Traffic, Beverly Center. Michael Sharkey, Studio Services Families at Barneys, Bloomingdales, Neiman Marcus, Saks Fifth Avenue, and Macy's.

To all the staff and friends at: CFDA, Kevin Krier, PMK, Bragman Nyman Cafarelli Huvane Baum Halls, Michaels Wolfe and Tencer, Baker Winoker Ryder, Wolf Casteler, Marleah Leslie and Assoc., Nancy Selzer and Assoc., Jason Weinberg & Associates, Rogers & Kowan, Three Arts Management, Janet Botash Group, Christine Malin, Patrick McColery and Rebecca Nevit, Karen Weiss, Larua Heinz, Visages, Smash Box Beauty, Smash Box staff, Nancy Corbett, Jean-Marc Vlaminck, Samantha Schwartz, Stacy Fischer, Amber Smith, Nicole Lisai. And L.A. Color Labs and Phillip Narduli for their contribution of beauty.

And finally, thank you, Jeannie Becker, Rebbeca Meiskin, Brad Bessey, Alex Duda, Jamie Glasson, Gabé Doppelt, Deegan Penner, Michael Weyman, Sam Griffin, Tom Julianne, Jeannie Kelly, David Coleman, Charla Krupf, Renny Chun, Lauren Goldstein, Carla Hall, Jason Kaufman, Steven Cojocarn, Anne-Marie Otey, Janice Nin, Lisa Bannon, Elizabeth Snead, Ann Bratskeir, Lisa Burke, Amy Spindler.